STRUCTURAL INTUITIONS

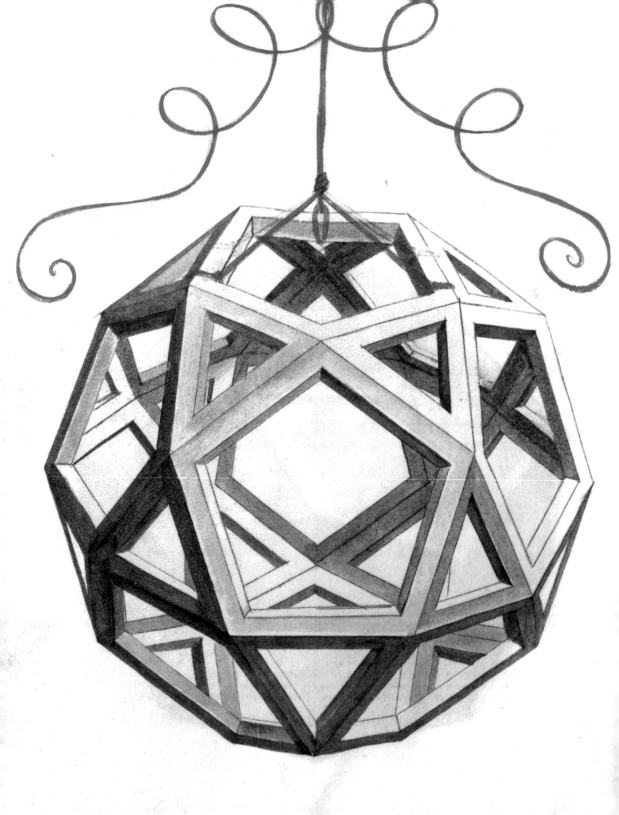

Structural Intuitions

Seeing Shapes in Art and Science

Martin Kemp

University of Virginia Press

CHARLOTTESVILLE AND LONDON

Publication of this book was assisted by a grant from the Page-Barbour Lecture Fund.

University of Virginia Press
© 2016 by the Rector and Visitors of the University of Virginia
All rights reserved
Printed in the United States of America on acid-free paper

First published 2016

9 8 7 6 5 4 3 2 1

Library of Congress Cataloging-in-Publication Data
Kemp, Martin.
Structural intuitions : seeing shapes in art and science / Martin Kemp.
pages cm—(Page-Barbour lectures for 2012)
Includes bibliographical references and index.
ISBN 978-0-8139-3700-7 (cloth : alk. paper)—ISBN 978-0-8139-3699-4 (e-book)
1. Art and science. 2. Pattern perception. 3. Cognition and culture. I. Title.
N72.S3K394 2015
701'.05—dc23

2014024532

Cover art: "Kandinsky" spritz bowl, Charlotte Sale, 2010. (Photo by Murray Ballard)

In memoriam E. H. Gombrich (1909–2001)

Contents

Preface

The invitation to deliver the Page-Barbour Lectures in spring 2012 was easy to accept. I knew the University of Virginia from previous visits, and had fallen in love with all things Jeffersonian. Monticello is one of my favorite places, as is the cluster of buildings around the Lawn at the university. As will become apparent, Jefferson's designs for the university's Rotunda are wonderful exemplars of the kind of geometrical structuring that lies at the heart of the lectures and book. A glance at the list of those who had delivered the previous lectures in the series founded by Mrs. Thomas Nelson Page in 1907 reinforced my sense of the honor of being invited, while setting standards that I felt unlikely to emulate.

In the event, the lectures were received with generosity, and I benefited greatly from discussions with academics and students across a wide range of disciplines, ensuring that the resulting book is more securely grounded than the lectures. I delivered three lectures in successive days—"Platonic Solids," "Patterns of Process," and "Taking It on Trust"—which have been developed into five chapters, with an introduction and afterword. Spoken lectures and written texts

are for me very different things, but anyone who heard the lectures and reads the book will recognize the recurrent obsessions that have driven my interest in visual things over the years.

Before and during the lectures, Walter Jost was an exemplary host, socially, intellectually, and personally. Richard Jones dealt with all logistics with clarity and unfailing warmth. All the staff at the university, not least those who attempted to make my animations of Leonardo's drawings run in PowerPoint, were helpful in an exemplary way.

In the production of the book, Dick Holway and Ellen Satrom have offered professionalism, patience, and understanding, striving to make the book as good as its text permits it to be. Ruth Melville undertook the copyediting with exemplary care and tact. Kristina Kachele has produced a book design of notable elegance. Sandra Assersohn, whose excellence as a picture researcher I knew when she worked on *Christ to Coke,* has done a wonderful job chasing down images from a wide range of sources and persuading rights holders to look on the book with favor. She and I are particularly grateful to contemporary practitioners of art, science, and technology for their support. Many of them were kind enough to read relevant sections of the book and to make suggestions.

A substantial portion of the text was written when I was the Robert Janson–La Palme Lecturer at Princeton, teaching a graduate course on Leonardo. Primary thanks for what was a hugely satisfying experience go to Robert himself. Susan Lehre and her team in the Department of Art and Archaeology provided warm support, and the "Famous Five" students, often in company with Leslie Geddes, were a delight. Julie Angarone, who dealt skillfully with computer issues, the visual resources team led by Trudy Jacoby, and all the librarians were unfailingly helpful. I am very grateful for the open-minded welcome from the historians of science, spearheaded by Graham Burnett.

The draft text was read for the Press by Philip Ball and Siân Ede, both of whom manifest great wisdom in the visual cultures of science and art. I am extremely grateful for their constructive comments, and I have done my best to take their suggestions on board. Philip Ball drew my attention to a range of recent science that deals with the phenomena in which I am interested. I have tried to mention, however briefly, the examples he provided in such a way as to direct attention to the references he also supplied, so that readers can follow up his suggestions on

their own behalf. He has inadvertently helped me to give the impression that I know more about science than I actually do. Both he and Siân Ede helped to make the introduction function in a more helpful manner. Siân also provided detailed suggestions about how the text and examples might work better. The faults that remain are entirely my own.

Throughout the whole process, from the time of the invitation to now, my personal assistant, Judith (Judd) Flogdell, has been wholly integral to everything that has been achieved. More specifically, she has worked hard to correlate the text and illustrations and compile the index.

Crossing such a wide territory of art and science has involved much brain-picking, and I cannot promise that I adequately remember all those who have generously shared their knowledge and ideas. I am grateful in various and diverse ways to Ian Ainsworth, Manuel Báez, Philip Ball, Cecil Balmond, Jonathan Callan, Annie Cattrell, Susan Derges, Finella Devitt, Molly Donovan, Chris Drury, John Dubinsky, Jayanne English, J. V. Field, Francesca Fiorani, Tina Fiske, Vincent Floderer, Donald Fry, Bill Gates, Mory Gharib, Andy and Holly Goldsworthy, Malcolm Goodwin, Peter Huestis, the Inglebury Gallery Edinburgh, Frank James, Matthew Jarron, Assimina Kaniari, Harry Kroto, Phyllis Lambert, Matt Landrus, Domenico Laurenza, Karen Lemmy, Karin Leonhard, Ken Libbrecht, Jean-Pierre Luminet, Marta de Menezes, Glen Onwin, Theresa Neurohr-Pasini, Peter Randall-Page, Manuela Roosevelt, Charlotte Sale, Conrad Shawcross, David Summers, Babu Thaliath, Julian Voss-Andreae, Sophia Vyzovoti, and Francis Wells.

I am of course indebted to many more people than I can readily recall, and perhaps I may be permitted to offer collective thanks to those I have forgetfully omitted.

MARTIN KEMP
Woodstock, Oxon, February 2014

STRUCTURAL INTUITIONS

Introduction

My concept of "structural intuitions" has been developing over the course of a number of lectures and publications. This is the first time it has become the prime focus of my attention. The structures are the shapes and patterns that exist in nature in complex relationships with various kinds of disorder and chaos. Analogous patterns can be witnessed across an almost unlimited range of forms and processes across the organic and inorganic worlds and across all the scales that we are capable of observing. The five regular bodies, the so-called Platonic solids, recur throughout history as observed and envisaged structures from microscopic to cosmological scales. Among the dynamic patterns, branching formations are notably common and characterize all kinds of systems that are involved in the flow of fluids. Spiral growth patterns recur on a widespread basis in the worlds of animals and plants. Waveforms constitute a fundamental pattern in physical and chemical dynamics. Folding—how a sheet of material reacts under compression or tension—has come to prominence recently but has always been of serious concern to artists who present draped figures. The same is true of splashing, which only became visible in all its orderly complexity in the era of instant photography

but has been of recurrent concern to artists who have portrayed water or exploited the dynamics of liquid media in their making of works of art. Such phenomena, transgressing taxonomic boundaries, provide the core of this book.

The structures also involve the perceptual and cognitive mechanisms and processes that have evolved over deep time to allow us to make orderly sense of how nature works. These are profoundly functional in our ability to understand what has happened in nature, what is happening, and what will happen. A fish swimming in water or bird flying in air exhibits a profound "feel" for how its body interacts with the complex patterns of motion in fluids, clearly beyond anything that humans can achieve. What we, as a species, add to the equation is our ability to extract the orders intellectually, analyzing them, formulating underlying rules, and manipulating them creatively in the service of making "things of a natural kind" in the fields that we call art, science, and technology. By "things of a natural kind" I mean inventions that work with the underlying warp and weft of nature rather than things that necessarily look like organisms. A machine tooled from metal components is, in this sense, a kind of mechanical body abstracted from nature, without imitating a natural organism.

The mental structures are those with which we have been endowed in our bodies and brains to make coherent sense of the teeming complexity of what we see around us every moment of our conscious lives. The structures, immanent in the massive potential of our embryonic brains, are realized in rich dialogue with the worlds around and within us. The result is that we can work readily with obvious regularities, like the shape of a table we need to walk round, and also with the indeterminate but nonrandom patterns of complex systems such as water in motion. The resonance of the inner and outer structures is neither simple nor given, but directed by our interests, skills, and selective attention. The selection is both individual and more broadly cultural. Alongside the powerful cultural variables there remains a core of basic structures dealing with such fundamental necessities as space, weight, and motion that we all share regardless of the filters of particular cultures. One of the greatest tricks in art and science is to redirect our selective attention in new ways through acts of visual pointing.

As a historian I am conscious that my tracking of shared properties of the mind over a wide historical and geographical span plays away from the specifics of the context within which the ideas arise, are realized, and are received. The contexts

are more evident in some of the episodes that follow than in others, but it is right to acknowledge that the structures as expressed in art and science do not exist as some kind of invariable, autonomous entities. They always find particular kinds of expression in concrete realizations that are specific to their time and place—shaped, colored, and understood in ways that vary significantly across time. I see no conflict between thinking that there are enduring tendencies in the human mind and believing that all cultural products are socially constructed. A construction can both follow certain necessary principles if it is to stand up and also be a particular expression of social forces. A Gothic flying buttress and a twenty-first-century bridge by Cecil Balmond are very much of their period, but they share underlying mathematical rationales in how they handle the resolution of forces of tension and compression that endow the structures with stability. The example of Newton's laws of gravitation, shortly to be discussed, makes essentially the same point.

The concept of structural intuitions raises obvious questions with respect to the long tradition of the philosophy of knowledge, especially scientific knowledge, and in relation to recent developments in brain science, most notably the kind of localization of functions that is being investigated in neuroscience.

To ask the philosophical question at its crudest: are the structures those that the human mind imposes on sensory experience or are they freestanding aspects of underlying order in nature? Again to oversimplify, Immanuel Kant and his followers incline to the first view, while those who advocate the reality of science and its empirical foundations adhere to the latter. I am wanting to have it both ways. On one hand, structuring is inherent in the functioning of the human mind, and can be developed in a malleable way in relation to experience and needs. On the other, order is a nonarbitrary feature of nature across the widest range of scales accessible to us. The order of nature may be expressed through probabilities and be subject to fixed uncertainties, but the pattern of things in nature is not a random field onto which we impose order. We have, as I will argue in chapter 5, a strong propensity to see what we want and what we expect, but this propensity is both strongly structured and in complex dialogue with external orders. It may be said that the greatest artists and scientists are those who demonstrate the greatest ability to see afresh and discern shadowy or unapparent orders. Art and science begin where existing knowledge ends.

Thus, to take an example I have used before, Newton's law of gravitational acceleration is a brilliant theoretical deduction, arising in very specific circumstances within Newton's life and in the broader context of intellectual and social history around 1687. It also carries a very high level of truth content in relation to how the force of gravity actually acts, even if it has subsequently been qualified by Einstein's concepts and remains ultimately elusive. Newton's law can be seen as generated in a Kantian manner but in intimate dialogue with empirical observations. The law generated new ways of seeing and the new ways of seeing can catalyze new theories. These processes are essentially nonlinear, simultaneous, and often individualistic; our description of them remains frustratingly tied to sequence and generalization. The thematic structure of this book inevitably leads to generalities, but without, I hope, losing sight of the obstinate particularities of human creations in their contexts.

We may describe the theory-driven processes as "top-down" and the empirical procedures as "bottom-up," suggesting a polar opposition, but the actual operation of the mental activities is compounded from both poles in a complex and messy way, whatever actual protagonists might declare. Even the most insistent empirical gathering of evidence is shaped by the conceptual framework that allows questions to be asked, while even the most abstract theory about the physical properties of nature will exist in some kind of dialogue with our experience of actual phenomena. Looking to examples that appear later in the book, we can place Andy Goldsworthy's constructions toward the empirical end of the range, and Cecil Balmond's algorithmically generated "sculptures" toward the other pole, but both artists are deeply engaged with the alternative end of the mental spectrum. Goldsworthy repeatedly exploits basic geometrical forms, while Balmond is an engineer who grapples with real materials. We might best regard each pole as a gravitational center that pulls certain kinds of thinkers predominantly in one direction. However strong the pull of one pole, the other necessarily exercises its inexorable attraction.

Where do structural intuitions stand in relation to modern neuroscience? The data and images produced by brain scanning are undoubtedly revealing a great deal about the localized mechanisms of the brain—though the science is certainly not telling us "how we think," any more than genetics is telling us "who we are." The scans produced by functional magnetic resonance imaging (fMRI) provide

spatial definitions of different kinds of mental operations that are reasonably robust if unsubtle, while the temporal dimensions of incredibly rapid interactions and complex longer-term processes are only now being clarified. Looking at fMRI scans, which emphasize the hot spots of blood flow in brains, the situation is rather like flying high over a city at night and being able to see the overall patterns of light emanating from the spaces and buildings and roads without being able to determine reliably what is actually happening to vehicles in the traffic, where they have come from, and where they are going.

The relatively new field of "neuro-aesthetics" is dependent on fMRI imaging, and aspires to disclose how aesthetic responses operate. Though some of the individual findings about the operation of the brain in the making and viewing of artworks are fascinating, the conceptual basis of the overarching quest seems highly oversimplified and rooted in the kind of artistic formalism that dominated in the 1960s. Meaning and context play little or no role in standard neuro-aesthetics, although our experience of every work of art is saturated in content and circumstance. Our responses are fluid, complex, malleable, untidy, and noisy, involving many faculties of the brain, including our strong response to circumstance. The most immediately fruitful area of neuroscience in art lies in the field of reception, that is to say, in looking at how our reaction is affected by plural inputs, not least the context of viewing, rather than chasing an ideal abstraction of the aesthetic experience. I will suggest in the afterword that the quest for such an ideal abstraction is inadvisable.

The interplay between structure and intuition that I am positing is, like the notion of imagination, intricate and neurologically complex, involving the teeming and fluctuating interaction of many mental modes. The totality of its functioning is still far from our grasp, and is likely to remain out of detailed reach using our current methods.

My sense of the kind of intuition that is at work in the mingled top-down and bottom-up processes shares a good deal in common with that formulated by René Descartes in his *Regulae ad Directionem Ingenii* (Rules for the Guidance of Our Innate Powers of Mind), written in the late 1620s:

> By intuition I understand not the fluctuating testimony of the senses, nor the misleading judgement of a wrongly combining imagination, but the con-

cept which the mind, pure and attentive, gives us so easily and so distinctly that we are thereby freed from all doubt as to what we are apprehending. . . . Thus each of us can see by intuition . . . that the triangle is bounded by three lines only, the sphere by a single surface, and the like. Such intuitions are more numerous than most people are prepared to recognise, disdaining as they do to occupy their minds with things so simple.

Descartes's use of "intuition" as the immediate, rational apprehension of simple, basic things, like a cat or a square, is more welded to rational processes of deduction than our modern sense of the term would generally allow, and less associated with imagination, but his emphasis on our instinctual grasp of the order and nature of things serves our present purposes well.

I am above all intending to signal the kind of instinctual perceptions that intuit deeper simplicities beneath surface complexities, saying in effect, "Can you see that, do you see what's happening there, can you see that pattern? There's some kind of rationale behind that." There is a preverbal component to this, acting as a perceptual rudder before the great ocean liner of analytical intellect travels in a particular direction. The determined direction may prove to be a blind canal. Intuitions can be wrong, directed by slanted interest and unwarranted preconceptions. They can be creatively redirected. They are very powerful agents.

There is no more vivid witness to this than Albert Einstein, who was reaching out into realms of implicit order far beyond our earthbound perceptions. "All great achievements of science must start from intuitive knowledge. I believe in intuition and inspiration. . . . At times I feel certain I am right while not knowing the reason." His most comprehensive review of the intuitive component came in his response to a series of questions formulated by the very distinguished French mathematician Jacques Hadamard and circulated to leading international figures in the mathematical and physical sciences. Their responses were published in 1945 as *The Psychology of Invention in the Mathematical Field*. Hadamard emphasized that he was dealing with the psychology of *invention* in the mathematical *field,* not with the broader question of the psychology of mathematicians. He also argued that artists really deal with *inventions,* while scientists may best be said to be involved with *discoveries.* This distinction seems obvious but it is not one that I wish to sustain during the course of this book.

Hadamard recognized that the response of Einstein, whom he knew personally, was exceptional and quoted the whole of his colleague's letter. Having apologized rather rhetorically for the shortcomings of his response, Einstein writes:

(A) The words or the language, as they are written or spoken, do not seem to play any role in my mechanism of thought. The psychical entities which seem to serve as elements in thought are certain signs and more or less clear images which can be "voluntarily" reproduced and combined. There is, of course, a certain connection between those elements and relevant logical concepts. It is also clear that the desire to arrive finally at logically connected concepts is the emotional basis of this rather vague play with the above-mentioned elements. But taken from a psychological viewpoint, this combinatory play seems to be the essential feature in productive thought—before there is any connection with logical construction in words or other kinds of signs which can be communicated to others.

(B) The above-mentioned elements are, in my case, of visual and some of muscular type. Conventional words or other signs have to be sought for laboriously only in a secondary stage, when the mentioned associative play is sufficiently established and can be reproduced at will.

(C) According to what has been said, the play with the mentioned elements is aimed to be analogous to certain logical connections one is searching for.

(D) Visual and motor. In a stage when words intervene at all, they are, in my case, purely auditive, but they interfere only in a secondary stage, as already mentioned.

(E) It seems to me that what you call full consciousness is a limit case which can never be fully accomplished. This seems to me connected with the fact called the narrowness of consciousness.

The answers, as Hadamard noted, do correspond tidily to his questions. Einstein's *A, B, C,* and *D* focus on Hadamard's issue of "what kind of internal entities mathematicians exploit, and, depending on the subject, whether they are motor, auditory, visual, or mixed." Point *E* picks up the question as to whether "the mental pictures or internal words present themselves in the full consciousness or in the fringe consciousness."

It is notable that Einstein, who expounded his theories algebraically rather

than geometrically, described the earliest creative moment as visual and somatic rather than verbal or symbolic. We should not underrate the bodily dimension to Einstein's first processes of visualization, not least in relation to the kind of warping of space-time with which he was so concerned. We cannot of course rule out the possibility that for Einstein the visual included a form of seeing algebraic formulas that could then be expanded into verbal formulations.

It is also worth noting that Einstein resists the idea that full consciousness can ever be achieved as a total state, independently of other unconscious processes. The conscious working of the pure analytical intellect is a concept only, never a real state. Other things crowd in unbidden. Without them a vital dimension of creativity—its unforecastable and ragged nature—would be lost.

In what follows I will be concerned with the geometrical undertow of visual perceptions rather than the symbolic analysis and synthesis of algebra or the manipulation of numbers. Even with respect to natural geometries, my agenda is quite constrained in that I look only to a limited degree at the kinds of mathematics of complexity that have made such inroads into the explanation of morphogenesis. Nonetheless I am left with a very wide territory, and, even so, there is much in the sciences and arts that lies outside its range. My phrase "structural intuitions" does not pretend to imply some kind of universal explanation of common ground in the sciences and visual arts. It cannot, for instance, encompass the deep humanity of Rembrandt's self-portraits or the complex statistics of the unpredictable phenomena of meteorology.

However, even in meteorology a potent tool of visualization was devised in the nineteenth century and has endured. The use of contour lines to designate zones of equal height on maps had been developed to great effect in the eighteenth century. In meteorology this visual method was taken up in the form of isobars—contour lines connecting points of equal pressure. Isotherms similarly joined locations of equal temperature. This was part of what Francis Galton, Darwin's cousin, called the more general "method of contours or isogens," which explored lines along which equal values pertained in any field of statistical analysis. He deployed it in wider areas, such as the plotting of birthrates to parents of older and younger women and men. It is now difficult to envisage a meteorologist's map without the contour lines. We know that if the contours are close together we can expect high winds, even if we do not know why. An act of abstract, diagrammatic

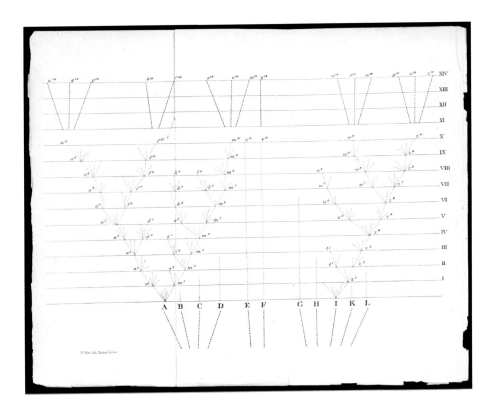

Figure 1. Diagram of evolution, Charles Darwin, from *The Origin of Species*, 1859

ordering—as a schematic visualization—has assumed a kind of special reality of its own kind.

Darwin's own theory of natural selection does not obviously fall under the embrace of the kind of visual intuitions that I am looking at. In *The Origin of Species* in 1859, which is exceptional as a work of natural history that includes no pictures, he provides but one illustration. On page 117 he provides a chart of evolutionary change in the form of a divergent system, looking rather like bushes arising from the two stocks, *A* and *I* (fig. 1). The horizontal lines mark kinds of isogens, indicating the stages at which "a sufficient amount of variation is supposed to have been accumulated to have formed a fairly well-marked variety, such as would be thought worthy of record in a systematic work." The intervals between the lines could be extended to "represent a million or hundred million

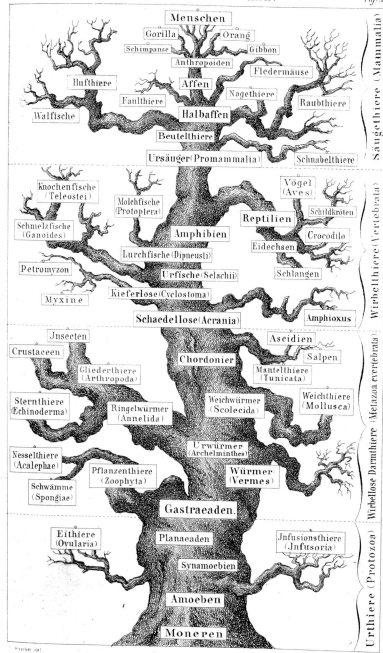

Figure 2. Evolutionary
tree for the descent
of man, Ernst Haeckel,
from *Anthropogenie
oder Entwickelungs-
geschichte des
Menschen*, 1874

generations," in which case they may be envisaged in concrete visual terms to show "a section of the successive strata of the earth's crust including extinct remains."

Darwin's scheme hardly looks like a natural tree—although in his notebooks he does produce some tree-like diagrams to characterize the relationship between species over time—and he speaks of it only as a diagram composed from "little fans." The upper section demonstrates a distinct stage at which species A has been replaced by eight new species, and I by six new ones. However, though it is not categorized as other than a diagrammatic tool, Darwin sowed the seeds of that most compelling and clichéd image the "evolutionary tree," which haunts school textbooks and educational displays in museums. Ernst Haeckel, the German Darwinian whom we will encounter more than once, played a significant role in cementing the idea that lines of evolutionary descent could be represented as real trees, in this case a gnarled oak (fig. 2). Our need to translate nonvisual things into visual images runs very strong and very deep. Branching systems will provide the major focus of the chapter on patterns of growth.

A nicely specific and personal example of how structural intuitions can work in unexpected ways in art and science is provided by a story I have told before, not least at the start of the lectures on which this book is based. I was introduced to the artist Jonathan Callan by Marina Wallace of Central St. Martin's College of Art in London. When we visited his studio he was sieving cement powder over a flat board punctuated by holes at nonregular intervals. He was fascinated by the configurations that were resulting below and above the board, especially above. A strange landscape progressively aggregated, formed by elegant minimountains of varied heights linked by parabolic cols at varied depths (fig. 3). The process was driven by Callan's intuitions and his feeling for the behavior of materials. He had found that cement powder flowed and cohered better than other granular materials. The landscapes echoed landscapes seen on earth but possessed a strangeness that evoked an extraterrestrial quality—or perhaps of structures on a very minute scale seen only by very powerful microscopes.

I happened to be reading Per Bak's 1996 book *How Nature Works: The Science of Self-Organized Criticality,* which brought into a more general domain the theories developed by himself, Chao Tang, and Kurt Wiesenfeld in a paper published in 1987. The archetypal model of self-organized criticality is a sandpile. If we create a conical hillock of sand by trickling grains through our fingers—as many of

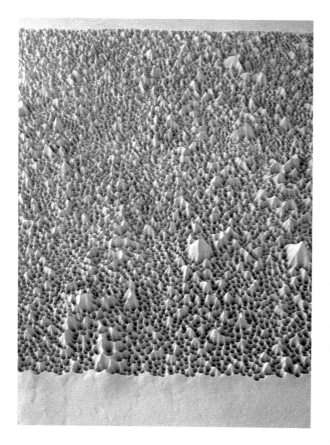

Figure 3. *Dust Landscape* (detail), Jonathan Callan, cement powder, 1999

us will have done on a beach as children (and as adults?)—we know that the cone will only progress to a certain point before there is a catastrophic avalanche or a series of avalanches. We may sense that there is a critical angle that cannot be exceeded. Rather surprisingly, there is not a simple rule that tells us when an avalanche will occur according to a set angle. The phenomenon is unpredictable and falls under the embrace of the modern sciences of complexity. There is a general shape to the phenomenon, and it occurs within certain parameters, but even a simple model of sandpiles resists being reduced to predictable, linear rules. The theory has proved to be of wide applicability to many systems that progress into a critical state, ranging from traffic jams to economics. The wider issue of the emergence of spontaneous order is a notably vibrant area in physics and applied mathematics, as Steven Strogatz is demonstrating.

I asked Jonathan Callan if he knew about Bak's theory, which he did not. This was not disappointing, since one of the points of what he was doing was that it was not based on derived theories but on visual and physical intuitions, coupled with a keen alertness to compelling structures. On the basis of the small studio model he went on to create landscapes on large scales, sometimes occupying whole rooms. I discussed his dust landscapes in the column I was then writing for *Nature,* the science magazine. I had suggested that we include one photograph of the dustscape taken directly from above, because I liked the cellular pattern that became apparent.

Much to my surprise, the essay drew a response from Adrian Webster of the Royal Observatory in Edinburgh, who published a letter in *Nature* indicating that the cellular structure of the piles corresponds to "Voronoi's cells," named after the Ukrainian mathematician Georgy Voronoi: "The key to the underlying geometry comes from noting that any grain of powder that flows through the board does so through the hole nearest to its starting position in the layer. It is then possible to draw on the board the catchment region of each hole, because it consists of all the points in the plane of the board that are closer to that particular hole than to any other, which is the definition of a geometrical entity termed the Voronoi cell." In their simplest form, Voronoi cells form a tiling of irregular polygons (fig. 4). Noting that the Voronoi tessellation has wide applicability, Webster focused on its use as a model of the universe, in which the galaxies are distributed at the walls of a foam composed from polygonal cells arrayed in three dimensions. The galaxies are posited to "inhabit thin sheets at the boundaries between huge voids."

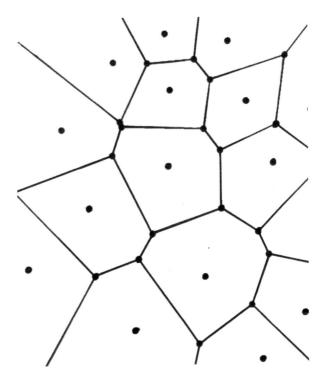

Figure 4. Diagram of Voronoi cells

It was now my turn to confess that I was unaware of this dimension to the patterns Callan had generated. Again ignorance served a purpose in what I was and am arguing. The artist's initial "invention" was driven not by theory but by intuitions about behaviors and structures based on creative looking at forms in nature and in his studio. At their best, such inventions have a nonspecific and multivalent quality that does not prescribe the resonances they might have now or in the future. I saw one resonance; Webster saw another. The story serves as an apposite illustration of what I mean by structural intuitions.

A word of caution is in order, however. We may see Callan's piles of cement as mountain-like and assume that the two structures arise from analogous mechanisms. With the partial exception of volcanoes, mountains do not aggregate like sandpiles but result from a process of uplift and erosion. Avalanches may be involved of course, not least of snow and ice, but we cannot automatically read a shared cause across from one form to an apparently analogous one. For the artists, this is not a problem, since we are not being presented with a theory or a proof but with something the artist has given us to share on our terms. We are being presented with a field for interpretation. For the scientist, by contrast, the visual analogy on its own does not pass beyond the realm of "so what?" unless it can be associated with a causal explanation that works to greater or lesser degrees in both cases. Even the great work of D'Arcy Wentworth Thompson, *On Growth and Form* (1917), tended to suffer at the time from the "so what?" charge. His vivid demonstrations of analogous geometrical morphologies that are generated across organic and inorganic systems were analyzed in terms of mathematics and even engineering but often lacked definite mechanisms through which they arose during morphogenesis, as he was well aware. Thompson, as will become clear, is one of the heroes of this book.

Three other general words of caution are also needed. The first is that my approach is that of a historian of visual continuities and their variants over the ages. I am not primarily concerned here with the rightness of a scientific theory. I do accept that science deals with nonarbitrary truth content—one theory is not as good or bad as any other—but I am concerned in this narrative with historically recurrent patterns of thought as they grapple with structures in nature. Whether the theory of the Voronoi foam is the correct model of the arrangement of galaxies is of interest to me, but its rightness or wrongness is not of prime concern in the enterprise of historical description on which I am at present embarked.

The second is that the quest for continuities does not obviously play toward the social contexts within which the images arose. The social functions of varied representations are discussed at various points, but do not provide a consistent focus for what I am doing. I am happy to acknowledge the importance and power of the social history of images, but I am working with themes that cross chronological, geographical, and cultural boundaries.

The third is that I am not intending the phrase "structural intuitions" to assume

a special level of reality in describing how our mind works. It is intended neither to be an explanation in itself nor to signal a distinct neurological process. At best it has the status of a term like *imagination,* which is a baggy descriptor that embraces a whole series of processes under a handy collective that serves a purpose in our discussions of what we can do. I am using the phrase as a convenient shorthand that points toward identifiable propensities in our processes of visualization that are dedicated to the extraction of order from natural forms and phenomena.

Although I am specifically concerned with the visual dimensions of structural intuitions, I am aware that they also operate powerfully in mental activities that do not involve images of a figurative kind. A nice example comes from the strange world of code breaking. In the wake of the Japanese bombing of Pearl Harbor in 1941, there was an urgent need to decipher the highly sophisticated and novel Japanese mode of encryption. Prospects did not look good, faced with 50,000 number groups of five digits. Captain Thomas Dyer, a key member of the team entrusted with the task, combined extraordinary persistence with special intuitive abilities:

> If you observe something long enough, you'll see something peculiar. If you can't see something peculiar, if you stare long enough, then that in itself is peculiar. And then you try to explain the peculiarity....
>
> A lot of it is, I'm convinced, done by the subconscious.... You look—it depends on what kind of thing you are dealing with—but you look at it until you see something that attracts your attention, your curiosity. Maybe it doesn't suggest anything at all. You go on to something else. The next day you come back and look at it again.

The hint of an underlying pattern, which seems to arise unbidden during this process, potentially provides the basis on which a full decoding can be laboriously accomplished.

Dyer's telling account of looking and relooking can be aligned equally well with the extraction of the double helix of DNA from Rosalind Franklin's key X-ray diffraction image or even with an eyewitness account of the aged Titian at work as the painter searched for an emergent order and visual logic in the chaos of his rough underpaintings:

He used to turn his pictures to the wall and leave them there without looking at them, sometimes for several months. When he wanted to apply his brush again he would examine them with the utmost rigour, as if they were his mortal enemies, to see if he could find any faults; and if he discovered anything that did not fully conform to his intentions he would treat his picture like a good surgeon would his patient. . . . Thus he gradually covered those quintessential forms with living flesh, bringing them by many stages to a state in which they lacked only the breath of life.

Cutting out the superfluous is vital in discerning what is the essential order of things—essential at least to us.

STRUCTURES, LECTURES, AND CHAPTERS

This book pursues the themes and the overall thesis of the lectures I delivered at the University of Virginia. However, the structure and style of the book are very different, even beyond the obvious distinction that there were three lectures and there are now five chapters, together with this introduction and the afterword. The lectures, delivered from notes rather than a written text, used large numbers of images to create a visual narrative of equal if not greater weight than the spoken words. As an example, the fifth chapter here corresponds to a lecture with almost a hundred images (in some fifty slides). The chapter itself contains only a third of this total, but it has the advantage that the reader can inspect key images for as long as he or she wants. The lectures were characterized by a more provisional and speculative exploration of ideas, which have been firmed up here. The book is thus something in itself, complementing the spoken words, rather than a close record of the talks as delivered.

Each chapter, as was each lecture, is marked by a strategy founded on the two main heroes of my long-term endeavor as a historian of visual things, Leonardo da Vinci and D'Arcy Wentworth Thompson. Leonardo puts in an appearance at or near the beginning of each chapter, and serves to draw attention to the particular kinds of patterns in nature that we are to explore. Alfred North Whitehead proposed the provocative aphorism that "the safest general characterisation of the European philosophical tradition is that it consists of a series of footnotes to Plato." In a sense this book and the lectures from which it was born can be characterized as a series of footnotes to Leonardo and Thompson. Both were intense

students of the formative geometry of nature. Strangely, given the different centuries in which they worked, their ideas emerged into the modern public domain at about the same time. At the end of the nineteenth century the full range of Leonardo's manuscripts was emerging through a series of facsimiles, transcriptions, translations, and anthologies, as Thompson was well aware. At this time Thompson himself was developing the mathematical ideas of morphogenesis that were to result in his classic *On Growth and Form* in 1917. Each of the first four chapters picks up a theme they would both have recognized. Leonardo certainly would have recognized the issues raised in the final chapter.

Leonardo will be familiar enough, though how his science is integral to every aspect of his creative life is perhaps less well known. I hope this aspect of Leonardo will progressively emerge over the course of his recurrent appearances in the book. The great Scottish biologist and classicist D'Arcy Thompson is less famous, though he is known across a wide range of disciplines in the visual arts, engineering, and architecture. Interest in his ideas is undergoing a notable revival, not least as new computational techniques are enabling us to model his insights into the geometry of growth. Thompson was professor of biology at Dundee from 1884 until taking up the Chair of Natural History at St. Andrews in 1917. He occupied the two chairs for a total of sixty-four years. He was in addition a recognized scholar of Greek and Latin classics and was widely respected by professional mathematicians and philosophers. He saw the mathematics of growth and form in biology as the crucial key to the very nature of nature. Botany and zoology, Thompson believed, conduct us to the edge of the mysteries of consciousness, the soul, and the infinite deity. Natural history not only provides insights into the technicalities of how diverse plants and animals are formed but also confronts us with the ineffable order in God's creation. In nature we can witness the beauties of form fitting function according to the principles of mathematical physics and see, as Thompson said, that they are "good."

Inevitably in a set of lectures that reviewed a wide range of material I have dealt with over the years, the new is combined with the old. Some of the sections of the book are based upon earlier writings, a number of which have appeared in rather obscure places, but there is a definite benefit from bringing them together in an overview and juxtaposing them with new material in the service of my overall theme. The overview does not mean that I am attempting some kind of joined-up history of the themes I explore. Each chapter relies upon a process of sampling

that often involves large chronological leaps. What is sampled relies considerably on my own personal interests and engagements, and reflects the kinds of visual and written stimuli to which I respond most enthusiastically. This certainly applies to the contemporary art I discuss, and some of the contemporary science. The artists at whom I look most closely are all known to me to greater or lesser degrees, and some of them are long-standing friends. The advantage is that I feel I can discuss their work in an appropriate way, and in some cases they have kindly read what I have written about them. Some of the discussed works are close in date to today, but as a historian my prime criterion has not been to select the latest examples.

The process of sampling is not based on a wide-ranging evaluation of what is important in art and science over the ages. I am happy to claim that much of the art and science at which I look is indeed important while recognizing that absent aspects of both may be as significant or even more so in the larger picture over the centuries. For instance, I admire Velázquez and Rembrandt enormously, and the fact that neither features here because they do not obviously "fit" with my themes does not say anything about my perception of their artistic status. The quest for underlying structure came to feature particularly prominently once art ceased to be predominantly concerned with the imitation of the optical appearance of nature. The greater degrees of abstraction in twentieth- and twenty-first-century art, in the era after the invention of photography, often deal more directly with underlying structures than the more naturalistic kinds of art that had prevailed for almost five centuries.

The kind of visual modeling I am exploring plays a key role at certain points in some sciences, but may be peripheral to other major scientific achievements. There are many sciences that deploy complex mathematics, including mathematics itself, that are not predominantly or even minimally visual. I greatly prefer geometry to algebra, and am far better at the former, but this reflects personal strengths and weaknesses rather than a more objective system of evaluation. In short, my view of both art and science is knowingly skewed by my enthusiasms.

It was easier selecting the themes and titles for the chapters than deciding what belonged in each. There are examples of phenomena and their representation in art and science that clearly belong in more than one chapter. This is particularly true of the works of art, in that they are often intended to have a multivalent qual-

ity that resists definitive classification. I am not worried if an example I have chosen is in the "right" place, since I do not think that there is such a thing as a certifiably "right" place in the kind of enterprise in which I am engaged. Fencing things into defined fields is not what I am about.

The first chapter concentrates on what is the oldest theme in the book, namely the beauty and wide connotations of the five regular geometrical bodies—the tetrahedron, the cube, the octahedron, the dodecahedron, and the icosahedron—often known as the Platonic solids in honor of the Greek philosopher. Their geometrical uniqueness has accorded them a special status in almost all eras of art and science, and they have not infrequently been sought within nature as one of the deep organizing principles behind natural form. As such they have come together in their formal and aesthetic guises most effectively and regularly in architecture and engineering. They are still playing notable roles in scientific questions, ranging from difficult issues of packing forms to hypothetical structures to the cosmos. They are detected at scales from the very smallest to the most immense.

The second looks at the lines, patterns, and shapes that emerge during processes of growth, often speaking eloquently of the forces and restraints that have determined how the forms have been organized—or have self-organized. The images are static but the structural intuitions in this case are implicitly dynamic through a kind of instinctive empathy that lets us sense how their organization has come about. We can in effect feel the shaping hands at work. Among the many different phenomena and configurations of growth I have selected just two, branching and spiraling. These have been the foci of some significant art and science, and spirals have even been regarded as presenting a key to what is beautiful. Branches and spirals conjoin within the botanical mathematics of phyllotaxis. The issues raised are central to one of the most fundamental debates in contemporary science, namely whether organisms in their whole and parts are determined by the overriding dictat of genetic codes or by more complex processes that involve substantial aspects of self-organization.

The third chapter centers on the engineering of thin materials or membranes under compression and tension—folding, stretching, and compressing—whether on their own behalf or in relation to a rigid frame. Architecture and the engineering of buildings unsurprisingly occupy a prominent place in the exploration of this theme, but we also look at the more evanescent yet remarkable structures of

bubbles and soap films. Nature and the human designers of structures have both followed an enduring quest for optimal or minimal structures, that is to say, the engineering of forms such that they exhibit maximum efficiency and minimum redundancy. Folds in cloth or paper automatically pursue this path, but it is only in recent years that the complexities of folding have been translatable into large-scale structures that constitute a radical extension of our architectural vocabulary. Amid this high tech, spanning the Gothic era to the present day, we will discover that painted folds exhibit a special potency in both historical and modern painting.

The fourth is devoted to the patterns of fluids in motion, as a more dynamic counterpoint to the structures created by growth in chapter 2. The dynamic implications of structural intuitions have been followed up very effectively by Babu Thalaith. The elusive complexities of fluids in motion, such as splashes, which seem to promise readily deducible laws yet resist reduction to predictive formulas, have delighted and frustrated observers from Leonardo onward. The stakes are high in human terms. On one hand the spirals of blood in the heart are central to life, while the raging vortices of huge storms bring death and destruction. The stakes are also high in terms of human understanding. Modern telescopy has revealed to us the wondrous spiraling galaxies that take us back to the dawn of material existence. The issue of self-organization in physicochemical systems of fluids, which is also apparent in chapter 2, is of interest in itself and more broadly intersects in biology with the big issue of the drivers of morphogenesis involving the intersecting roles of genes and nongenetic factors. The more regular phenomena of waveforms, which manifest self-organization in one of its more obviously tidier guises, give us a glimpse into the world of visualized music.

The final chapter bears in upon the trustworthiness of the widely varied kinds of naturalistic representation that dominated Western art for five hundred years. I am here concentrating on what can be seen with the "naked eye" rather than dealing with the related issue of trust in optically assisted vision with telescopes and microscopes. The earlier chapters had played toward underlying structures rather than the detailed recording of immediate visual appearance. The issue of the trust solicited by naturalistic rendering looks, on the face of it, to be rather different in emphasis from the other chapters. However, it becomes clear that images inculcate trust when they play toward the same kind of gravitational pulls

in our perception and cognition that can be translated into underlying structures. Faced with the visually new, we inevitably effect a way of seeing that has been acquired to make sense of things we know and think we understand. There are even instances in which a well-structured and detailed depiction becomes more real than the real thing, since it picks out and exaggerates features in a seen object that involve how we distinguish it from something else. At the more extreme end, it leads to the art of caricature. This picking out and exaggerating equates to traditional rhetoric, which involves the effective demonstration of the true or plausible. In itself the effective representation of something is deeply functional, and can involve a range of resemblance from high naturalism to schematization. Where a representation is located in this range is determined by the job it is intended to do. I owe my interest in such things to Ernst Gombrich, to whom the book (and most notably this chapter) is dedicated.

The afterword is not intended as a conclusion in a synoptic manner. Rather it lays out some thoughts on "science and art" (or even "sci-art"), a topic that has become rather fashionable but does not really exist in the schematic way that the term implies. Appealing to shared qualities of creativity and imagination does not really achieve anything in the way of understanding. Unsurprisingly, as a historian, I will suggest that a historical approach is best suited to discerning any enduring commonalities in science and art.

D'Arcy Thompson, as we will see, claimed that his great *On Growth and Form* was "all preface." Leonardo once confessed that one of his collections of loose sheets of paper, teeming with drawings and notes, was "without order, drawn from many pages that I have copied here." He hoped that he would be able "to put them in order in their places according to the subjects with which they will deal. I believe that before I am at the end of this, I will have to repeat the same thing many times." The statements of Thompson and Leonardo are all too apposite to what follows. For my part, I can characterize what I am doing as "just sampling." I hope that the samples are engaging in themselves, and expect that readers will be able contribute many more on their account. I also hope that the themes behind the sampling lead the reader into some big and fascinating questions.

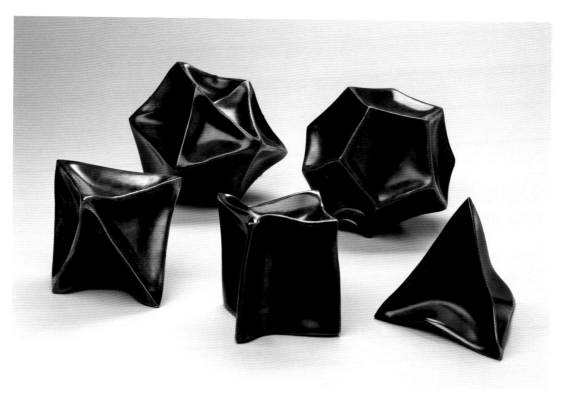

Figure 5. *Collapsed Platonic Solids*, Julian Voss-Andreae, bronze, 2009. (*From the left:* the octahe-dron, the icosahedron, the cube, the dodecahedron, and the tetrahedron; largest object 9 in/23 cm)

I

Platonic Perceptions
The Regular Solids

The way that the basic elements of mathematics are discernible within (or under or behind) the manifold variety and contingencies of nature has lain at the heart of major aspects of the arts and sciences across the whole span of human culture. In terms of the visual themes that concern us here, the "elements" are predominantly geometrical—very literally, in that the geometries with which we are primarily concerned are those defined in Euclid's *Elements of Geometry*. They are also elemental with respect to Plato's characterization of the regular solids as the building blocks of nature. The five regular bodies feature here across a chronological range from the Neolithic to modern day, across a thematic range from slate domes to astronomy, and across a range of scales from the cosmic to the molecular. Our route here is broadly chronological, though not in the sense of an even-paced survey. I have selected episodes that I think are particularly telling and about which I am relatively well informed.

There are just five regular solids, that is to say, convex bodies composed from regular polygons of the same size with the same number of faces at each vertex or corner (fig. 5). It is perhaps surprising that there are only five such polyhedrons and that no more have been discovered since Euclid expounded their basic geometry. In the thirteenth and last book of his *Elements of Geometry,* written around 300 BC in Alexandria and one of the most perfect books ever conceived, Euclid discussed why there are only five. He describes the way that "that no other figure, besides the said five figures, can be constructed which is contained by equilateral and equiangular figures equal to one another." He shows that other possible solid arrays of flat figures result in geometrical "absurdity." They can all be inscribed in a sphere in such a way that their vertices lie on the surface of the sphere. In the eighteenth century the great Swiss mathematician Leonhard Euler noted that if we count the number of faces in each of the bodies, subtract the number of edges, and then add the number of vertices, we always obtain the answer 2. The strictly limited number and succinct visual conviction of the solids have entranced philosophers, scientists, and artists over the ages, and they have regularly been accorded deep significance in the nature of things. The version I am illustrating them with here is the intriguing set of *Collapsed Platonic Solids* by the German sculptor Julian Voss-Andreae, whom we will meet again.

What is the nature of our attraction to the five regular solids? It seems both visual and tactile. I suspect it lies in the combination of a deep symmetry around an intuited center and the controlled asymmetry they manifest as their facets are seen from progressively different angles under changing degrees of foreshortening. There is also the anticipatory tease of what the concealed faces will look like. Will our intuitions be met or uncomfortably confounded?

The five polyhedrons are commonly known as the "Platonic solids" after the great philosopher of the fifth century BC. Plato was not their discoverer but was the first to characterize them as the fundamental building blocks of the created cosmos. In his *Timaeus,* written more than half a century before Euclid's treatise, he identifies four of the solids with the elements of earth, water, air, and fire, while the fifth, the dodecahedron, "god used in the delineation of the universe." Plato's leading speaker in the dialogue, Timaeus, expounds how god created the universe in its whole and in its parts according to a system of harmony and proportions.

When he turns to the four elements he explains their nature according to their geometrical form.

To earth, then, let us assign the cubical form; for earth is the most immoveable of the four and the most plastic of all bodies. . . . To water we assign that one of the remaining forms which is the least moveable [the icosahedron]; and the most moveable of them [the tetrahedron] to fire; and to air that which is intermediate [the octahedron]. Also we assign the smallest body to fire, and the greatest to water, and the intermediate in size to air; and, again, the acutest body to fire, and the next in acuteness to, air, and the third to water.

We are then asked to "imagine all these to be so small that no single particle of any of the four kinds is seen by us on account of their smallness: but when many of them are collected together their aggregates are seen. And the ratios of their numbers, motions, and other properties, everywhere god, as far as necessity allowed or gave consent, has exactly perfected, and harmonised in due proportion."

The physical properties that Plato assigns to the geometrical bodies—their stability or mobility, their sharpness or relative bluntness, their weight or lightness, and their relative sizes—determine how they behave in themselves and how they interact among themselves. For example, "when a few small particles, enclosed in many larger ones, are in the process of decomposition and extinction, they only cease from their tendency to extinction when they consent to pass into the conquering nature, and fire becomes air and air water."

The untidiness in Plato's elegant account of the geometrical nature and behavior of the four elements is the exclusion of the dodecahedron, composed from twelve pentagons. Plato's solution is to equate the fifth body with the overall design of the universe. This may be because it most obviously evokes the sphere within which it can be inscribed—and the sphere is god's most perfect figure. The dodecahedron is also the only body composed from faces that have more than four sides.

For a philosopher who focused on the perfect nature of the eternal unchanging world that lies outside the changing imperfections of the material world composed from substance, this is an exceptionally physical account of how the basic

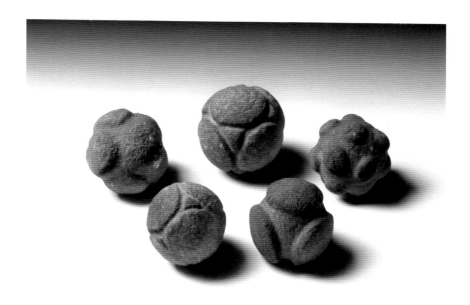

Figure 6. Five Neo-
lithic carved stone
balls from various
locations in Scotland

constituents of the universe behave. Plato is far from recommending the empir-
ical and experimental study of nature through the senses as the prime access to
truth. However, the idea that god shaped formless substance according to a sys-
tem of geometrical proportions could be taken as a sanction for extracting geom-
etry *from* natural appearance—which was certainly not Plato's intention. He does
not see true perfection as residing within nature, since the geometrical harmo-
nies were only expressed "as far as necessity or god's consent allowed." Indeed,
the title of this chapter, "Platonic Perceptions," embodies a certain paradox, since
the mere perception of nature was a low form of knowledge in Plato's scheme of
things. As we will see, the Platonic solids came to play a key role in observational
sciences from the Renaissance to now.

INTO THREE DIMENSIONS

The Neolithic craftsmen who created a large series of carved stone balls, discov-
ered mainly in Scotland (fig. 6), have been claimed as prehistoric precursors of
Euclid. More than four hundred of these balls are known and have been variously

dated between 3200 and 1500 BC. They tend to be of similar size—around 70 mm in diameter, but larger ones are known, and they are carved from a variety of stones. They may be regarded as polyhedral in shape with convex extrusions on their faces, or, more accurately, as spheres into which channels have been carved in regular geometrical patterns. Some of resulting shapes correspond to rounded versions of the five regular polyhedrons, but others do not. The round extrusions can number as many as 160. Their function is unknown, and they do not appear to have been bound with thongs to use as weapons, since none show any signs of having being deployed violently. Indeed, some are decorated quite elaborately on their faces with spirals, concentric rings, and crisscross patterns, which suggests that they served decorative functions in some kind of prestigious way, perhaps adorned with thongs or threads in their grooves.

Looking at their form, I think it is possible that they might be stone versions of balls of clay that were bound back and forth with leather thongs in regular patterns. Those with wider grooves and correspondingly smaller faces may have been bound more times than those with thinner grooves. The stone versions would then have been carved as more permanent examples of forms that obviously meant something special, whatever that meaning was.

Even if the carved stones cannot be taken as systematically representing the five regular solids, as sometimes claimed, the basic motivation behind their making is the same that draws us into the wonder of the enticing symmetries and optical asymmetries of those that Plato so admired. Whatever else they show, the stone balls do serve as ancient witnesses to the age-old attraction of forms that are both symmetrical and "endless" as we turn them in our hands.

Envisaging the polyhedrons in their exact geometrical configurations requires visualization in three dimensions. However, no depictions or descriptions of their depiction—or accounts of actual models being made—are known before Luca Pacioli and Leonardo da Vinci collaborated on their realization in the late fifteenth century.

The circumstances of Leonardo's collaboration with Pacioli are to be found in the Milanese court. Leonardo had been working in Milan since 1482, in part for Duke Ludovico Sforza. After fourteen years he was joined by the Franciscan friar and mathematician Luca Pacioli, who had previously been employed in the ducal court at Urbino, where he was deeply influenced by the painter-mathematician

Piero della Francesca. Indeed, the Italian treatise that he persuaded Leonardo to illustrate in 1498, *De Divina Proportione,* draws so closely on Piero's Latin *De Cinque Corporibus Regularibus* that Luca has been accused of plagiarism— although this is a rather modern judgment about intellectual property rights. Piero's book, the third of his treatises, following one about abacus-school mathematics and another on pictorial perspective, is illustrated with neat line drawings of the polyhedrons in space, but in nonconvergent perspective; that is to say, the parallel sides of bodies are shown as remaining parallel rather than receding to a "vanishing point." They are lucidly illustrative but do not give the impression of solid bodies.

Leonardo translated Piero's linear diagrams into images that were characteristically more visual and tactile, literally endowing them with solidity. Pacioli's treatise is more Platonic in flavor than Leonardo's own thinking, but they shared a respect for the foundational qualities of geometry in the structuring of the world. Leonardo transforms the abstract "idea" of the bodies into tangible, sculptural form, not only showing them as if they were material solids systematically thrown into relief by light and shade but also illustrating a *vacuus* version of each, that is to say, as a skeletal or fenestrated construction in which each face is treated like a window through which the configuration on the rear of the solid can be glimpsed (fig. 7).

In addition to the five canonical polyhedrons, Pacioli also describes the semi-regular or Archimedean solids—ones whose vertices are truncated—and builds stellations on their faces (fig. 8). The more complex of these present substantial problems of visualization and representation, challenges that Leonardo triumphantly overcomes. It is clear from his drawings of all kinds of form in space that he possessed exceptional powers of spatial visualization, envisaging the solids and their transformations as 3-D mental models, akin to working in clay or envisaging the exterior and interior volumes of a building. Given the less than meticulously geometrical foreshortening of the solids, I suspect that Leonardo availed himself of the shortcut of a "perspective window" of the kind he shows being deployed to depict an armillary sphere.

The prime manuscript of *De Divina Proportione* was dedicated to Galeazzo Sanseverino, commander of Duke Ludovico's forces and the husband of Bianca Sforza, the duke's illegitimate (but legitimized) daughter, whom Leonardo por-

. C VI .

**DVODECEDRON ABSCI
SVS VACVVS .**

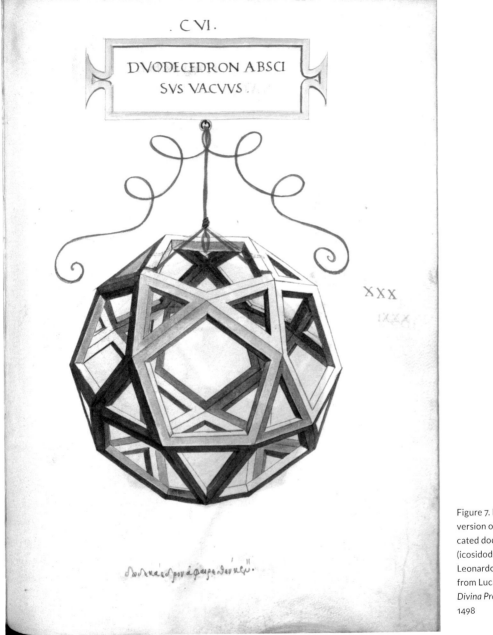

XXX

δωδεκαεδρον ἄφαιρα διακεν.

Figure 7. Fenestrated version of a truncated dodecahedron (icosidodecahedron), Leonardo da Vinci, from Luca Pacioli, *De Divina Proportione*, 1498

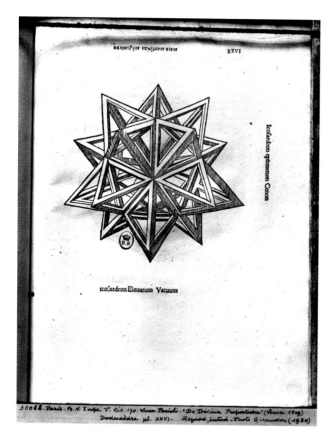

icosaedron Eleuatum Vacuum

XXVI

Icosaedron epimoon Caoa

trayed as a fourteen-year-old bride, shortly before her tragic death. Later, when both Leonardo and Luca were in Florence, where they shared quarters for a time, the printed edition of the book was published in 1509 with a dedication to Piero Soderini, who as *gonfaloniere* was the leader of the Florentine republic. Pacioli's portrait by Jacopo de' Barbari shows the Franciscan mathematician with models of an icosahedron in glass and a dodecahedron in wood, and we know that he supplied the government of Florence with a set of models, probably at Soderini's instigation. The principle at work is presumably the high-minded ideal that was enunciated in Plato's *Republic:*

Geometry will draw the soul towards truth, and create the spirit of philosophy, and raise up that which is now unhappily allowed to fall down. Nothing will be more likely to have such an effect. Then nothing should be more sternly laid down than that the inhabitants of your fair city should by all means learn geometry. Moreover the science has indirect effects, which are not small. . . . In all departments of knowledge, as experience proves, any one who has studied geometry is infinitely quicker of apprehension than one who has not.

Figure 8. Fenestrated version of a stellated icosahedron, Leonardo da Vinci, from Luca Pacioli, *De Divina Proportione*, 1498

Whether contemplating the proportional harmony of the Platonic solids served to raise the vision of the Florentine councillors above petty politics remains doubtful.

The title of Pacioli's book signals not only the proportional notions expounded

in the *Timaeus* but also the specific proportion of the so-called golden section: the division of an interval AB at C such that AC:CB = AB:AC. The resulting proportion is "irrational" in that it cannot be expressed in numbers. Pacioli stresses that it deserves the symbolic epithet "divine," since, like God, it is not subject to rational demonstration. It is used to construct the dodecahedron, which, as noted above, is seen as fundamental to the design of the universe.

Significant though the "divine proportion" was in Pacioli's treatise, we should not be carried away with the tendency to see it as the key to Renaissance notions of beauty. As the "extreme and mean ratio"—its standard Euclidean name before and during the Renaissance—it was but one of such irrational ratios expressible geometrically but not arithmetically. It did not gain its widely privileged status until much later, as we will see. It is also clear that Pacioli, like Leonardo, regarded the visual beauty of proportions, like the harmonies of music, as expressible in the ratios of whole numbers.

The printed book with Leonardo's compelling illustrations exercised an enduring fascination far beyond the world of mathematics. One of their more improbable carved manifestations is in British Jacobean tombs, such as those of Sir Thomas Gorges in Salisbury and the Ashleys at St. Giles in Wimborne. It seems that the fenestrated solids came to convey a generic sense of mysterious cosmic harmonies, in addition to whatever more specific meaning they may have carried in each case.

The notion of divine proportion in its more general sense is of course embodied in Leonardo's famous "Vitruvian Man," based on the writings of the first-century BC architect Marcus Vitruvius Pollio (fig. 9). The drawing and texts deal with geometrical and arithmetical systems—all laid out on the page with great elegance. Leonardo is illustrating Vitruvius's discussion of human proportions, which is designed to establish harmonic principles for the design of sacred buildings. In the first chapter of the third book in his ten-book treatise, the Roman architect tells us,

The members of temples ought to have dimensions of their several parts answering suitably to the general sum of their whole magnitude. Now the navel is naturally the exact centre of the body. For if man lies on his back with hands and feet outspread, and the centre of a circle is placed on his

navel, his figure and toes will be touched by the circumference. Also, in the same way that a round figure may be produced, a square can be discovered as described by the figure. For if we measure from the sole of the foot to the top of the head, and apply the measure to the outstretched hands, the breadth will be found equal to the height, just like sites which are squared by rule.

The great majority of later draftsmen who have attempted to illustrate Vitruvius's scheme jumped to the conclusion that the circle and square should both be centered on the navel. Vitruvius does not say they share the same center. In fact, the only unforced way to make the square and circle work is to assume that the circle is centered on the navel, as he says, and that the square is lower, effectively centered on the man's genitals. Leonardo does exactly this. He additionally shows the way that the man's feet seem to trace an arc of the circle by showing the man's legs spread at a 60° angle that has its apex in his navel. He noted, "If you open your legs so much as to decrease your height by 1/14 and spread and raise your arms so that your middle finger is on a level with the top of your head, you must know that the navel will be the center of a circle of which the outspread limbs touch the circumference; and the space between the legs will form an equilateral triangle."

The man's legs actually turn around the fulcrum of his two hip joints and do not revolve around the center of the navel. The illustrated position is the one that works *uniquely* with the main circle. Leonardo also demonstrates the only points at which the man's extended fingers touch the circle, given their pivots at the end of his shoulders. Setting the man's raised arms at an angle centered on the median line of his horizontal arms, Leonardo is able to make these points coincide with the intersection of the upper edge of the square and the circle. He was too alert a geometer and possessed too sharp an awareness of the levers and fulcrums of the limbs not to be aware of the contrivances involved.

There are also other "disguised" features in Leonardo's ingenious demonstration. The most notable is that the outer profile of the man's left leg is drawn as if in profile to waist level, leaving the outer line of his left hip outside this profile, which does not happen with his right hip. The left foot of his diagonal leg, which we might expect to be shown in profile, is slightly inclined toward the viewer. There is a sense that Leonardo is making the figure in its whole and parts "look right," in defiance of rigid logic.

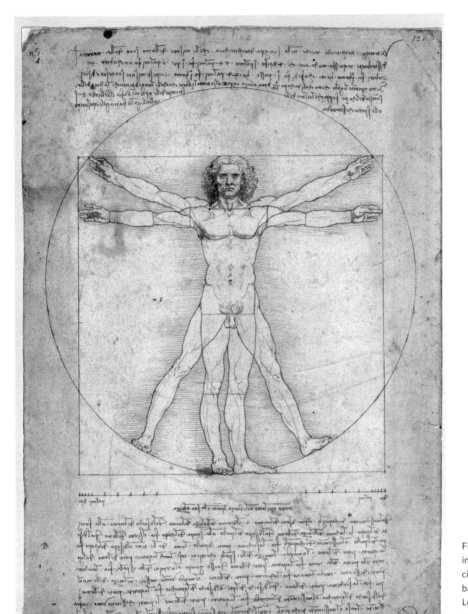

Figure 9. Man inscribed in a circle and a square, based on Vitruvius, Leonardo da Vinci, ca. 1498

Within the overall schema, Vitruvius (followed by Leonardo) undertakes a detailed numerical, linear analysis of the internal proportions of the human body. For example, "the face from the chin to the top of the forehead and the roots of the hair is a tenth part; also the palm of the hand from the wrist to the top of the middle finger is as much; the head from the chin to the crown, an eighth part." There is no evidence in Leonardo's drawing or other proportional studies of the human figure that he was considering the kind of elaborate internal fretworks of metaphysical geometries that are often imposed on his drawing. Indeed, the many compass marks show that the internal music of the body is composed from measured intervals, not pentagons, logarithmic spirals, and so on. His procedure is essentially empirical and pragmatic; the circle and square are *drawn out of* the overall form of the body, as are the internal numerical ratios. As Vitruvius says: "Number is found from the articulation of the body, and . . . there is a correspondence of the fixed ratio of the separate members to the general form of the body." Platonic mathematics, of a kind, arises from the pious and empirical scrutiny of nature, in a notably un-Platonic way.

As a footnote to this discussion it is worth mentioning that Leonardo later specifically criticized Plato's equation of the elements with the regular polyhedrons (F27r). Although he allows that the fluidity of water, air, and fire allows us to envisage the elements in the world system as nested inside each other in their polyhedral configurations, he points out that the elements always adopt spherical configurations around the center of the world. This is, of course, a misrepresentation of Plato, since the Greek philosopher was speaking of minute particles, not the overall arrangement of the elements around the earth.

Plato, Pacioli, and Leonardo were convinced in their different ways that they were contemplating the highest form of harmonic beauty when they looked at the ideal geometrical figures. Leonardo's great German contemporary Albrecht Dürer, who well understood the geometry of the solids, showed a different side to the human quest to comprehend the geometrical divine. In his virtuoso engraving *Melencolia I* of 1514 (fig. 10) he revealed a darker dimension—our earthbound inability to ascend to the highest and ultimately infinite levels of understanding. Dürer's penumbral "angel," with the sallow skin and haunted eyes of the melancholic—the temperament dominated by black bile—has ponderously slumped into inertia, surrounded by the tools of intellectual and practical endeavor. The

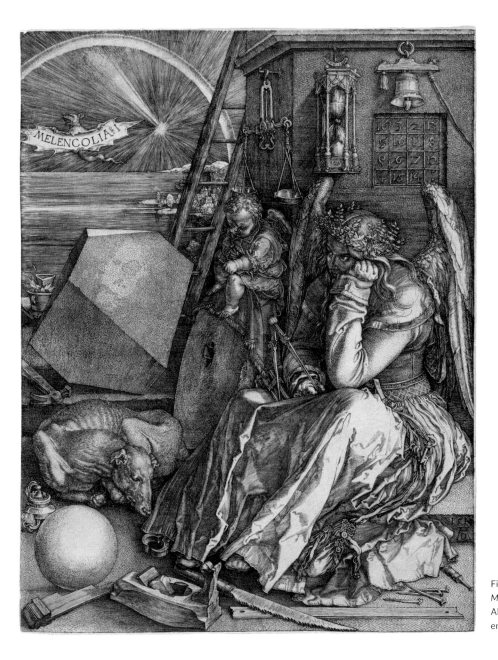

Figure 10.
Melencolia I,
Albrecht Dürer,
engraving, 1514

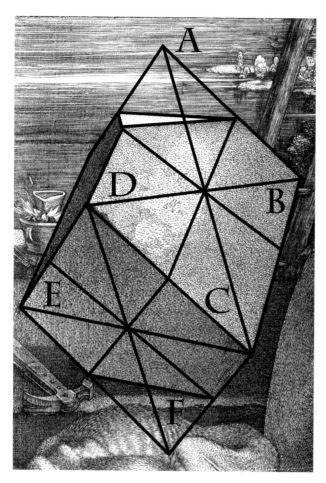

chubby putto and emaciated dog are comparably overcome by pessimistic lassitude. The mysteries the angel is contemplating are signaled by the "magic" number square in which the vertical and horizontal rows, the diagonals, and the four squares forming the four quadrants all add up to 34.

The sphere alone overtly signals the final mystery of perfection. The polyhedral body speaks of something quite different. It is lurchingly asymmetrical. It has been hugely overinterpreted by later mathematicians armed with techniques beyond even Dürer's considerable compass. We can best see it as a square or rectangular body, *ABCDEF,* truncated at only two of its eight corners (fig. 11). It stands precariously on one of its small triangular faces. The front and rear edges of its two more visible sides lie parallel to the picture plane, while the other sides converge to rather distantly placed "vanishing points." It has been constructed independently of the main perspective

Figure 11. Analysis of the geometrical solid in Dürer's *Melencolia I*

of the engraving, which has a much closer viewpoint. The only feature that is inconsistent with the body being seen as a truncated square is the shortness of CF/DE. Either Dürer has misconstructed the inclined and shadowy face of the body (a mistake that he had the skill to avoid) or it is a rectangular block, devoid of the square's perfection. The latter explanation is more likely.

Either way, it is not a happy body. It has been incompletely truncated and exists discordantly both in itself and in the composition. Its surface is blotchy and its forward edge is chipped and abraded. Set beside it on its plinth is a threatening

hammer. Its skewed geometry and material imperfection present a haunting conundrum to the Platonic contemplator of divine symmetry, just as the number square shows that there is something very peculiar about numbers. Dürer's disconcerting geometrical body solicits but ultimately frustrates our intuition of regular order.

MACRO

The illustrations in *De Divina Proportione* exercised a wide influence in the arts and sciences. The portrayal of the solids in convincing perspective became a stock challenge for the authors of books of artists' perspective, and Daniele Barbaro in his *La Practica della Perspectiva* (1568) showed an accurate way to depict them using geometrical projection from plan and elevation.

By far the most substantial and profound impact of the Leonardo-Pacioli figures occurs in the *Mysterium Cosmographicum*, written by twenty-five-year-old Johannes Kepler in 1596–97. The full title is *Preliminary for the Cosmographical Treatise, containing the Mystery of the Cosmos, and concerning the genuine and proper causes of the number, magnitude and periodic motions of the sphere, demonstrated by the five regular geometrical solids*. What Kepler was proposing is splendidly illustrated in a folding plate that portrays the cosmos as an assertive masterpiece of geometrical metalwork (fig. 12). He states that the intervals between the observable orbits of the planets could be explained by recourse to the geometry of the five Platonic solids. In so doing he was transferring the solids from Plato's tiniest scale to the largest macroscopic scale then conceivable.

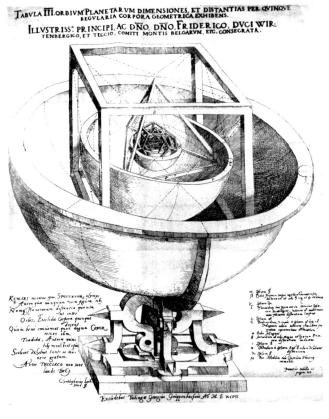

Figure 12. Model of the cosmos using platonic solids inscribed in spheres, Johannes Kepler, from *Mysterium Cosmographicum*, Tübingen, 1596–97

His schema exploits the way that each of the five solids can be inscribed within a sphere, and how each of them can contain an inscribed sphere. He found that if the solids and their spheres were nested inside each other in the sequence of octahedron, icosahedron, dodecahedron, tetrahedron, and cube (working outward), the resulting ratios of intervals between the spheres corresponded remarkably closely to those of the basic circles of the planets—in the order of Mercury, Venus, Earth (with its moon), Mars, Jupiter, and Saturn—as Kepler determined on the basis of the superb observations of Tycho Brahe. For someone as committed to the divine nature of Platonic geometry as Kepler, this notably subtle correlation was thrilling.

It should be emphasized that he was not describing the physical behavior of the planets moving around the sun but revealing the underlying template or design principles through which God's geometrical majesty was manifest. Indeed, twenty years later, when Kepler came to define the actual orbit of Mars and other planets as elliptical in his *Harmonices Mundi,* the conceptual value of the schema of the ratios of the orbits remained effective as a demonstration of the underlying conjunctions of harmonic geometry at the heart of God's conception—though not as an actual description of the physical behavior of the planets moving along elliptical paths. The music of the orbits' ratios still resonated to the conceptual harmonies of the polyhedral system.

What Leonardo and Kepler share, in full measure, is the highest ability in spatial and plastic visualization. Kepler is able to envisage geometrical sculpture in a truly Leonardesque way. He tells how he arrived at his schema when he was improvising a series of triangular configurations within a circle to demonstrate to his audience the "leaps" of the great conjunctions of the planets. However, the logic of Kepler's intellectual method is very different from Leonardo's. In his *Harmonices Mundi,* in which he recapitulates his first two laws of planetary motion and formulates the third, he systematically builds up from the first geometrical principles, which serve as inviolable a priori foundations, "conceived in the mind." He begins with the construction of regular polygons, passing to the solid polyhedrons, progressing through the arithmetical proportions of music, followed by the metaphysics, psychology, and astrology of harmony, and culminating in a configuration of the observable heavens according to the schema he had outlined in his *Mysterium.* The geometry is not drawn out of the observa-

tions, nor is the geometry imposed on the data. The conceptual framework in our mind and the observations of nature are bound to work together in harmony because that is how God has willed it. Kepler's final move is to take his "eyes and hands away from the table of proofs, lift them to the heaven, and pray devoutly and humbly to the father of light."

Kepler's polyhedral construction met Plato's goal of intellectual remove from material considerations, but the astronomer was not averse to its physical realization on its own account. He planned to construct a large mechanical model of the divine structure as a *Kredenzbecher*—that is to say, shaped like the kind of goblet that would sit on a buffet. He came to envisage it as a great metallic artifact to serve as a very expensive courtly wonder, like the ten-foot-high armillary sphere that Antonio Santucci built from wood and metal for the Medici in Florence. Not only was Kepler's model meant to move but it was also intended to dispense alcoholic beverages appropriate to each planet from its hollow armatures. Like most scientists working on costly endeavors at this time, Kepler was of necessity a courtier. The context in this instance is the court of the duke of Württemberg.

Kepler's Platonizing geometries might seem remote from the tenor of modern astronomical science with its complex visions of space-time, multidimensional mathematics, and vast bodies of data, but this proves not to be the case. In October 2003 *Nature* ran a cover story that proposed a finite polyhedral model for the universe. It was being advocated by the major astrophysicist Jean-Pierre Luminet and his colleagues at the Paris Observatory. The model they were proposing stood at some remove from the finite universe of Kepler. It relied on a kind of dodecahedral space proposed by the French mathematician Henri Poincaré in 1904. The dodecahedron is manipulated in higher dimensional space of the kind that resists commonsense visualization, so that opposite faces can be "glued" after being twisted through 360°. This "gluing" means that endless motion is possible, since exiting one face involves entering the opposite one at the same time. Although finite, Luminet's universe remains vast, at about ninety billion light years in diameter.

As far as such concepts can be represented on a flat surface using conventional perspectival techniques for depicting three dimensions, they have been by Jeff Weeks, one of Luminet's collaborators. He has produced a seductively simple sphere tiled with curved pentagons and a densely faceted view through the surface

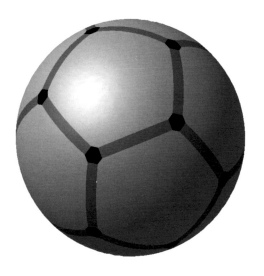

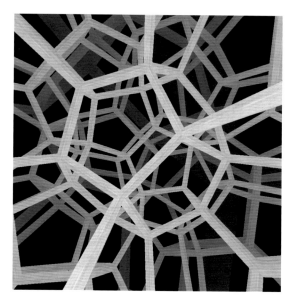

of a hypersphere tiled with 120 spherical dodecahedrons (figs. 13 and 14). They bear obvious comparison with the solid and *vacuus* bodies drawn by Leonardo and with Kepler's grand model.

From the perspective of Luminet, these historical parallels are fundamental, since he openly sees himself and the modes of visualization exploited by his team as belonging to a majestic succession that involves Plato, Pacioli, Dürer, Kepler, and other of the great "mathematickers," as I have called them. Luminet himself spells out this historical succession in *Celestial Treasury: From the Music of the Spheres to the Conquest of Space,* coauthored with Marc Lachièze-Rey. The data that Kepler harmonized with his geometrical vision were those obtained by Tycho Brahe; those integrated by Luminet come from measurements of micro-wave background temperature fluctuations from the Wilkinson Microwave Anisotropy Probe. The microwave background provides a record of the universe some 400,000 years after the big bang (estimated at 13.77 billion years).

I should say that my intention here is not to judge whether Luminet's theories will stand up to rigorous testing, which I am wholly unequipped to do, but to

STRUCTURAL INTUITIONS

demonstrate age-old continuities in modes of visualization and the recurrent beauty of the insights that lie behind them.

As a modern-day *uomo universale,* Luminet also creates works of art and is actively involved in musical composition. His best-known image is his disorientating ink drawing *Black Hole* (1979), later used as the cover image for the English editions of his book on black holes (fig. 15). Against a dark background of indefinite dimension, Luminet sets a fractured Gothic basilica of the kind portrayed in meticulous perspective by the Dutch church painters of the seventeenth century. It sits precariously above the kind of checkerboard floor also beloved of the church painters, which has been rent asunder by some kind of geometrical cataclysm. The basic recession of the edges of the tiles as they converge toward the central vanishing point is orthodox enough, as is the lateral recession of the other edges of the tiles to what perspectivists called the "distance points." That is as far as the orthodoxy

Figure 15. *Black Hole*, Jean-Pierre Luminet, ink on paper, 1979

goes. The horizontal intervals that govern the width of the tiles into the depth of the image do not observe a consistent rule on either side of the gash, and the apparent enlarging of the more distant squares on the right produces an illusion of curvature. For good (or bad) measure, the slice of tiled floor in the lower left, with its three adventitious stairs, has its own independent vanishing point. The sides of the gash also retreat to their own independent vanishing point. The result

is a visual tug of war between conflicting perspectival gravitations that implies something beyond three dimensions, much as cubism's multi-viewpoint faceting strove to evoke spaces destabilized by mobile viewpoints.

The sides of the squares that were originally joined horizontally, before the floor was wrenched apart, are deformed as they are sucked into the vertiginous gash, into which tumbles an untidy cascade of dice. As Luminet says, "Dice . . . imply irreversible disorganization arising from chance." We may also pick up the allusion to Einstein's famous statement: "Quantum mechanics is certainly imposing. But an inner voice tells me that it is not yet the real thing. The theory says a lot, but does not really bring us any closer to the secret of the 'old one.' I, at any rate, am convinced that *He* does not throw dice." Einstein's intuition about order is of precisely the kind that has fueled the intuitive quest that we are currently exploring.

Luminet explicitly draws our fundamental instinct for orderly structure into the creative operation of all the arts and sciences.

> Creativity in art and science is integral to recreate a modern "humanism of knowledge," according to which the arts and sciences are not to be conflated because they work in very different ways, with illogical and logical means, but they well up from the same instincts and intuitions. . . .
>
> It is also right to acknowledge the passionate engagement that potentially flows undetected beneath the dry crust of the standard scientific paper. Knowledge must not be separated from emotion; their common root is amazement about the world, which is expressed through a harmonious integration of all those intellectual and creative faculties that we use to respond to the wonder of things, both immense and minute.

AND MICRO

Kepler, the supreme master of geometry on a cosmological scale, also takes us to the microlevel. In 1611 Kepler presented his treatise *The Six-Cornered Snowflake* (*De Nive Sexangula*) as a New Year's gift to his friend Johannes Matthäus Wacker von Wackenfels, whom he greeted as an "aficionado of nothing"—punning on *nix* as the Latin for snow and the old German for zero. To be interested in "nothing" was of some philosophical import, since zero plays a mysterious role in the nature

of things, above all numbers. Kepler also points out that impoverished mathematicians have "nothing" and can therefore give "nothing" (or maybe just a crystal of snow). Kepler's twenty-four-page treatise comprises a series of sprightly speculations on why snowflakes are hexangular—like a Christmas star—his thoughts triggered by a snowflake that settled on his coat as he crossed the Charles Bridge in Prague.

He surmised that the answer might lie in "packing," as it is now called, that is to say, the way that tiles and solid bodies can be packed most compactly and stably, as in a pyramidal stack of cannonballs on the deck of a ship. He is in effect signaling what became the science of crystallography. His personal quest takes him through examples in nature, including the inevitable honeycomb. He ends by realizing that the solution remains elusive. This is hardly surprising, since the proof of why the bases of the cells in a honeycomb adopt rhombic configurations has been solved only relatively recently. And as recently as August 2009, *Nature* published a lengthy and complex "Letter" on the packing of the regular and semi-regular geometrical solids. The specific mechanisms by which the basic pattern of snowflakes is expressed via systems that have moved out of equilibrium have also emerged only recently. These kinds of natural geometries are no dead letter of historical science.

Kepler as a mathematician had not solved the problem, but as a philosopher of God's designs in nature he did need some kind of principle he could adduce as the general cause for the form-adopting nature of snowflakes and other geometrical manifestations of packing. He adduced a *vis formatrix* or "formative virtue"— what Robert Hooke in his *Micrographia* in 1665 called "the plastick Virtue of Nature." Hooke was similarly fascinated and puzzled by the forms of snowflakes, which were emerging with added layers of complexity in the eye of his microscope. In their different ways, the Platonist Kepler and the empiricist Hooke were indicating that there was an inevitable tendency in nature to organize itself geometrically. And that we gain pleasure from the contemplation and representation of the patterns.

Over the years the snowflake has become a locus classicus for the artistic geometry of nature. The most unlikely contributor to the story is a Vermont farmer with no orthodox scientific credentials, Wilson Bentley (1865–1931). Fascinated by the form of snowflakes, the twenty-year-old Bentley invented a photographic

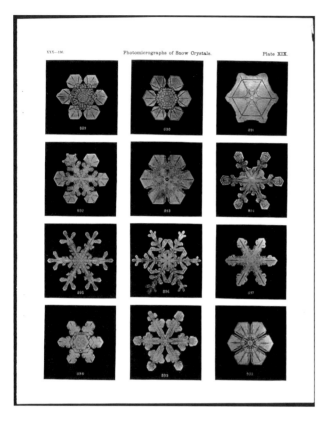

Figure 16. Twelve types of snowflake, Wilson Bentley, from *Snow Crystals*, 1931

rig that combined a bellows camera with a microscope, achieving the first photograph of a single snow crystal. From his rural base, "Snowflake Bentley" published a series of well-regarded books and articles in scientific and popular journals.

His 1931 book *Snow Crystals,* containing photographs of 2,400 crystals, remains one of the classics of the geometrical sciences of nature (fig. 16). His systematic procedures, exquisite manual dexterity, incredible patience, and tolerance of working in freezing conditions were driven by a sense of poetic wonder. The passionate tone is conveyed in a piece he wrote for *Harper's Monthly Magazine:* "Quick, the first flakes are coming; the couriers of the coming snow storm. Open the skylight, and directly under it place the carefully prepared blackboard, on whose ebony surface the most minute form of frozen beauty may be welcome from cloud-land. The mysteries of the upper air are about to reveal themselves, if our hands are deft and our eyes quick enough."

Bentley demonstrated that no two snowflakes are ever precisely alike. As we now know, there are a number of reasons for this: the complex construction of the crystals from a mean of 10^{18} water molecules; their formation under varying temperatures as they swirl within their cloud; and the unpredictability of the processes of aggregation from one crystal to another. Bentley also saw that the great majority of crystals are not wholly symmetrical, in contrast to the popular belief. The more symmetrical ones are those that are generally selected for illustration.

The complexity and visual magic of the infinite variations on the hexagonal base continue to attract sophisticated scientific attention, as in the research

of Ken Libbrecht, professor of physics at Caltech, who is the modern master of snowflake art (fig. 17).

Our continued exploration of the microdimensions of natural polygons and polyhedrons could traverse many examples: from the fretted geometry of the eye of the fly in Hooke's *Micrographia* to the geometrical capsids of viruses (those most stylish agents of disease); and from the decorative polyhedral skeletons of silicon in the tiny radiolaria, as illustrated so beautifully in Ernst Haeckel's books in the late nineteenth century, to the packing of silicon atoms as Voronoi polyhedrons in a foam lattice. Here I intend to focus on just one spectacular example, the molecule C_{60}, Buckminsterfullerene. I do so because the story of its discovery and its aftermath demonstrates particularly well the visual processes involved in its "architectural" visualization. It also serves to show how something previously overlooked in scientific theory and observation on a microscale can be seen in a different light via an actual piece of engineering on a very large scale.

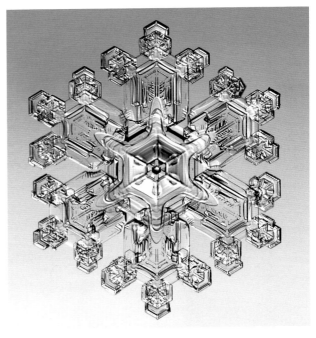

Figure 17. *Snow Crystal*, Ken Libbrecht, 2003

In 1985 a research team in chemistry at Rice University, including Robert Curl, Harry Kroto, and Richard Smalley, developed techniques to isolate a complex 60-cluster of carbon atoms that exhibited very different properties from the standard graphite-like or diamond-like arrays. What was needed to understand the structure of the molecule was an "engineering" model that left no valences dangling in a redundant manner.

The solution they proposed owed much to Kroto's memory of the geodesic dome designed by the architect and visionary Buckminster Fuller for the American pavilion at Expo 67 in Montreal (fig. 18). Built on an island in the St. Lawrence River, it survives as an elemental skeleton, following a fire in 1976 that

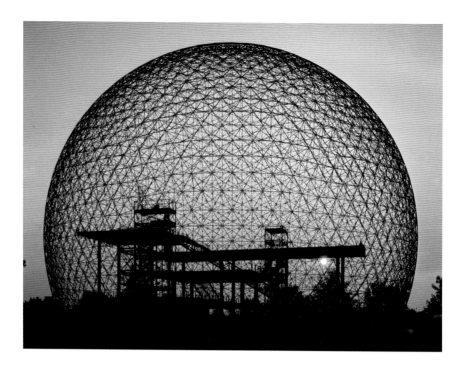

destroyed the acrylic membrane that formed its outer skin. Kroto had earlier constructed a cardboard sky map for his children in the form of a Fuller "stardome." The "stardome" consisted of half of a truncated icosahedron. The full truncated solid has twenty hexagonal and twelve pentagonal faces, and sixty vertices. Was this how the sixty carbons were distributed? On the basis of Kroto's hunch, Smalley worked into the night to construct by hand the first paper model of the hypothetical structure, which was subsequently confirmed by other data, including electron microphotographs. The result was the now familiar semiregular polygon (fig. 19).

The name accorded by the team to the newly defined molecule was Buckminsterfullerene—appropriately enough—and the related family of carbon structures that have been subsequently identified are known as fullerenes. The vernacular nickname "Buckyball" comes from the resemblance of the models of the molecule to what was then the favored paneling for footballs (soccer balls) using pentagons and octagons.

STRUCTURAL INTUITIONS

Kroto brought to the Buckyball team his natural instincts as a visualizer and designer. He had considered at one point founding a studio to develop scientific graphics. He is one of those major visualizers, like Leonardo and Kepler, who have a special sense of how complex symmetries in works of nature and art operate in three dimensions.

The Buckyball became the new star of chemistry. As Kroto said in his 1996 Nobel Prize address: "This elegant molecule . . . has fascinated scientists, delighted lay people, and has infected children with a new enthusiasm for science and in particular it has given chemistry a new lease of life."

The form of C_{60} has become familiar beyond its scientific context as a symbol of science—not as famous as the double helix, but it does look as if it is assuming iconic status. It has, as we might expect, been picked up in art. The German sculptor Julian Voss-Andreae, based in the United States, where he qualified as a physicist, has consistently explored molecular issues on large

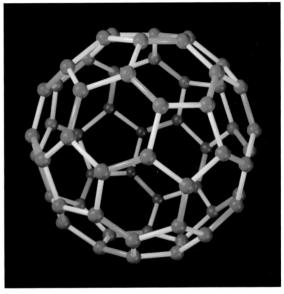

Figure 19. Buckminster-fullerene, C_{60}

scales as a form of scientific sublime. He has worked a number of variations on Buckyballs, one of which weaves its geometrical way around and through vertical trunks in a Portland forest—a dialogue between geometry and nature of the kind that runs through this and later chapters (fig. 20). At the start of chapter 1 (fig. 5) we saw a set of his collapsed platonic solids in bronze for his *Quantum Objects* series. It is as if a portion of their internal breath has been sucked out, leaving them with creased contours and concave faces. The effect of the hollow versions of the semicrumpled bodies is notably somatic, amusing, and uneasy. Alongside such artistic manifestations, collapsed solids have recently been investigated in the context of the science of elastic shells by Ee Hou Yong and his colleagues at Harvard, who have mathematically modeled what happens when a crystalline shell with defects or faults is deflated, creating analogues of the Platonic solids.

A neat story, then. A semiregular, Archimedean solid memorably cements engi-

Figure 20. *Quantum Reality (Large Bucky-ball around Trees)*, Julian Voss-Andreae, Douglas firs and steel, diameter of the steel structure 30 ft/9 m, 2007

neering solutions at the largest and smallest scales, and insinuates itself into artistic imaginations and into new scientific research. However, everything turns out to be not quite as it looks.

Kroto decided as a jeu d'esprit to use a molecular modeling kit to build a small-scale Bucky dome, along the lines of the one he had seen in Montreal, but without the inner skin of triangular struts. The assumption was that an array of hexagons punctuated by pentagrams would naturally form a dome that approached a portion of a regular sphere. This proved not to be the case. The resulting models (fig. 21), on which he worked with Ken McKay, did not turn out as expected. The model that corresponds to a giant fullerene of 240 molecules is discernibly not constant in curvature but seems to exhibit "ghost" vertices coinciding with each of the pentagons. There seems to be something like a dodecahedron or icosahedron lurking immanently in the structure. Adding more faces (or atoms) on

further computer models proved to push the shape even more toward an evident icosahedral symmetry. This was not what was expected, although in the realm of abstract mathematics Maurice Goldberg had earlier studied this class of figures when he was looking at multisymmetric polyhedrons.

Figure 21. Two models of the geometry of progressively larger fullerenes, Harry Kroto and Ken McKay

Kroto went back to looking.

Then I realised that I (and apparently everyone else) had overlooked something that had been under our noses in the literature for years. I had looked at electron microscope images of spheroidal carbon particles several times in the past and only now realised what I must have been looking at.... What I realised was that I and others had missed the fact that the rings were not quite circular but possessed subtle curvature variations which betrayed the fact that they were actually quasi icosahedral as were our Giant Fullerene models. I had seen what I wanted to see rather than what was actually there.

He also looked again at Fuller's Montreal dome, and now picked up the previously unnoticed "asymmetry of the hexagons which abut the pentagons." Fuller

had found what Kroto discovered, namely that aggregations of entirely regular polygons result in progressively nonspherical shapes, as was confirmed in computer models by McKay. A spherical form requires a certain amount of fudging of the regularities.

As Kroto has noted, his simple model-building project

> was originally initiated to satisfy the aesthetic creative impulse to build a 3-dimensional model or sculpture based on a molecular structural recipe. In the event the resulting model turned out to have some unique and unexpected shape characteristics which led to further scientific investigation that explained some important nanoscale structural observations that had been seen many years beforehand and mistakenly explained.

There are multiple morals to this story. The first involves the efficacy of our intuition to seek polyhedral order in natural and human structures. The second is that theoretical modeling can act both as a spur to discovery and as a means of revealing problems with underlying assumptions. The third is that once the problems become evident they can lead to fresh observations, even when looking at very familiar images. The final moral is that a visual dialogue across arts and sciences or across different sciences and technologies can result in wholly unexpected outcomes. We might also note in passing that the building of material models by hand still has a vitally creative role to play in this age of computer graphics.

EARTHLY HEMISPHERES

Fuller, for his part, is now largely known for his geodesic domes of the kind that served as the American pavilion in Montreal. In addition to his notable activities as a visionary designer, such as the airplane-like Dymaxion car produced in the 1930s in collaboration with W. Starling Burgess (fig. 22), he envisaged a spectacularly wide range of polyhedral and spherical structures built from linear or plastic skeletons of straight and curved trusses and prefabricated components.

To call Fuller an engineer, even a visionary engineer, is inadequate. The material realization of his structures was all one with his eccentric metaphysics, both of which he imparted to devoted attendees at Black Mountain College in North

Carolina, which from 1933 to 1957 played experimental home to those who were radically extending the boundaries of artistic practice, like John Cage in music and Merce Cunningham in dance. Fuller joined the faculty in 1948.

Figure 22. Buckminster Fuller with geodesic dome and Dymaxion car, ca. 1930

Fuller accorded a profound significance to the regular solids with triangular faces, above all the minimal tetrahedron. He aspired to replace the standard *x, y,* and *z* coordinates of space, based on a cubic unit, with tetrahedral vectors of energy set at 60°. He explained in his *Explorations in the Geometry of Thinking* how the tetrahedron provided the fundamental basis for his complex, all-embracing, dynamic, and sometimes obscure system of "Synergetics." He describes the tetrahedral form as a "60-degree vectorial coordination comprehensive to both physics and chemistry, and to both arithmetic and geometry, in rational whole numbers. . . . Synergetics follows the cosmic logic of the structural mathematics strategies of nature, which employ the paired sets of the six angular degrees of

PLATONIC PERCEPTIONS

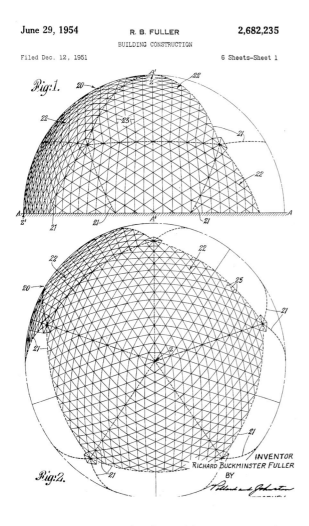

June 29, 1954 R. B. FULLER 2,682,235
 BUILDING CONSTRUCTION

Filed Dec. 12, 1951 6 Sheets—Sheet 1

Fig:1.

Fig:2.

INVENTOR
RICHARD BUCKMINSTER FULLER
BY

Figure 23. Patent designs for geodesic dome, Buckminster Fuller, 1954

freedom, frequencies, and vectorially economical actions and their multi-alternative, equi-economical action options." The fourth basic dimension is provided by thought itself. The science of Synergetics stretches unrestrainedly from engineering to theology, and from geometry to social structures.

Yet Fuller in this tetrahedral world came to stress that in nature everything is curved and immanently spherical. The reconciliation of polyhedral and spherical is accomplished by a move similar to that made implicitly by Plato when he identified the dodecahedron with the form of the universe. If the vertices of a polygon are projected onto the surface of a sphere, the more vertices there are in the polygon, the closer the compound surface of flat planes comes to approximate a sphere, given the right array of surface tiling. His geodesic domes (fig. 23) manifested this reconciliation in terms of a structural integrity that he saw as derived from nature. Fuller followed Leonardo in asserting that everything was accomplished in nature with no excess and no redundancy. The supreme goal is an optimum structure that achieves the maximum strength with the minimum of materials and weight.

One class of Fuller domes (as in fig. 22 above) relies on curved and penetrated surfaces that approximate to a polyhedron, as the visual inverse of those that use polyhedrons to approximate spheres. The curved trusses of such domes strongly recall the illustrations of microscopic skeletons of radiolaria by the German Darwinian Ernst Haeckel (fig. 24). Reacting to the high levels of interest among art-

ists and designers, Haeckel compiled sets of spectacular microscopic illustrations in his *Kuntsformen der Natur* (*Art Forms of Nature*), supplemented by plates of larger animals and plants that displayed extravagant designs. Haeckel's plates were issued as splendid sets of lithographs between 1899 and 1904, and as two bound volumes in 1904. The impact of Haeckel's conflations of nature and artistry will resurface more than once in this book.

Fuller's designs live on not only in the microworld of Buckyballs but also in key streams of high-tech architecture and engineering from the 1960s onward—even if shorn of his metaphysics. Examples range from Nicholas Grimshaw's domes at the Eden Project in Cornwall, as we will see in the next chapter (fig. 53), to the urban umbrella of Norman Foster's roof of the Great Court in Robert Smirke's severely classical British Museum (fig. 25). The form of Foster's roof—part half torus and part squashed cushion—underlines the paradoxical flexibility of such tetrahedral geometry. It transpired that the round Reading Room was not precisely located at the center of the huge rectangular space vacated by the departing British Library. Like Fuller's Montreal dome, the perfect polygons, in this case isosceles triangles, deform just enough to accomplish the complete and apparently seamless closure of the structure. The effect is at once artificial in its glistening modern materials and surprisingly natural in its organic geometry.

Figure 24. Geometrical forms in unicellular organisms, Ernst Haeckel, from *Generelle Morphologie der Organismen*, Berlin, 1866

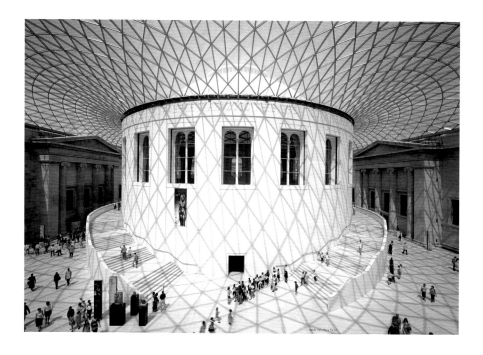

With respect to the organic resonances of such geometry, some links are worth noting here. Foster had worked with Fuller and later reconstructed the Dymaxion car. The cofounder of the firm that served as project engineers for Foster's Great Court and Grimshaw's Eden Project was Ted Happold, a huge fan of D'Arcy Wentworth Thompson, whose masterpiece of natural geometry, *On Growth and Form,* will provide a major focus for the next chapter. Thompson devoted close attention to the engineering of Haeckel's radiolaria. It was in Jena, where Haeckel worked for almost fifty years, that a light hemispherical dome was constructed in 1923 to serve as a planetarium on the roof of the headquarters of the major German optical company Zeiss. Engineered by Walther Bauersfeld, it was the first geodesic dome (fig. 26).

Between 1969 and 1971 Fuller, Foster, and the American architects Synergistics collaborated on a scheme for an experimental, multipurpose theater, dedicated to Samuel Beckett and to be set underground within St. Peter's College in Oxford (fig. 27). In the design document, its form is described as "a concrete cylindrical

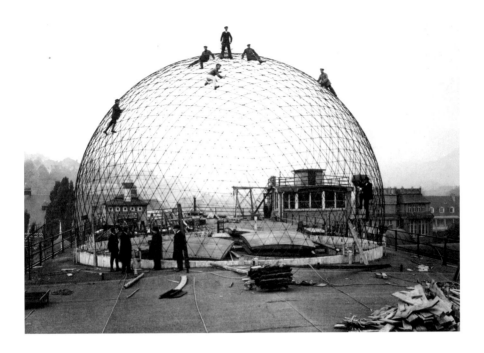

shell defined in cross-section as elliptical and enclosed at each end by a semi-ellipsoidal shell, all combining to form a self-contained, continuous shell held in position by a structural cage." The effect is like an egg that has been sectioned longitudinally and pulled apart. Or we might be reminded of a marine organism anchored to rocks with vertical breathing tubes. Or, as a juxtaposition on the Foster website indicates, an oval bar of soap: "In the midst of trying to describe the form of the theatre—he [Fuller] ran into the bathroom and came back with a bar of soap, saying, 'This is what it would look like.'" As the project began to run into the practical difficulties of the constrained site, the high water table, and escalating costs, Fuller (who had waived his design fees) threw in the idea of "a demountable structure" that "could be air-freighted anywhere in the world and assembled by unskilled labour in a matter of a day." The offer seems not to have been taken seriously, and the remarkable design for the underground structure was never to be realized.

Fuller's visionary structures represent an extreme of mathematical metaphysics

Figure 26. Geodesic dome under construction on the Zeiss Building, Walther Bauersfeld, Jena, 1923

Figure 27. Design for the Samuel Beckett Theatre for St. Peter's College, Oxford, Buckminster Fuller with Synergistics and Norman Foster, 1969–71

in engineering. My other example of an innovatory dome with a spherical profile stands at the intuitive and material end of the construction business. Andy Goldsworthy does not use calculated engineering or mathematics, and indeed does not want to address them. Yet he makes structures that are masterpieces of engineering design.

As a preface to looking at the slate domes that Goldsworthy created at the National Gallery in Washington, it is worth stressing that the hemispherical form, contrary to commonsense expectation, is not the most naturally stable form for dome construction. Across the upper parts the weight pushes downward, tending to lower the curvature, while an outward force arises at the sides, which tend to collapse away from the center. The geodesic dome resolves these forces of compression and tension within the thin skeleton of trusses aligned as a network. The greatest historical exemplar of a hemisphere, the huge coffered dome of the Pantheon in Rome, is a monolithic concrete construction in which the thickness and density of the cast material diminishes toward the open oculus at the top. A hemispherical span of this kind was not emulated until the twentieth century.

The dome of the Pantheon is in fact highly relevant to the nine slate domes that Andy Goldsworthy squeezed into and just beyond a long, sunken, rectangular enclosure that lies outside a wall-length window in the foyer of the East Wing of the National Gallery in Washington (figs. 30 and 31).

Goldsworthy's decision to construct domes that are spherical in profile makes reference to the Pantheon-like dome of the gallery itself and even more profoundly to the dome that Thomas Jefferson designed as the centerpiece of the University of Virginia. The drawings for Jefferson's dome, which was destroyed by fire in 1895 and was carefully reconstructed, show how the implicit full sphere controls the simple proportional system of the dome and its inner spaces (figs. 28

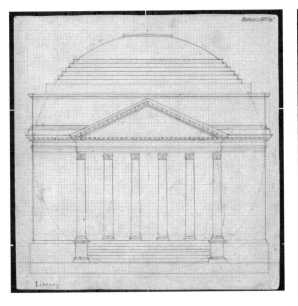

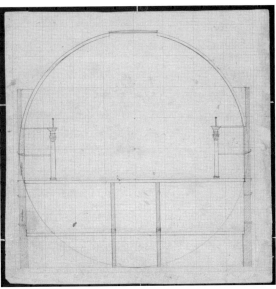

and 29). We may sense that Leonardo's Vitruvian man is not far away, and the reference to Vitruvius's own text is likely to be direct. Goldsworthy was attracted by the idea that the visible portion of the dome invoked the embedded sphere of which it is implicitly part. His domes, lower than hemispherical in profile and partially merging with each other, strongly convey the implication that they are the visible manifestations of a submerged system of geometrical forms and forces.

Where Goldsworthy departed radically from the classic precedents was in choosing to adopt one of his characteristically handmade, unengineered, and "primitive" systems of construction. He decided to use rough sheets of Virginia slate piled flat on top of each other in a corbeled construction: a series of beds or layers of stone laid horizontally above each other, with each higher bed offset in such a way that a space is progressively covered by overhanging stones at each successive layer. Not only does Goldsworthy adopt a corbeled system, but, as is his custom, he eschews mortar or any other form of adhesive. Corbeling is an ancient mode of construction, later supplanted by the angled masonry blocks of round or pointed arches and vaults. Even the "primitive" structures, such as the Mycenaean

Figure 28. Elevation of the Rotunda for the University of Virginia, Thomas Jefferson, 1818

Figure 29. Section of the Rotunda for the University of Virginia, Thomas Jefferson, 1818

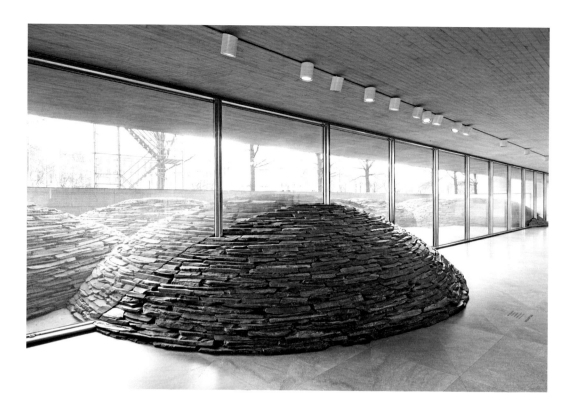

Figure 30. *Roof*, Andy Goldsworthy, seen from the foyer of the East Wing, National Gallery, Washington, 2004–5

tomb of the thirteenth century BC called the Treasury of Atreus, provide only a partial precedent, since they adopt a steeper pitch than the hemisphere, often in a "beehive" configuration. The extent to which Goldsworthy's aspirations lay outside the reach of conventional engineering is evident in the reaction of the gallery's consultant engineer, Dennis McMullan, who provided elaborately calculated reassurances about floor loading but did not deal at all with the question of whether the slate domes would actually stand up.

The question was a real one. Goldsworthy had a history of building astonishingly adventurous sculptures on a wide range of scales using a great variety of natural materials. He works with drystone wallers to achieve some of his most daring stone constructions. But he had not built domes. The question became an urgently practical one when some of the lower beds in the first of the nine domes began to tilt inward.

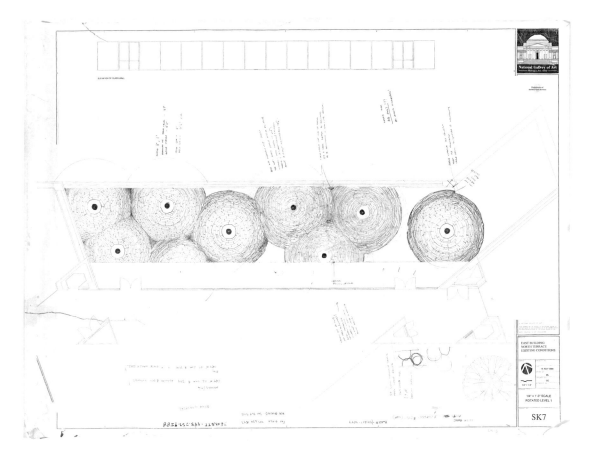

Figure 31. Installation drawing for *Roof*, Andy Goldsworthy, National Gallery, Washington, 2004

A series of drawings—exceptional for someone who normally produces very few preparatory designs—show him working toward a solution that converges intuitively on those of earlier designers. He widened the footings of the lower beds internally while retaining the outer spherical profile (fig. 32). The result is that the inner profile adopts something close to a parabolic curve, or, more significantly, a catenary curve. This is the curve produced when a chain (a *catena*) is suspended from its ends (fig. 33). The nature of the catenary is that all the forces of compression and tension are resolved within the fabric of the curve. This profile is akin to the beehive shape adopted for traditional corbeled domes by builders who certainly knew nothing of catenaries and parabolas. We will see other catenaries in action in chapter 3.

Figure 32. Design for the section of one of the domes of *Roof* on his drawing board, Andy Goldsworthy, National Gallery, Washington, 2004

The external spherical surfaces of the domes in *Roof* encounter each other in a variety of ways, sometimes pressing hard into each other and sometimes touching more gently, in both cases creating vertical planes of intersection like soap bubbles in a foam. One dome extrudes through a glass wall into the space outside the wall of the gallery, and another into the foyer itself. There is a strong sense of compressed process and motion, almost an implication of revolving vortices, not least in relation to the black voids of the open oculi (fig. 34). At the same time we witness a restoration of the natural state of the slate. The corbeled courses serve to reconstitute the kind of flat-bedded strata in which slate is found. Slate is a metamorphic rock, resulting from the crystallization of minerals in shale, rather than sedimentary, and it is the presence of plate-like minerals, such as mica, laid down in parallel layers that dictates the sharp cleavage planes of slates of the kind used in roofing. The fractured cutting edges of the slate are vital to the overall impact.

It remains improbable that such low domes composed of rings of separate unfastened slates, in which more than half of the rings do not hang directly over the footings, could be strongly stable. What seems to be happening is that each

ring of separate stones effectively consolidates as a continuous ring once the next layer of stones is laid in place, and so on. There is no book on the theory of such structures to be consulted by Goldsworthy or by the engineer. It is a matter of the artist's conjoined intuition, visualization, skill, accumulated experience, and experimentation that gives him a profound feeling for what will work. It is a feeling that is simultaneously visual, tactile, and somatic—and insusceptible to systematic description. After the last ring—a single slate punctuated by a dark hole—was set in place on the eighth dome, twenty-six people clambered onto it, testifying to a strength that would have pleased Buckminster Fuller, however much the American engineer would have been out of sympathy with the monumental weightiness of Goldsworthy's structures, which are not so much high tech as trad tech.

Figure 33. Parabolic and catenary curves

Figure 34. *Roof*, Andy Goldsworthy, National Gallery, Washington

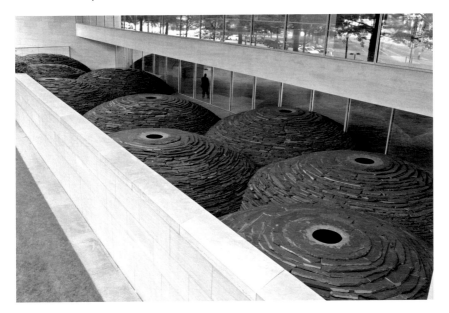

The juxtaposition of Fuller and Goldsworthy serves the culmination of this chapter well, since they represent two poles in the process through which the designer realizes the "Platonic" basics in nature. The engineer and artist share in common two central motivations: an unwavering commitment to natural geometry, and a desire to push structures to extreme limits. These find expression in the examples here of forms with spherical profiles. However, their attitudes and procedures stand at wide remove from each other. Fuller's motivations are intellectual, metaphysical, visionary, and mathematical, finding expression in optimal structures that are of the maximum lightness and economy, using the most modern prefabricated components and materials available to him. Goldsworthy's motivations are instinctive, somatic, grounded, and nontheoretical, finding expression in shapes that derive from the nature of traditional materials, using hand-based techniques that exploit and extend traditional methods of construction. Where Fuller's domes are springy, shiny, and skeletal, Goldsworthy's are massive, rough-hewn, and textured. Fuller is dedicated to the overtly engineered. Goldsworthy acts, as Leonardo had envisaged, as a "second nature in the world."

That such divergent visions can arise from natural geometry testifies to the extraordinary range of possibilities that can arise from the series of apparently simple shapes that constitute one of the basic mathematical forms of nature.

2

Shaped by Growth
Branches and Spirals

Everything, above the level of elementary or fundamental particles, is shaped by growth in one way or another. This obviously applies to the animal and plant kingdoms, but it also applies at very small scales in the organic world. Every molecule—we may think of the complex arrays of proteins—and every crystal is part of a shaped process of aggregation and has the potential to join ever larger aggregates, even perhaps participating in those great physicochemical colonies of mass and force that make up higher organisms. My focus here is on two of the most visually seductive of the manifestations of growth that have particularly attracted the attention of scientists and artists, not least in the twentieth and twenty-first centuries. The two phenomena are the dendritic systems by which branches arise, and the closely related issue of spiral formations in plants and animals. The objects at which we will be looking are the outcomes of the processes involved. These outcomes are essentially static, however much they speak of the shaping forces behind them. In chapter 4 we will be looking at some of the dynamic phenomena in their own right.

A nice sense of what we will be looking at is conveyed by John Ruskin in his *Elements of Drawing, in Three Letters to Beginners,* first published in 1857. It is worth quoting him at some length, both because he serves to set up the theme of this chapter very well and because it is a pleasure to be carried along on the flow of his prose. Ruskin's instructions for the tyro artist are poised elegantly between the science of shape and the expressive contingencies of nature.

The prolific critic of art and society is widely taken as advocating the pure and innocent imitation of nature, which is true to a degree, but only providing we realize that his notion of imitation embraced both intuitive and analytical insights into how living things have assumed their wonderful variety of shapes. A very nice passage from Letter II entitled "Sketching from Nature" makes this clear. He takes the leafy branches of trees as a key example:

> I have directed your attention early to foliage for two reasons. First, that it is always accessible as a study; and secondly, that its modes of growth present simple examples of the importance of leading or governing lines. It is by seizing these leading lines, when we cannot seize all, that likeness and expression are given to a portrait, and grace and a kind of vital truth to the rendering of every natural form. I call it vital truth, because these chief lines are always expressive of the past history and present action of the thing. They show in a mountain, first, how it was built or heaped up; and secondly, how it is now being worn away, and from what quarter the wildest storms strike it. In a tree, they show what kind of fortune it has had to endure from its childhood: how troublesome trees have come in its way, and pushed it aside, and tried to strangle or starve it; where and when kind trees have sheltered it, and grown up lovingly together with it, bending as it bent; what winds torment it most; what boughs of it behave best, and bear most fruit; and so on. In a wave or cloud, these leading lines show the run of the tide and of the wind, and the sort of change which the water or vapor is at any moment enduring in its form, as it meets shore, or counter-wave, or melting sunshine. Now remember, nothing distinguishes great men from inferior men more than their always, whether in life or in art, knowing the way things are going. Your dunce thinks they are standing still, and draws them all fixed; your wise man

sees the change or changing in them, and draws them so,—the animal in its motion, the tree in its growth, the cloud in its course, the mountain in its wearing away. Try always, whenever you look at a form, to see the lines in it which have had power over its past fate and will have power over its futurity.

Whether the form is static in nature or is a mobile subject, the artist should always strive to evoke the short- and long-term processes that have shaped what we see. Although Ruskin is far from studying the complex mathematics of growth and form in nature in the scientific manner of D'Arcy Thompson, he is fully alert to the way that a natural form exhibits a certain mathematical character that is then shaped by the kind of multiple contingencies that mold the shape of actual trees in given conditions. He provides a simple sketch of the ur-tree (a notably English kind of ur-tree) and draws the attention of the aspiring artist in the direction of some rules.

So in trees in general, and bushes, large or small, you will notice that, though the boughs spring irregularly and at various angles, there is a tendency in all to stoop less and less as they near the top of the tree. This structure, typified in the simplest possible terms at c, Fig. 17, is common to all trees that I know of, and it gives them a certain plumy character [i.e., like a plume], and aspect

a *b* *c*

Fig. 17.

of unity in the hearts of their branches which are essential to their beauty. The stem does not merely send off a wild branch here and there to take its own way, but all the branches share in one great fountain-like impulse; each has a curve and a path to take, which fills a definite place, and each terminates all its minor branches at its outer extremity, so as to form a greater outer curve, whose character and proportion are peculiar for each species. That is to say, the general type or idea of a tree is not as a, Fig. 17, but as b, in which, observe, the boughs all carry their minor divisions right out to the bounding curve; not but that smaller branches, by thousands, terminate in the heart of the tree, but the idea and main purpose in every branch are to carry all its child branches well out to the air and light, and let each of them, however small, take its part in filling the united flow of the bounding curve, so that the type of each separate bough is again not a, but b.

Later in *Elements of Drawing,* in the section titled "The Law of Radiation" (Letter III, "On Colour and Composition"), he elaborates on the theme of the "plumy" shape.

Now, there are two kinds of harmonies of lines. One in which, moving more or less side by side, they variously, but evidently with consent, retire from or approach each other, intersect or oppose each other; currents of melody in music, for different voices, thus approach and cross, fall and rise, in harmony; so the waves of the sea, as they approach the shore, flow into one another or cross, but with a great unity through all; and so various lines of composition often flow harmoniously through and across each other in a picture. But the most simple and perfect connection of lines is by radiation; that is, by their all springing from one point, or closing towards it; and this harmony is often, in Nature almost always, united with the other; as the boughs of trees, though they intersect and play amongst each other irregularly, indicate by their general tendency their origin from one root. An essential part of the beauty of all vegetable form is in this radiation; it is seen most simply in a single flower or leaf, as in a convolvulus bell, or chestnut leaf; but more beautifully in the complicated arrangements of the large boughs and sprays. . . . besides this, nearly all beautiful trees have a tendency to divide into two

Fig. 41.　　Fig. 42.

or more principal masses, which give a prettier and more complicated sym-
metry than if one stem ran all the way up the center. Fig. 41 may thus be con-
sidered the simplest type of tree radiation, as opposed to leaf radiation. In
this figure, however, all secondary ramification is unrepresented, for the sake
of simplicity; but if we take one half of such a tree, and merely give two sec-
ondary branches to each main branch (as represented in the general branch
structure shown at b, Fig. 18 . . .), we shall have the form Fig. 42. This I con-
sider the perfect general type of tree structure; and it is curiously connected
with certain forms of Greek, Byzantine, and Gothic ornamentation.

As always with Ruskin his accounts carry a powerful sense of how the kinds of
man-made design that he most admired had picked up on these essentials of natu-
ral form. Looking at what he calls "branch flakes," that is to say, the palm-like fans
of secondary branchlets toward the end of a main branch, he produces a clever
visual analogy.

I have before pointed out to you the general resemblance of . . . branch flakes to an extended hand; but they may be more accurately represented by the ribs of a boat. If you can imagine a very broad-headed and flattened boat applied by its keel to the end of a main branch.

Fig. 45.

Ruskin believed that the largely anonymous masons and craftsmen of the medieval period were piously obedient to the principles of the "leading lines" in a way that was deeper and more instinctual than the more consciously geometrical rules of dogmatic classicism. The ribs of high Gothic vaults, radiating from the central "trunk" of a pier, and the delicate naturalism of motifs on carved capitals in Byzantine and Gothic cathedrals bore witness to nature as a growing, living thing. His own pictorial drawings of medieval sculpture (fig. 35), particularly those made in his beloved Venice, do not so much replicate the details of the carver's art as evoke the inner vitality of their shared source in nature. He was of course perpetually alert to the flowering of plant forms in Gothic architectural carving, such as the "botanical" capitals in the cathedrals at Reims and Naumburg, which transform inert stone into growing nature.

BRAMANTE, LEONARDO: TRUNKS AND BRANCHES
Educated Renaissance architects and theorists were well aware that the ancient Roman architect Vitruvius believed that the earliest shelters in the prehistoric eras were constructed from tree trunks in a direct and rude manner. He also records

the legend that the leafy Corinthian capital was "invented" in a later era when an open basket placed on the grave of a Corinthian maid was invaded by a vigorously growing acanthus plant.

Although we do not obviously see nature as lying immediately behind the component parts of classical architecture in the Renaissance, all the theorists insisted that the proportional systems they deployed were extracted from the mathematical foundations on which God had built the natural world. Alberti's treatise on architecture, modeled on the ten books by Vitruvius, emphasizes the harmonics that are inherent in natural design. Thus the tapering of classical columns toward the top is justified by reference to the form of the main trunk of a tree. In one instance Alberti allows the tree-column to feature overtly. In private buildings the architect can enjoy greater license than in public structures, and for garden porticos it is permissible to make columns that "resemble tree trunks, their knots removed and their branches tied into bundles," accompanied by other natural decorations.

Figure 35. "Foliage of the Capital on South-East (or 'Vine') Angle of the Ducal Palace, Venice," John Ruskin, 1851–52

When Bramante was in Milan, in the employ of Ludovico Sforza alongside Leonardo, he used the tree-trunk column in an altogether more serious context in the exterior arcades he built at the historic basilica of S. Ambrogio in the late 1490s. Selected columns are not smooth cylinders but feature the blunt ends of lopped branches (fig. 36). It is apparent that knots are not positioned casually. We can see that the severed limbs are roughly disposed in four vertical rows, and that four knots equally spaced around the circumference of the column are disposed in horizontal rows or whorls that are rotated by 45° at each successive level (fig. 37). The result is that we can trace diagonal alignments of knots ascending the "trunks" in successive helices that run in crisscross patterns. The placement of the knots is not absolutely precise mathematically, in keeping with the vagaries

Figure 36. Tree-trunk
column in the canon-
ica of S. Ambrogio,
Milan, Donato Bra-
mante, ca. 1497

Figure 37. Scheme of
severed branches at
S. Ambrogio

of nature, but we are invited to see an underlying system to their distribution. In
nature, a whorl of four is rare and the quarter rotation does not seem to be used. It
seems that Bramante has invented a system that looks natural but is not.

Leonardo himself later sketched pairs of tree-trunk columns, one of which
appears in the lower left corner of a sheet at Windsor dominated by designs for
double staircases (figs. 38 and 39). The "rustic" columns are bound at their bases
by knotted thongs (either in stone or brass) and appear to be intended for a screen
with a portico, perhaps facing a garden. In the two tree-trunk columns there is
more than a hint of the spirals that Bramante had created, as there is in Leonar-
do's later sketches of similar columns. The first drawing on the page was proba-
bly the see-through sketch of the "tree of the vessels," in which he is essaying the

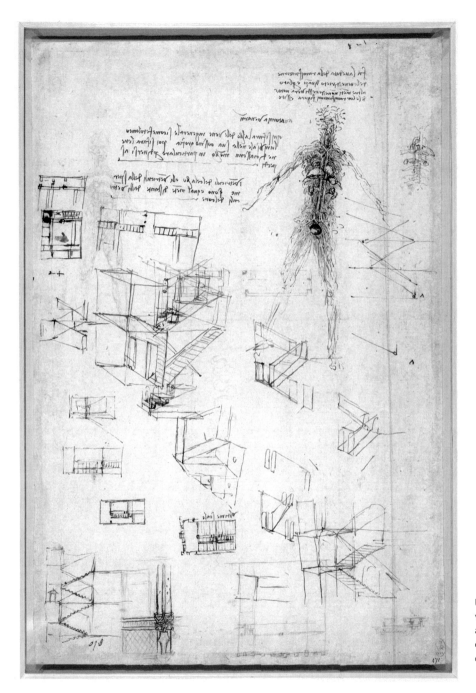

Figure 38. Tree of the vessels, staircases, and tree-trunk columns, Leonardo da Vinci, ca. 1509

Figure 39. Detail
of the tree-trunk
columns

idea of showing the whole vascular system
with the heart, liver, and kidneys as if isolated
from the body. Blood vessels—staircases—
columns for a screen. It looks as if Leonardo's
"diversity" rules. However, there are charac-
teristically Leonardesque links. The notion of
a see-through body is matched by his innova-
tory see-through sketches of staircases in tow-
ers; the "tree" of the blood vessels is matched
by the column as "tree."

The kind of natural geometry of which
Bramante was clearly aware was explored in
some detail by Leonardo. We may well imag-
ine that they exchanged views on this topic.
A series of sketches explore various kinds of
ramification, including ones in which alter-
nate lateral branches serve to divert the main
branch. The deviation in the main branch
will be proportional to the size of the lateral
one. Especially relevant from our present
point of view is a marginal drawing in MS G in which a series of whorls are origi-
nating from an upright stem, above which Leonardo sketches two stems, one that
exhibits straight "veins," while the other shows a spiral arrangement (fig. 40). The
notes deal in some detail with the underlying systems for "the birth of ramifi-
cations in plants." Earlier in the manuscript he notes that "Nature has disposed
the ramifications in many plants so that the sixth leaf is always over the first, and
so on successively, unless the rule is impeded." This is helpful not least because
"one will not cover the other, since they originate in five different directions." He
makes it clear that he is specifically directing these "botanical" analyses toward
those painters who aspire to portray "every natural thing." Such issues of math-
ematical branching were not as yet of consequence to those who wrote herbals.

As always with Leonardo, a basic system discovered in one sector of nature was
not isolated from the generality of that kind of system in other sectors. Branch-
ing in plants would necessarily be an expression of the general rules of branching,

above all the rule that guaranteed a steady flow of fluids through progressively finer or larger ramifications. He decided that if the same volume was to be passed after a bifurcation, then the two subbranches together must equal the parent branch; that is to say, the cross-sectional areas of the two subbranches added together would equal the cross-sectional area of the branch from which they derive. If the bifurcation occurs asymmetrically in the ratio of 1:2, the total of their different cross-sectional areas should again be equal to that of the parent branch, and so on. He sees this as the basic law that governs all branching systems—most notably water in rivers and canals, all the vessels of blood and air that irrigate the body, and the ramifications that provide "nourishment" in plants. Thus in one of the anatomical sheets at Windsor he draws the branching bronchi in the lungs as a marvelously coralline structure, dividing repetitively and regularly half by half

Figure 40. Studies of branching systems in plants, Leonardo da Vinci, ca. 1510–15

Figure 41. Systems of branching in trees, Leonardo da Vinci, ca. 1500

in a kind of fractal array (19045v). When he dissected the "old man" in the hospital of S. Maria Nuova he identified the cause of death as the tortuosity and silting up of the old man's system of aged vessels, which no longer obeyed the geometrical and dynamic rules that ensured efficient flow.

Leonardo explains in MS M, compiled close to the time when Bramante was building his columns, that all trees obey the same basic rule (fig. 41). In the upper drawing he shows that at each stage in the branching, as denoted by the inscribed arcs, the total area of the branches should equal every other stage, including the main trunk at *i–k*. As the "pipe theory" of branching, this notion has been explored fruitfully in modern botany, and has provided some spectacularly effective models of self-organization for the representation of trees. In the lower sketch Leonardo speculates, in a Ruskinian manner, that all the branches tend to be orientated toward the center of the tree at *m*. He knew of course that vagaries of growth in actual situations resulted in considerable variations on this basic system.

Leonardo exercised the column-trunk motif on an architectural scale toward the end of this period of working for the Duke of Milan. He transformed one of the large corner rooms in the Castello Sforzesco into a gigantic bower. Tree trunks sweep upward from the walls, branching in a fan-like manner at the springing of the vault (fig. 42). Thicker and thinner branches then ramify systematically in an openwork weave, leaving a small open oculus in the center across which is suspended a Sforza-d'Este shield. The branches are intertwined with a golden rope that is intricately knotted in the kind of elaborate pattern with which he experimented in his drawings. Judging the decoration's original effect is difficult

Figure 42. Interlace of branches and ropes in the vault of the Sala delle Asse, Castello Sforzesco, Milan, Leonardo da Vinci, ca. 1498

given its very deteriorated condition, but it seems evident that he has striven to observe the rules of branching in the whole and the parts, insofar as they are compatible with the requirements of the setting. Some skillful pruning was needed to make the trunks embrace the windows. What he has done here, interweaving and pruning the luxuriant branches, is akin to what he was to do in designing a wig for Leda (fig. 97, below). He is creating a knowing *fantasia* that works consciously contrived variations on the underlying patterns of nature.

This way of remaking nature was to be eloquently reaffirmed by Goethe: "Ultimately, in the practice of art, we can only vie with nature when we have at least to some extent learned from her the process that she pursues in the formation of her works."

AIR AND LIGHTNING

A contemporary version of a Leonardesque branching system is beautifully realized in Annie Cattrell's *Capacity* (fig. 43), in which the airways within the lung are emulated in glass. She was inspired by corrosion casts at Guy's Hospital in London. A corrosion cast is made by injecting the pipework in a human or animal body with a rapidly hardening polymer, and dissolving away the surrounding tissue with a strong alkali solution to isolate the kind of freestanding "tree" that Leonardo had described. The febrile delicacy of Cattrell's sculpture was not based on a direct representation of a medical model, but resulted from her working with molten glass in such a way that the lungs are in effect molded by the breath they transmit. She describes its making:

> The process of blowing air (breathing) into malleable glass is central to the concept of making the human lungs out of glass. In *Capacity* I used lampwork techniques [using a torch to melt the glass] to form the sculpture. The glass is borosilicate, which is traditionally used by laboratory glassmakers. This type of glass is a particularly poor conductor of heat and is also highly resilient to thermal shock. Therefore a solid rod of borosilicate glass can be hand held at one end and inches away, when placed under an intense flame, can be molten and ready to form. This process allowed me to spend long periods constructing and modelling the overall structure of *Capacity*.

The link between the process and what it represents is central in the conception of the sculpture. The delicate fragility of glass bronchi intensifies the connection between the intricacy and complexity of the body and the precarious relationships that underpin and enable its survival.

When Cattrell was artist-in-residence at the Royal Institution in London, famed not least for Faraday's experiments with electricity, she encountered electrical dendrites created in the eighteenth century by Georg Christoph Lichtenberg while professor at Göttingen. Lichtenberg's learned activities ranged from the mathematical sciences and physiognomics to commentaries on the satirical engravings of William Hogarth. He discovered what are now known as "Lichtenberg figures" when he was experimenting with static electricity. He was fascinated to observe that a layer of dust on a large block of resin arranged itself into a radiating "tree" of notable delicacy and complexity. In the late 1930s Lichtenberg figures were recorded directly on a photographic plate by Arthur von Hippel and Fred Merrill. They arranged an impulse generator and pressure tank so that the traces of an electrical discharge could be recorded in any gas and over a wide range of pressures. Capturing in miniature the pattern of forked lightning in the sky, von Hippel declared that the images "transfer terror into enchantment"—a kind of miniature sublime.

Cattrell made a photogram (a direct print on photosensitive paper) of a Lichtenberg demonstration owned by the Royal Institution (fig. 44). She was engaged

Figure 43. *Capacity*, Annie Cattrell, 2000

both by the image in its own right and with its historical feel. She discovered that
it had been donated by the distinguished Soviet physicist and broadcaster Sergei
Kapitsa. Part of its appeal is the wear and tear to which the acrylic block had been
subjected over the years, endowing it with an evocative patina, like a scratched
photographic negative or a crackly shellac gramophone record.

Lichtenberg himself was alert to the ubiquity of branching systems in nature,
but resisted the temptation to roll them all together, either causally or under a
mystic banner of universal design. He distrusted the schematization of thinking
that can accompany the facile juxtaposition of apparently similar structures, just
as he rejected the easy formulas of physiognomics for judging someone's charac-
ter. He was fully aware of the sheer diversity of causes behind phenomena that

might implicitly seem to share common origins in nature. As one of the greatest ever writers of aphorisms, he supplied one that we do well to bear in mind during the course of our present journey: "The noble simplicity in the works of nature only too often originates in the noble short-sightedness of him who observes it."

D'Arcy Thompson, as a mathematical biologist, was also well aware of this problem. He was, as we will see, wary of overclaiming when many of the parallels he drew were not demonstrably subject to shared causal explanation. Thompson was to overcome this limitation most effectively in his studies of spiral growth in animals and plants, where the mathematics he had used at the beginning of his book to understand increases in the volume of organisms could be seen to operate in a mechanical manner.

COOK'S SPIRALS OF LIFE

A disconcerting level of "spiralomania" runs through a mode of thinking that arose in the later nineteenth century and persists today, not least in websites that see the conjunction between the "golden section," the Fibonacci series, and the logarithmic spiral as holding the mystic key to "beauty" in nature and art. It is all too easy to project these conjunctions and their associated ideas onto the art of the past.

The conjunctions of spirology run as follows.

1. The golden or "divine" section (or ratio or proportion), or "mean ratio" as it was called for most of its history, occurs when a line AB is divided at C such that the ratio AB : AC is the same as the ratio AC : CB. The ratio cannot be expressed precisely in numbers, but is (to seven decimal points) 1 : 6180339.

2. The Fibonacci series, described by the Pisan Leonardo Fibonacci in 1202, is an arithmetical sequence that he illustrated by a highly conceptualized account of reproduction in rabbits. A pair of newly born rabbits are alone in a field. They are (for the purpose of the illustration) able to mate when they are one month old, and at the end of the second month their two baby rabbits (one female and one male) are born, making two pairs. After another month, the original pair produces another pair, making three pairs in total. Another month on, and the original pair and their offspring each produce further pairs, making five . . . and so on. Counting the accumulation of pairs month by month (not the individual rabbits), the sequence runs: 1, 1, 2, 3, 5, 8, 13, 21, 34, 55, 89 . . . For the purpose of the

Figure 45. Logarith-
mic or equiangular
spiral

Figure 46. Conjunc-
tion of a "golden
spiral" with a series
of rectangles
generated from the
Fibonacci series/
golden section

demonstration, rabbits are deemed to be immortal. The sequence can be calcu-
lated by adding the number in each successive pair to the one that preceded it. The
ratio of successive numbers converges on the ratio of the golden section: thus by
the time we reach 55 and 89, giving a ratio of 1 : 61818182, we are close to the golden
mean.

3. The logarithmic or equiangular spiral differs from the Archimedean spi-
ral (in which the interval between each successive whorl remains constant) by
steadily increasing the intervals in a geometrical progression, without altering its
overall shape. The radius of curvature increases regularly at every point (fig. 45).
In modern terms, we can say that the spiral remains self-similar at every stage. The
so-called golden spiral expands outward by the golden ratio for every 90° of rota-
tion. This can then be mapped onto a series of rectangles constructed according to
the Fibonacci series/golden section (fig. 46).

The most dedicated early advocate of the pervasive significance of the con-
junctions was Sir Theodore Andrea Cook in his *Spirals in Nature and Art* (1903)
and his more comprehensive *Curves of Life* (1914). Cook was a notable character.
Trained as a classicist at Oxford, he also exhibited high sporting talent, captain-
ing the British fencing team at the Olympics in 1896 and 1900. An accomplished
oarsman, he wrote *The Art and Science of the Oar*. He served from 1910 as the long-
term editor of the aristocratically oriented magazine *The Field*.

Cook devotes the first half of his second book to geometry in nature (especially spirals), before turning to their manifestation in art. The biological authorities cited most enthusiastically by Cook—the Reverend Henry Moseley, who explored the geometry of shells, and Arthur Church, who wrote on the phyllotaxis of plants—were also much admired by Thompson. Canon Moseley's *On the Geometrical Forms of Turbinated and Discoid Shells,* published in two parts in the *Philosophical Transactions of the Royal Society* in 1838, was a valiant early attempt to bring mathematics and natural history into analytical union. Church, in his *On the Relation of Phyllotaxis to Mechanical Laws* in 1904 and his incomplete project *Types of Floral Mechanism* (1909), analyzed various kinds of geometrical arrays, most notably in germinating buds. His drawings of phyllotaxis made with the help of a camera lucida, including the classic geometry of the sunflower, are of considerable beauty in their own right (fig. 47). Looking at *Helleborus* (the Christmas rose) he

Figure 47. Drawing of spiral distribution in a sunflower bud, Arthur Church, 1901

noted that "the phenomena observed are due to (i) the peculiar properties of the Fibonacci series of numbers normally utilized by flowering plants in the arrangement of their lateral leaf-members, and (2) to the geometrical properties of intersecting spiral curves corresponding to the Fibonacci series." He believed that the mathematical series served the "aim" of the plants, but admitted, as Thompson was to do, that "the reason for such a mechanism of symmetry is still far to seek."

Looking at the shell built by a mollusk, Moseley had earlier been content to attribute the "learned geometry" of the "humble architect" to God's universal design.

The logarithmic spiral that Moseley and Church had eloquently explored was granted a privileged place among Cook's curves. Such an arrangement in plants ensures that "no two leaves would be exactly above each other." Alongside the practical advantages, Cook argued that the ratio shared by the spiral, the Fibonacci series, and the golden section constituted the fundamental underpinning of visual beauty in nature and art. Following the American mathematician Mark Barr, he assigned the Greek letter phi (Φ) to the ratio and the spiral. Phi was chosen because it is the first letter in the name of Phidias, the renowned Greek sculptor.

Cook saw the logarithmic spiral as the "curve of life" itself. This is not to say that its mathematics provided the complete explanation of the ultimate mystery of life.

> Nothing which is alive is ever simply mathematical. In other words, there is in every organic object a factor which baffles mathematics, as we have hitherto developed them—a factor which we can only describe as Life. The nautilus is perhaps the natural object which most closely approximates to a logarithmic spiral; but it is only an approximation; the nautilus is alive and, therefore, it cannot be exactly expressed by any simple mathematical conception: we may in the future be able to define a given nautilus in the terms of its differences from a given logarithmic spiral.

In a rather odd move, he equates the ineffable divergence from pure mathematics with Darwinian natural selection.

> It is these differences which are one characteristic of life. It will be observed that from another point of view Darwin had long ago stated almost the same proposition when he showed that the origin of species and the survival of the fittest were largely due to those differences from type, those minute adaptations to environment, which enabled one living creature to pass on its bodily improvements to an improved descendant.

The "curve of life" is also manifested in great art.

> A great painting also makes an irresistible appeal to us which needs no argument and I may fairly compare the masterpieces of art with the shells or flowers that have survived [through natural selection], because bad pictures, though they do not "die," are certainly forgotten. . . . The comparison between a masterpiece of painting and a beautiful shell . . . ought to reveal the same proportions as have been developed . . . to explain the processes of natural growth. . . . It will clearly be of some significance, therefore, if I can also show that there is as great a measure of agreement with Φ in the one case as in the other. If so, it will not imply that the artist had any preconceived idea of using the proportions in his composition, any more than the Nautilus had any conscious plan of developing a certain spiral in its shell. But it will suggest the possibility that there exists a very real link between those processes of artistic creation which are vaguely called "instinctive" and those principles of natural growth which are admittedly fundamental.

Figure 48. Bishop's crozier and leaf-line, Albrecht Dürer, from *Underweysung der Messung*, 1525

Elsewhere he attributes this creative instinct to a special "sensitive fibre" possessed by insightful artists.

It is on these premises that Cook launches his impressive search across age-old and worldwide art and design for the phi spiral. He adduces such wide-ranging examples as a Paleolithic carving on a reindeer antler, a Mycenaean vase in the Louvre, the Ionic capital of Greek architecture, a Maori war canoe, the so-called Prentice Pillar in Rosslyn Chapel in Scotland, a series of spiral staircases in Gothic churches, and the wonderful etching by Rembrandt of the shell of *Conus marmoreus*. He looks in some detail at Albrecht Dürer's pioneering exploration

of varieties of spirals in the German painter's vernacular book of mathematics *Underweysung der Messung* (Introduction to Measurement) in 1525. Dürer sought German terms to describe figures that usually had only Latin names. We find such descriptions as "egg-line," "snail-line," "mussel-line," and "leaf-line," the last of which he cleverly exploits in a design for a bishop's crozier (fig. 48).

Above all, Cook looks to Leonardo's drawings, having obtained "500 careful photographs of the originals existing in England." He had no difficulty in finding spirals in the drawings in the Royal Collection. Cook illustrated such examples as the famous *Star of Bethlehem* (with its vortex of leaves) and studies of spiral turbulence in fluids (fig. 95, below), including the water drawings and the cataclysmic vortices of the Deluge drawings. Cook notes that Leonardo "was certainly a student of shells also, as we shall see later on but for the present I will only draw your attention to the deliberate copy of an ammonite in his sketch for the 'Leda' in the Windsor collection." The "ammonite" in question is the tight spiral on the side of the elaborately plaited wig that Leonardo was designing for his copulatory nymph (fig. 97, below).

Cook's set piece comes when he spells out his notably well-researched analogies between the spiral formations in Leonardo's drawings, the spiral staircase in the Château of Blois (fig. 49), and a rare sinistral form of the shell of *Voluta* (*cymbiola*) *vespertilio* not found in France. Cook asks,

> Can such lines as are developed in this masterpiece at Blois be the result of a merely architectural solution of the problem? Can they be merely one more example of what we have seen already of the fortuitous correspondence between perfect workmanship and the lines of Nature?

He answers,

> Surely they must have been intimately inspired by the natural object they so closely imitate, by the shell so rarely shaped by some left-handed Angel of the Ocean. And if so, this is no ordinary imitation; it is a copy with the very striking and logical and persistent differences necessitated by architectural considerations. This, in fact, must be an example of that greatest art which imitates the greatest models with a difference that reveals the strength

Figure 49. Spiral
staircase at the
Château of Blois

and personality of the designer; which discards the trivial and preserves the essential; which loves knowledge much, and is therefore unafraid of novelty; which realises the existence and the value of a studied exception here and there among all ordered things; which can unite design with fact, and originality with truthfulness; which has, in fact, discovered that the beauty of Nature is to be found not in agreement, but in difference. . . .

The Blois staircase was definitely suggested by a certain shell; this involves that the architect was an Italian; we find further that he must have closely studied shells and leaves in order to try and discover the secret of their growth and beauty; that he was left-handed; that he must have been appointed architect to the King of France; and that he must have lived at or near Blois between 1516 and 1519.

Cook's final answer is of course Leonardo da Vinci. Inasmuch as the ample spiral staircases that characterize the Loire chateaux contain echoes of the designs made by Leonardo when he was working for Francis I, Cook was justified in his comparisons if not in his attribution.

After his substantial treatment of Leonardo and the Loire spirals, Cook finishes his book with tenuous analyses of three famous masterpieces: Frans Hals's *Laughing Cavalier,* Botticelli's *Venus,* and Turner's *Ulysses Deriding Polyphemus.* He argues, with a certain amount of hesitancy, that all three (and other "great" works) must instinctively have been created according to repeated application of the phi ratio to intervals within the pictures. Like many subsequent attempts to apply the golden ratio/logarithmic spiral/Fibonacci series to old master paintings, Cook's detailed imposition of the geometry on the compositions is opportunistic, contrived, and arbitrary.

THOMPSON'S CURVES OF GROWTH

As someone who enjoyed a developed sense of visual culture, Thompson admired Cook's range of reference across nature and the arts. However, the notion of the "curve of life" was not attractive to Thompson. He drily pointed out that the best examples of logarithmic spirals in animals were formed from dead material such as shells and horns. Above all, he resisted the "mystical conceptions" to which Cook ultimately resorted. For Thompson, if something cannot be explained, it

is because we do not yet have the means to explain it, not because it has metaphysical origins. As a better mathematician than Cook, he was well aware of the phi conjunctions, but saw them as the natural consequence of the mathematics involved. Toward the end of his chapter on phyllotaxis in *On Growth and Form* he provided no comfort for the mystical spirologists of a Pythagorean bent. The passage, though not easy, is worth quoting at some length.

> The fact that the successional numbers, expressed as fractions, 1/2, 2/3, 3/5, represent a convergent series, whose final term is equal to 0·61803 . . . , the sectio aurea or "golden mean" of unity, is seen to be a mathematical coincidence, devoid of biological significance; it is but a particular case of Lagrange's theorem that the roots of every numerical equation of the second degree can be expressed by a periodic continued fraction. The same number has a multitude of curious arithmetical properties. It is the final term of all similar series to that with which we have been dealing, such for instance as 1/3, 3/4, 4/7, etc., or 1/4, 4/5, 5/9, etc. It is a number beloved of the circle-squarers, and of all those who seek to find, and then to penetrate, the secrets of the Great Pyramid. It is deep-set in Pythagorean as well as in Euclidean geometry. It enters (as the chord of an angle of 36°) into the thrice-isosceles triangle of which we have spoken . . . ; it is a number which becomes (by the addition of unity) its own reciprocal; its properties never end. To Kepler (as Naber tells us) it was a symbol of Creation, or Generation. Its recent application to biology and art-criticism by Sir Theodore Cook and others is not new. Naber's book, already quoted, is full of it. . . . But indeed, to use Sir Thomas Browne's words (though it was of another number that he spoke): "To enlarge this contemplation into all the mysteries and secrets accommodable unto this number, were inexcusable Pythagorisme."
>
> If this number has any serious claim at all to enter into the biological question of phyllotaxis, this must depend on the fact . . . that, if the successive leaves of the fundamental spiral be placed at the particular azimuth which divides the circle in this "sectio aurea," then no two leaves will ever be superposed.

It is typical of Thompson's assiduous international scholarship that he should

refer to Henri Adrien Naber's rather obscure 1908 exposition of Pythagoreanism, *Das Theorem des Pythagoras, wiederhergestellt in seiner ursprünglichen Form und betrachtet als Grundlage der ganzen Pythagoreischen Philosophie* (The Theory of Pythagoras, Restored to Its Original Form and Considered as the Foundation of the Entire Pythagorean Philosophy).

On Growth and Form appeared in successive editions over the course of Thompson's long life, culminating in 1945 in an edition that runs to over 1,000 pages. It continued to be admired as a classic of its kind, but its mode of analysis dropped severely out of fashion within biology. The major focus of research into the genesis of the forms of organisms shifted decisively into the hands of geneticists. I will have more to say about this in chapter 4. For at least half a century the most vigorous afterlife for Thompson's text was in the worlds of the visual arts and technologies. Thompson's book featured regularly on reading lists given to students in schools of art, architecture, and engineering, generally in the abridged version by the American biologist John Tyler Bonner (now available with an introduction by Stephen Jay Gould). A concerted study of the full extent of Thompson's international influence across these professions still has to be undertaken. We will see Thompson acting as a source for designers in chapter 4.

A notable example of Thompson's impact in Britain is the Independent Group's exhibition at the Institute for Contemporary Art in London entitled *Growth and Form: The Development of Natural Shapes and Structures.* It coincided with the Festival of Britain in 1951, which marked a concerted effort to forge a new kind of British modernity. Organized by the great Richard Hamilton with particularly vigorous input from the photographer Nigel Henderson, the ICA show made multiple visual references to Thompson (fig. 50). In photographs of the installation we can recognize the screen as based on Thompson's analyses of the spicules of sponges, while the square print of the tetrahedral skeleton of *Callimitra* is clearly based on Thompson, who in turn had used an image by Ernst Haeckel (fig. 76, p. 114). A related symposium was organized, and the resulting book, *Aspects of Form,* included such intellectual heavy hitters as Rudolf Arnheim, Ernst Gombrich, and Conrad Waddington.

Thompson has been heavily identified with the study of spiral formations in a way that would have surprised him. Of the 779 pages of text in the 1917 edition, the chapters on spirals occupy 160. He does however acknowledge that "exam-

Figure 50.
Growth and Form,
photograph by
Nigel Henderson,
exhibition
organized by the
Independent Group
at the Institute for
Contemporary Art,
London, 1951

ples of spiral conformation . . . are peculiarly adapted to mathematical methods of investigation." He is not shy in acknowledging their beauty. Referring to Cook, Thompson invokes

> the beautiful spiral curves of the horns of ruminants, and of the still more varied, if not more beautiful, spirals of molluscan shells. Closely related spirals may be traced in the arrangement of the florets in the sunflower; a true spiral, though not, by the way, so easy of investigation, is presented to us by the outline of a cordate leaf; and yet again, we can recognise typical though transitory spirals in the coil of an elephant's trunk, in the "circling spires" of

a snake, in the coils of a cuttle-fish's arm, or of a monkey's or a chameleon's tail.

However, he adds a well-founded note of warning.

> Among such forms as these, and the many others which we might easily add to them, it is obvious that we have to do with things which, though mathematically similar, are biologically speaking fundamentally different. And not only are they biologically remote, but they are also physically different, in regard to the nature of the forces to which they are severally due. . . . There cannot possibly be a physical or dynamical, though there may well be a mathematical Law of Growth, which is common to, and which defines, the spiral form in the Nautilus, in the Globigerina [a genus of Foraminifera], in the ram's horn, and in the disc of the sunflower.

Thompson begins his exploration of the logarithmic or equiangular spiral with a grand illustration of an X-ray of *Nautilus pompilius* (fig. 51), which has become a kind of symbol for his enterprise. There follows a careful exposition of different kinds of spiral, helix, and screw, emphasizing that the "property of continued [self-]similarity is only found in the logarithmic spirals" among the many varieties of curves. As a keen student of history, he recognizes that Jan Swammerdam in the seventeenth century understood that all spiral shells "were referable to one common type, namely to that of a simple tube, variously curved according to definite mathematical laws." Thompson emphasizes that the tube grows only at one end, progressively widening to create a rolled-up cone. The increase in volume of the organism is accommodated by a logarithmic expansion of the spiral's width.

Thompson's sustained accounts of the subtle and often complex geometries of univalve, bivalve, spiral, and turbinated shells, accompanied by tables of ratios and angles based on actual measurements, have probably been more admired than read in their considerable detail. He acknowledges that "the mathematical notation" in his chapter 11 is "considerably more complicated than any that I have attempted to make use of in this book." His subsequent chapter, "The Spiral Shells of the Foraminifera," extends his analysis to a much smaller scale, and the simpler patterns prompt him to take one of his characteristic swipes at

evolutionary theory, not so much in itself but as the sole explanation for the forms of organisms. He points out that the little organisms speak of basic shaping forces that remain common over the long eras of evolution.

Chapter 13 deals with horns, teeth, and tusks, followed by a short and restrained chapter on phyllotaxis. It opens,

> The beautiful configurations produced by the orderly arrangement of leaves or florets on a stem have long been an object of admiration and curiosity. Leonardo da Vinci would seem, as Sir Theodore Cook tells us, to have been the first to record his thoughts upon this subject; but the old Greek and Egyptian geometers are not likely to have left unstudied or unobserved the spiral traces of the leaves upon a palm-stem, or the spiral curves of the petals of a lotus or the florets in a sunflower.

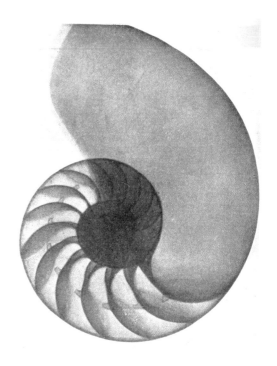

Figure 51. X-ray of the shell of *Nautilus pompilius*, D'Arcy Wentworth Thompson, from *On Growth and Form*, 1917

Cook and Thompson are nicely complementary figures, one orientated toward the arts and the other highly scientific in focus. Cook's speculations are, on the face of it, more immediately amenable to artists than the more uncompromising mathematical rigor and complexities of Thompson, but I think it is true to say that the latter has more frequently served as a point of reference for artists, designers, architects, and engineers. It may well be because the precise science of Thompson seems more fully certified, prestigious, and modern than Cook's more elusive and historically orientated ideas. In short, Thompson rightly looks more "scientific" to those nonscientists who wish to draw visually upon high-level science.

SCULPTED

A number of leading contemporary sculptors have made sustained and imaginative use of spiral formations, including Andy Goldsworthy and Chris Drury

(both of whom feature elsewhere in this book). Of younger sculptors, Briony Marshall, who initially trained as a biochemist, has creatively explored a range of geometrical and dynamic organizational systems in nature, including the projection of embryonic growth in terms of a logarithmic spiral. In the context of the present chapter, and given the limits on what I can include, I have decided to concentrate on a number of sculptures by Peter Randall-Page, whose exploration of the geometry of nature as a generating principle is notably Thompsonian and serves our present purposes particularly well. He also provides a series of visual links with other chapters.

Randall-Page is committed to the formative hand of geometry of nature: "Art is ideal in the mathematical sense like nature, not in appearance but in operation." As he acknowledges, he has drawn this formulation from Ananda K. Coomaraswamy's *Transformation of Nature in Art* (1935). The son of a Sri Lankan father and an English mother, Coomaraswamy established himself as an authority on the thought and art of India and Sri Lanka, and served as a curator at the Museum of Fine Arts in Boston. In his book *Transformation* he sought to bring universal principles of creative insight in Indian art into harmony with Western medieval art and thought. In fact, the actual quotation reads in Coomaraswamy's original, "Asiatic art is ideal in the mathematical sense: like Nature (*natura naturans*), not in appearance (viz. that of *ens naturata*), but in operation."

What is *natura naturans*? It literally means "nature naturing." What it designates, above all in the medieval philosophy of St. Thomas Aquinas, is nature as an immanent formative power, *in action as a process of shaping,* rather than nature as the perceived appearance of the actual forms that have been deposited in the natural world (which fall into the category of *natura naturata*—"nature natured"). This distinction is apposite for artists who wish to stress that they are working in accordance with natural processes rather than recording appearance as it is on the immediate surface.

It is significant that the earliest phase of Coomaraswamy's career should have been spent as a geologist in Ceylon and India. Among his discoveries was a shale infused with the skeletons of radiolaria, those microscopic masterpieces of polygonal geometry that captivated Haeckel and Thompson, as we have seen. Their shapes arise from natural process, or "operation," to use Coomaraswamy's word.

As Thompson said: "Cell and tissue, shell and bone, leaf and flower, are so many portions of matter, and it is in obedience to the laws of physics that their particles have been moved, moulded and conformed. . . . Their problems of form are in the first instance mathematical problems, and their problems of growth are essentially physical problems."

The underlying mathematical motifs that Randall-Page has drawn from "nature's pattern-book" are realized in particular forms in relation to a series of factors that run parallel to those of nature: the behavior of the material—its texture, color, and reaction to the carver's tools; the limits of scale at the top and bottom ends; the relationship of parts to whole and surface to volume; the need for the surface patterns to respond to the overall form; and, not least, what actually "looks and feels right" in terms of a really "natural form." Precise mathematics flexibly comes and goes in the creative dialogues between hand and material, and eye and shape. Calculation does not always play the same role nor does it occur at the same point in the process of creating in his works.

Seed, the seventy-ton granite sculpture in the Core education center building at the Eden Project in Cornwall, shows Randall-Page at his most Thompsonian (fig. 52). The overall egg or beehive shape of *Seed* results from his sense of the instinctive "rightness" of its contours in relation to size, mass, and material. A set of nodes, systematically graded in their diameter and protrusion, spiral around the form. Randall-Page set out to project a computer-generated configuration onto the surface of the stone. However, this method was not delivering what he felt was needed, and he resorted to the traditional Euclidian tools of straightedge and compass. As he explains:

> I plotted the pattern of around 1,800 nodes directly onto the surface of the stone using a ruler and compass. I drew two primary spirals traversing the form in opposite directions to represent the two dominant alignments of circles. Using horizontal bands I was then able to divide each circumference into numerical divisions of two consecutive Fibonacci numbers, in this case 21 and 34. Joining these points created two families of opposing spirals whose intersection represented the centre of each node.

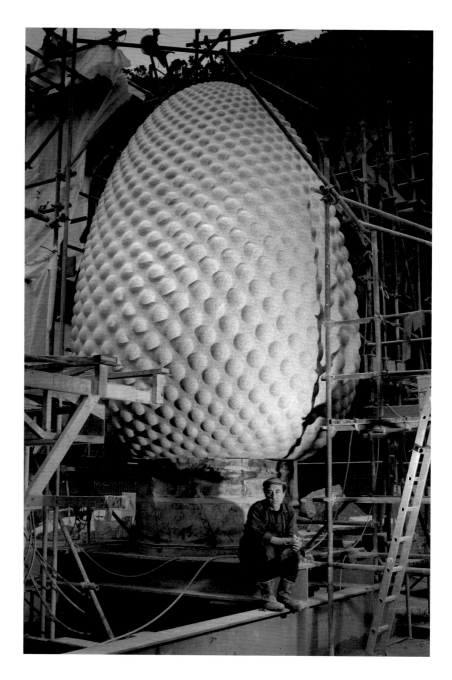

Figure 52. Peter
Randall-Page with
Seed before its
installation, 2007

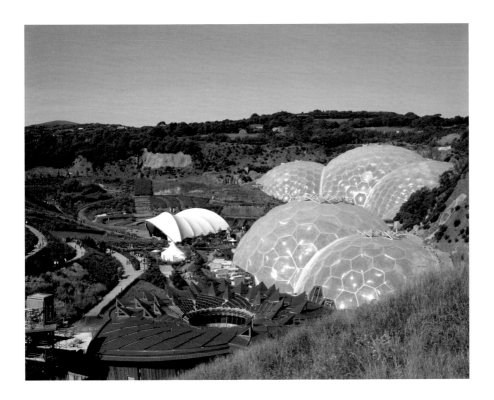

The resulting sculpture, designed for the contemplative "inner sanctum" in the Core (fig. 53), exercised a notable impact on the design of the building, into which it was lifted by a mighty crane. The building of the center joined the series of geodesic domes designed by Nicholas Grimshaw and Partners for the large-scale environmental project in the former clay pit in Cornwall. The architect Jolyon Brewis, who worked directly on the new building, responded to the geometry of *Seed* with a design based on the mathematics of sunflower seeds and pinecones. From the spiraling plates of the roof, a series of pyramidal roof lights and ventilators extrude like the spikes on a spiraling conch shell, or a cactus. The sculpture and building share their foundations in *natura naturans*.

Seed shows Randall-Page at his most mathematical. In subsequent sculptures the processes of design have moved in a more irregular direction, in which the balance between mathematical archetype and organic unpredictability has per-

Figure 53. Eden Project in Cornwall (the Core, *left foreground*), Nicholas Grimshaw and Partners, 2000–2005

ceptibly shifted. One series begins with large natural boulders that have been irregularly shaped by remorseless processes of erosion by fluids and abrasion by solids. Each boulder exists within the range of possible forms, given materials and process, and none is precisely identical to any other, though they recognizably belong to the same family of things. When the generative and secondary spirals of the surface patterns are stretched across surfaces of varied curvature they respond flexibly, dipping and swelling (fig. 54). *Sung-Woon,* made from granite with inset steel disks, was placed at the Gwangju Biennale in South Korea in suggestive dialogue with a shapely shrub that had uncannily adopted curves of an analogous type.

The sculptor's sense of natural process is very evident in the pair of granite sculptures *Exhalation* and *Inhalation* (figs. 55 and 56). The former is covered by an array of low cylindrical protrusions, like the suckers of an octopus's tentacle or pimples on a table-tennis bat. With *Inhalation* the protrusions are sucked inward, drawing an outer layer of air into its spongy surface. The conjoined result is a kind of primitive respiration.

Sometimes the marking of the boulders seems to echo the inorganic world of chemical reactions. In the *Skin Deep* series (fig. 57) the surfaces are scored by patterns that exude a basic rationale but resist any obvious regularity. The patterns seem to self-organize in some kind of interplay between forces of tension and

STRUCTURAL INTUITIONS

compression. They look rather like rectilinear versions of the Belousov-Zhabotin-sky reaction, which we will encounter in chapter 4 (fig. 101).

There is however a key difference in aim between what Randall-Page is looking for and what the scientists are seeking. Scientific morphologists analyze the form and its genesis in terms of its mechanisms—looking to explain each structure as an expression of underlying rules of causation—whereas the sculptor's creations play suggestively to the general case, inviting us to see the broad resonances rather than a specific illustration, whether of a chemical reaction or germinating stem. This is in keeping with the general rule that an artist provides a field for interpretation, not a logical statement about scientific rules.

Figure 56. *Inhalation*, Peter Randall-Page, 2008

Figure 57. *Skin Deep III*, Peter Randall-Page, 2007

Figure 58. Cloth, crumpled and dropped

3

Folding, Stretching, Compressing
The Engineering of Shape

Left to their own devices, and given a stable set of conditions, all kinds of solid but malleable materials will naturally settle into stable configurations. If we drop a piece of cloth casually on a flat and horizontal surface, the resulting form might simply look disorderly and in need of tidying up (fig. 58). It is in fact a structural miracle of self-organization. It has settled into an array in which all the forces of compression and tension that necessarily exist in any construction are resolved within the "skin" of the fabric itself. Nothing is needed to hold it up other than itself—no supporting skeleton below or means of suspension to hang it from above. If we rearrange it by pulling upward one or more zones of the cloth, when released it will settle again into another stable if somewhat different configuration. Such resolution of forces is the ideal for engineers, promising both stability and economy of materials. But it is far from easy to follow this example in actual buildings on large scales and using available materials.

The builders of the great arches and vaults of the Gothic cathedrals no less than the high-tech constructors of our own era have striven to erect space-covering

structures that hold themselves up in the most efficient way possible. Often supplementary supports become necessary, especially if the structures become very large, as when Gothic masons added flying buttresses to resist the outward pressures that lofty stone vaults and weighty towers exercised on the slender arches, piers, and walls of jointed or cemented stone (fig. 59). Only recently have the structural principles behind such buttresses been analyzed mathematically, showing how the thrusts are resolved within their elegant curves. Medieval masons arrived at what are close to optimal solutions, using the kind of intuitions, empirical testing, and trial and error that we witnessed in Goldsworthy's sculptures, with the addition of their well-honed geometrical skills with straightedge and compass. Their geometrical procedures do not in themselves explain why the structures stand up, but they did provide a design system for shapely masonry forms that mesh elegantly with engineering principles they could not themselves formulate in terms of the thrusts the buttresses needed to accommodate. The achievements of the masons remain awesome.

The types of configurations that resolve the thrusts within the substance of a form will vary enormously in their levels of visual complexity, and in their appeal and utility to artists, architects, and engineers. For practical and aesthetic reasons, architects and engineers have tended to gravitate toward the simpler shapes, although as we will see, this is not so apparent in very recent designs.

CATALAN CATENARIES

We already encountered one example of the catenary or "chain-like" curve in chapter 1 when looking at Goldsworthy's *Roof* (figs. 30 and 34). This is the curve adopted by a uniformly flexible, nonstretchy chain of constant density that is suspended from two laterally spaced points, even when those points are at different heights. The definition of the catenary curve as distinct from a parabola was published in 1691 by Gottfried Leibnitz, Cristiaan Huygens, and Johann Bernoulli in separate responses to a challenge laid down by Johann's brother, Jacob. It was Huygens who coined the term *catenary*. The curve was first knowingly used for large-scale structures in suspension bridges in the nineteenth century. The hanging of the road deck from huge looping chains or cables is now a standard technique for bridging very wide rivers or chasms.

The inversion of the hanging chain to provide a stable arch or vault was implicit

in many early structures (and in Goldsworthy's *Roof*). It seems to have first been posited in print by Robert Hooke in 1675, when he stated that "as hangs the flexible line, so but inverted will stand the rigid arch." When he was working with Christopher Wren on the engineering of the dome of the new St. Paul's Cathedral in London, he devised a structure that incorporated an inverted "catenary" within its fabric, although the curve he actually used was the closely related parabola.

The properties and engineering potential of the inverted catenary were analyzed by a number of theorists of arches in the nineteenth century, but the first major exploitation of multiple catenaries as a means of designing large and complex buildings occurred in the sacred and domestic architecture of the extraor-

Figure 59. Flying buttresses at York Minster

Figure 60. Catenary
arches in the Casa
Milà (La Pedrera or
"Quarry"), Barcelona,
Antoni Gaudí,
1906–12

dinary Catalan designer Antoni Gaudí (fig. 60). He was seeking a radically new style of construction, at once natural and geometrical, in contrast to the rigid post-and-lintel structures that prevailed in all but a few buildings, mainly ecclesiastical. The catenary promised just this, as a form that arose naturally, and was, as he knew, of some mathematical complexity. He realized that the catenary could be transformed into a variety of "organic" configurations by processes of skewing. In addition, he researched the complex geometry of surfaces such as the hyperboloid and paraboloid, so that he could construct *intersecting* combinations of convex and concave curvatures in vaults that were rigorously geometrical and yet seemed nature-like and sensuous in their sinuosity. For the necessary compound of the mathematics of complex curves and structural probity, he worked closely with the Alsatian engineer Eduardo Goertz.

Famously, for his towering and intricate Basilica and Expiatory Church of the Sagrada Família in Barcelona, begun in 1883 and still inching its way toward completion, Gaudí devised incredibly elaborate string models of hanging catenaries to arrive at stable configurations for the intersecting arches and 3-dimensional curves of the vaults. He created looping cobwebs of curved strings suspended from points projected onto the inverted ground plan. To factor in the weight that would bear down on the structures, he hung small bags of sand that dragged the catenaries downward, so that when inverted they could be expected to bear equiv-

 STRUCTURAL INTUITIONS

alent loading. The profiles of the string curves in the models were transformed
into series of segments meeting at points, but the vertices could be adjusted to
reinstate the continuous curves. His actual models do not survive, but recon-
structions are displayed in the museum attached to the church (fig. 61). Gaudí was
literally turning the logic of architectural model building upside down.

Gaudí's quest for organic geometry extended integrally from the whole to the
parts. Details that look decorative to us were integral to the principles that gov-
erned every aspect of the design. He was unsurprisingly drawn to Ernst Haeck-
el's revelations of the microscopic mathematics of tiny marine organisms, and we
may sense not-so-distant echoes of the silica skeletons of radiolaria and nassellaria
across many scales inside and outside Gaudí's buildings (figs. 62, 63, and 64). His
aspiration was that the resulting building should appear to the pious visitor as
a force of nature itself, as a spiritual distillation of God's perfect engineering at
every scale, rather than as a banal container made by human agency.

BLOWING BUBBLES

The basis of the highly adventurous structures invented by Gothic masons and by
Gaudí are very fine skeletons that are infilled with thin "membranes"—even if in
ruined churches it is not unknown for the skeletal ribs of a vault to fall away, leav-
ing the curved shells of the vaults in place. Ribbed structures can exert a strong
visual appeal. A soaring fan of ribs provides a wonderful and literally uplifting
visual effect, as we saw with the branching structures that Leonardo deployed in
the Sala delle Asse (fig. 42, above).

It is also possible to construct vaults embodying complex curves without an
independent armature of ribs. The great examples in nature of thin membranes or
films that adopt stable shapes are bubbles and the compounding of bubbles into
foams. Again we are dealing with miracles of natural engineering.

Once more we can start with Leonardo, who was fascinated by the "cohesive-
ness" of water. We now know that what we call surface tension results from the

different bonding of molecules in the body of the water and at its surface. In the body of the water, each molecule forms an optimal number of hydrogen bonds to other water molecules. On the surface, the interactions with the neighboring molecules are more limited, leaving a higher level free energy for the bonds across the surface. For Leonardo, as we will see, the behavior of bubbles is explicable as a manifestation of shared orders across different phenomena in nature and in man-made objects.

Leonardo's main accounts of bubbles are found in the seventy-two-page Codex Leicester, owned by Bill Gates. It was compiled in the years following 1506 and focuses particularly on water in the body of the earth, though it is far from being a finished treatise. One of the aspects of water that attracts Leonardo's attention is the architectural geometry of bubbles. He realizes that the form toward which

Figure 63. Sagrada Família exterior, Antoni Gaudí

Figure 64. Stauromedusae, Ernst Haeckel, from *Kunstformen der Natur*, 1904

a bubble tends is spherical: "It is shown in the water bubble how much the water is uniformly dispersed so that it clothes a more or less spherical body, formed of water somewhat less dense than the other; and the cause is evident because when it breaks it makes a certain amount of noise" (23v). He envisages that the film of water under tension stretches, becoming less dense, and audibly snaps back together when the bubble breaks.

However, in practice, the sphere is ideal rather than real, as he argues in a note to accompany one of his small marginal illustrations (fig. 65): "The bubble made in the air, which breaks its cohesiveness with the cane which blows into it, does not fall in spherical figure, because its excessive water runs below and gives more weight there than elsewhere, so that it accelerates its motion there and breaks it at its third above" (25r).

Figure 65. Bubble formed at the bottom of a hollow cane, Leonardo da Vinci, Codex Leicester, 25r

Figure 66. Analysis of a bubble on the surface of water, Leonardo da Vinci, Codex Leicester, 12v

Figure 67. Large bubble surrounded by smaller ones, Leonardo da Vinci, Codex Leicester, 23v

In the case of a bubble rising to the surface of water in the kind of turbulent flow that so fascinated him, it will form a hemispherical "dome" (fig. 66):

Once the air included within the water has arrived at its surface, it immediately composes a figure of a half sphere, which is clothed with a very thin cohesion of water. This occurs of necessity, because "the water has always cohesiveness within itself, which is so more powerful as the water is more viscous"; and once this air has arrived at the opening of the surface . . . , not finding any more the weight that pressed it from above, it raises on its head the surface of the water, with so much weight of water joined with it as the aforesaid cohesiveness can have; and it stops here with a perfect circle as the

STRUCTURAL INTUITIONS

base of half a sphere. The water has the aforesaid perfection because its sur-
face was uniformly extended by a uniform power of air. And it cannot be
more than a half sphere, because the greatest width of the spherical bodies
is at their diameter; and if this enclosed air were more than a half sphere, it
would be less at its base than where the diametric line is, so that the arc of
that half sphere would not have shoulders or resistance in its weakest part,
that is the widest one, and so it would come to break in that place of great-
est width, because "the weakest part of any arc is always at the border of its
greatest width." (25r)

The tricky text is clarified by a figure on another folio that shows how the mid-
dle of the three horizontal planes, c–d, corresponds to the base of a stable hemi-
sphere, whereas the bases of the walls press outward along the upper plane a–b
and tilt inward along the lower e–f (fig. 66). He explains elsewhere that "if it [the
bubble] were less than half a sphere, it would need a ring of smaller bubbles placed
in opposition, to buttress it," as shown in another of the tiny drawings, which is
actually intended to demonstrate how small bubbles cluster around a large one
(23v; fig. 67). The vision and the vocabulary are that of the architect-engineer in
perpetual dialogue with nature. However, Leonardo is aware that the geometry of
bubbles and of droplets of water conforms most closely to the ideal at the small-
est scales, and that the dome of an actual cathedral compounded from masonry
demands a more elevated profile. He would have been surprised and delighted by
Goldsworthy's *Roof*.

The evanescent and iridescent beauty of bubbles featured as a recognized
subject in painting with the advent of pictures of "everyday life" in the seventeenth
century, where they came to stand for the transitoriness of human existence.
The greatest visual master of the genre over the course of three centuries is Jean-
Baptiste-Siméon Chardin. In what may be the earliest of his surviving versions of
the subject, a well-dressed and serious young man carefully inflates a large bubble,
while a blunt-faced infant, who may be wearing a toy version of a soldier's hat,
strains to see what is happening (figs. 68 and 69). The text below a contemporary
engraving suggests that the bubble's iridescent flightiness is as transient as that of
"Iris," that is to say, the rainbow.

The bubble itself is brilliantly observed and conjured into painterly existence

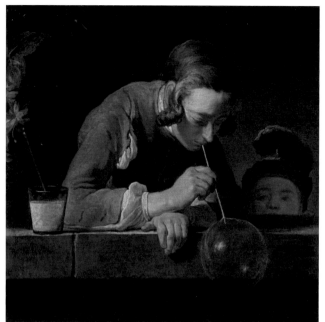
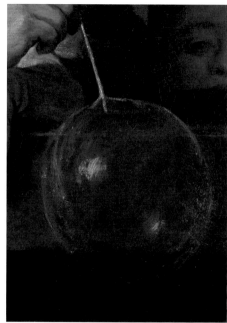

Figure 68. *Young Man Blowing a Bubble*, Jean-Baptiste-Siméon Chardin, ca. 1743

Figure 69. *Young Man Blowing a Bubble*, detail

with a few thickish streaks of deftly applied pigment. The iridescent colors, caused by the interference of light reflected from inner and outer surfaces of the very thin film, stand out subtly against the predominantly dun tone of the picture as a whole. The two highlights, one on the outer convex surface and the other reflected lower down from the inner concave face of the soap film, do just enough to entice our eye into seeing the mobile sheen of the bubble.

The tip of the straw down which the youth delicately inflates the bubble seems to protrude into the surface of the bubble, while two lateral spurs coincide with the surface itself. We find exactly the same kind of tube for blowing a bubble in a virtuosic chromolithograph by Maximilien Rapine from a painted image by Blaise-Alexandre Desgoffe in 1872 (fig. 70), which was designed to illustrate the interference phenomena of colors in thin plates in accordance with the wave theory of light advocated by the great physicist Thomas Young. This suggests that the spurred configuration of the tip of the straw was a refinement of the simple cylindrical straw, tube, or cane, perhaps invented in the eighteenth century to blow superior bubbles.

STRUCTURAL INTUITIONS

Leonardo did not discuss the colors of bubbles. He was generally more involved with structure, including optical geometry, than with the kind of fleeting illusions that attracted later artists. He explained that such odd phenomena as the blur resulting from speedy motion might be of interest to natural philosophers but not something artists should strive to represent. Chardin is less overtly theoretical than Leonardo, but he is in his own way an intensely focused and intellectual artist, deeply involved in the business of seeing and the tropes of representation. He has left no clue for us that he was concerned with scientific explanations, such as Newton's pioneering study of interference colors. He was however as dedicated to close observation of beguiling optical phenomena as any scientist and as Leonardo.

The twentieth-century master of the bubble was Joseph Cornell, famed for his evocative assemblages in boxes that serve as small but intense cabinets of wonder. A universe of thought is crystallized within their small interiors. He is the Vermeer of the Found Object. His earliest such construction was the first in what became an extended *Soap Bubble Set,* exhibited in 1936 in an exhibition at the Museum of Modern Art in New York. The series involves recurrent found objects, without actual bubbles but evoking or echoing bubble forms—like white clay pipes that can be used to blow soap bubbles (as in Millais's famous painting *Bubbles* for Pears soap). There are also historic maps of the moon's surface, balls, eggs, shapely glasses, and (in the first one) a doll's head reminiscent of the infant in Chardin's painting.

The illustrated example (fig. 71) contains two casts of the clay pipes, secured to worn strips of wood at the sides, and a typical lunar backdrop, with star charts on the side walls. The seven wooden cylinders at the top display (from the left): a flat species of sea urchin (a "sand dollar" in the US) and a fuller sea urchin shell, both with five-part symmetry; an early cellular state of an organism, perhaps at a stage of gastrulation; a round star map labeled "Deneb" (the brightest star in the constellation Cygnus); a turbinated shell, perhaps of a type of snail; what appears

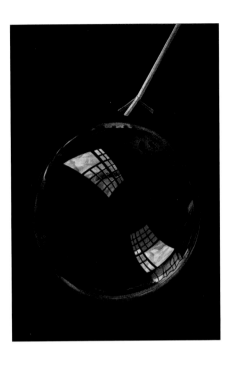

Figure 70. Soap bubble illustrating interference phenomena in the colors of thin plates, Maximilien Rapine, after Blaise-Alexandre Desgoffe, from Amédée Guillemin, *Le Monde Physique*, Paris, 1883

Figure 71. *Soap Bubble Set*, Joseph Cornell, 1949–50

to be a limpet shell with half of its upper layer scraped away; and an ammonite. The shells and cells are examples of natural engineering of the kind that delighted D'Arcy Thompson. On the shelf are two glasses, one containing a bleached fragment of driftwood and the other a plaster cast of a coral, while a white-painted ball that is not secured in a definitive position sits between them. The spherical echoes of the long-departed bubbles blown by the pipes are manifest. We are implicitly invited to think about the mystery of cosmic space, the nature of time, land, and sea, the insistent geometry of natural shape, and the transparent magic of glass. Within its small compass it invites us into vast fields of contemplation.

We know more of Cornell's intellectual engagements than we do of Chardin's. He testified to his fascination with Sir Charles Vernon Boys's *Soap Bubbles and the Forces Which Mould Them,* originally delivered as three lectures for young

people at the Royal Institution in London during the winter of 1889–90. The frontispiece to Boys's subsequent and popular book shows a beam of light projected onto a screen through a small hole in a card, behind which is a spinning disk with six holes round its rim (fig. 72). The speed of the disk is literally fine-tuned by blowing through the holes until the note is precisely that emitted by the tuning fork on the stand in front of an arched jet of water. The resulting shadow of the apparently continuous jet reveals that it has been broken "musically" into

an arc of beads. If the card turns fractionally slower, "all the drops will appear to slowly march onwards, and what is so beautiful . . . , each little drop may be seen to gradually break off, pulling out a waist which becomes a little drop, and then when the main drop is free it slowly oscillates, becoming wide and long, or turning over and over, as it goes on its way."

Boys's pretty experiment lies behind a series of photographs, *The Observer and the Observed,* by Susan Derges in 1991 (fig. 73). Derges does not just photograph Boys's droplets, but she allows her optical presence as an observer to insinuate itself into the image. The camera, focused on the droplets, registers Derges's face behind the jet as an out-of-focus blur, while each droplet, a watery lens, transforms her image into a sharp semblance of her facial features or of her observing eyes, inverted, stretched, and compressed in an instantaneous bending of space. The title refers to a recurrent theme in modern physics, namely the presence and

Figure 72. "Experiment for showing by intermittent light the apparently stationary drops into which a fountain is broken up by the action of musical sound," C. V. Boys, from *Soap Bubbles and the Forces Which Mould Them,* 1902

effect of the observer within the system of observation. The "circles of confusion" caused by the out-of-focus sheen in her observing eyes are more nearly spherical than the arcing droplets. An act of aided observation becomes wondrously suggestive.

FRAMES

When bubbles are aggregated as foam, their sphericity is molded into beautiful patterns of polyhedrons. When they are stretched across a twisted wire frame, they behave as complex curved films, assuming the shapes of the minimal surfaces. The basic physics of foams and films was established by the Belgian physicist Joseph Plateau, whose other major contribution was the study of stroboscopic images, inventing a revolving device called a phenakitiscope that prefigures cine-

Figure 73. *The Observer and the Observed*, Susan Derges, 1991

matography. His experiments, calculations, formulas, and laws were described in his impressive and monumental two-volume publication *Statique expérimentale et théorique des liquides soumis aux seules forces moléculaires* (Experimental and Theoretical Statics of Liquids Subject Only to Molecular Forces) in 1873. Within the worlds of art, engineering, and architecture it has generally been the curvaceous seduction of films rather than the complex and difficult solid geometry of foams that has proved to be more productive.

If we take an oval wire frame and bend it and dip it into a soap solution, the resulting thin film will assume a complex curvature when it stretches across the margins of the frame (fig. 74). The resulting membrane is the one that plays

this role with the minimum surface area—in this case assuming a shape like a saddle. Demonstrating the existence of this minimum area for any given boundary is called Plateau's problem, and the most ready solution remains the practical one provided by an actual wire frame traversed by a film of soap or oil.

Figure 74. Soap film across a curved wire frame

Plateau experimented with great care and at considerable length with geometrical frames in three dimensions, including the simpler of the regular polyhedrons. He found the results surprising and pleasing: "One often obtains . . . extremely pretty results: for example, with the cubic frame, the new system . . . contains, in its middle, a film cube with edges and faces slightly convex, attached by its edges to the films based on the solid edges; in the same way, with the frame of the tetrahedron, the new system presents, in its middle, a film tetrahedron with convex edges and faces, etc."

The translation of Plateau's configurations into the geometry of the natural world was accomplished by D'Arcy Thompson. Indeed, it seems fair to claim that no contemporary scientist was more appealing to Thompson than the great Belgian physicist. He was particularly delighted with "Plateau's *bourrelet*" or "surface of continuity," that is to say, the small cushioning curves that make the transition between two or more planes at the junctions of thin films. Looking at the curvaceous result Plateau obtained with a tetrahedral wire frame, Thompson saw its relevance to a particular kind of nassellarian skeleton that had been depicted by Haeckel (figs. 75 and 76), speculating that if the curved shape of the interior tetrahedral bubble is in turn used as the frame it would result in the same structure as we see in *Callimitra*.

Thompson wrote that

Figure 75. Comparison of a film within a tetrahedral frame and the skeleton of *Callimitra*, D'Arcy Wentworth Thompson, from *On Growth and Form*, 1917

Figure 76. Skeleton of *Callimitra*, D'Arcy Wentworth Thompson, after Ernst Haeckel, from *On Growth and Form*, 1917

among a certain group called the Nassellaria, we find geometrical forms of peculiar simplicity and beauty. . . . It is obvious at a glance that this is such a skeleton as may have been formed (I think we may go so far as to say must have been formed) at the interfaces of a little tetrahedral group of cells, the four equal cells of the tetrahedron being in this particular case supplemented by a little one in the centre of the system. We see, precisely as in the internal boundary-system of an artificial group of four soap-bubbles, the plane surfaces of contact, six in number; the relation to one another of each triple set of interfacial planes, meeting one another at equal angles of 120°.

The intersection of the faces of bubbles at 120° is one of Plateau's laws.

The concept of minimal surfaces is integral to the engineering principle of optimum structures as it was developed in the early twentieth century. A key text was the 1904 paper "The Limits of Economy of Material in Frame-Structures" by the Australian engineer Anthony Michell. He sought to construct a frame such that a minimum quantity of material would be used to sustain a given load—with no redundancy and no insufficiency. He determined that the mechanical principles of an optimal design should be founded on orthogonal and tangential curves, the geometry of which he outlined in a diagram—the overall shape of which already has a familiar look for us (fig. 77). The involute is any curve orthogonal to all the tangents of a given curve; that is to say, a succession of tangents to the circle meet the logarithmic spirals at right angles.

Figure 77. The geometrical engineering of optimum structures, based on "The Limits of Economy of Material in Frame-Structures," Anthony G. M. Michell, in the *Philosophical Magazine*, 1904

Michell's innovatory mode of analysis and the principles of optimal structures and the geometry that lay behind it are still actively cited today. Particularly striking examples of optimal structures of the kind advocated by Michell were the twin hangars for airships built at Orly near Paris by Eugene Freyssinet between

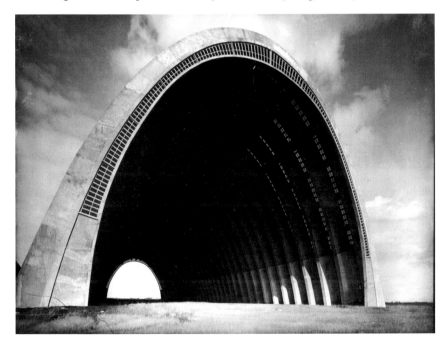

Figure 78. Airship hangars at Orly, Eugene Freyssinet, 1921–23 (destroyed)

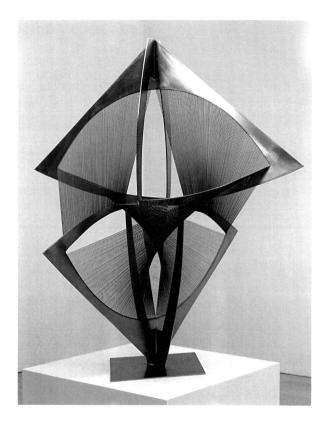

Figure 79. *Torsion, Variation*, Naum Gabo, ca. 1974/75

1921 and 1923 using highly innovative technology to construct a series of arches from stressed concrete (fig. 78). Generally described as parabolic, the arches are better understood as catenaries in terms of how they transmit the stresses within their structure. These great wall-less vaults were needed to accommodate the huge bellies of the airships. They extended to 330 feet in length and soared to a height of 200 feet. They were destroyed by Allied bombing in the Second World War.

The principles of minimal surfaces and optimum structures found brilliant sculptural expression in the constructions of the Russian artist Naum Gabo. He was trained in Munich in natural sciences and engineering—and it shows. In a series of elegant openwork sculptures, Gabo combined curving skeletons with tensely divergent arrays of strings in a way that invites the spectator to participate in the evolution of forces in space (fig. 79). As he wrote, his sculpture involves "a continually unfolding manipulation of space which must be read as an experience in time. . . . I don't want [the spectator] just to come up and stand in front of it, but to walk around it, look through it, up at it, down at it. In other words, in 'reading' the space, to forget his customary terrestrial movements and restrictions and become as they are—weightless." Looking at his constructions of this kind, we will not be surprised to find that he was much taken with Thompson's natural geometry, particularly the great biologist's parallels between Plateau's bubbles and Haeckel's radiolaria. Gabo's sculptures do not actually rely on minimal engineering for their stability—if we cut the many strings, the skeleton would not collapse—but they speak to us in the visual language of structural efficiency in human and natural engineering.

It was another Russian, a member of the first group of constructivists, who invented what is the most improbable example of a structure that relies upon members in compression and tension. In 1921 Karl Ioganson exhibited his *Study in Balance,* now lost, in which a series of separate rods or struts, as compression members, were held in a stable spatial configuration by tense strings or cables attached to their ends in such a way that the rods did not touch each other. Such an angular network of rigid compression components and flexible pure tension members is known as a tensegrity structure. The visual effect of a tensegrity structure is rather like a body composed of conjoined kites, though in the classic kite structure the two compression rods touch at their perpendicular crossing point. The system made its first appearance in an engineering context in 1948 with Kenneth Snelson when he was studying with Buckminster Fuller. So taken was Fuller with the magic of Snelson's suspended network that he appropriated and developed it to the point at which he could in 1962 obtain a patent for the basic unit

Figure 80. *Easy Landing,* Kenneth Snelson, Maryland Science Center, Baltimore, 30 × 85 × 65 ft/10 × 25 × 20 m, 1977

of three struts and nine cables in the configuration of an irregular octahedron. He subsequently went on to patent tensegrity designs for single and later double domes of separate struts linked by cables.

Snelson himself was less concerned with the application of tensegrity to practical engineering, preferring to realize its potential in soaring sculptures and towers, such as *Easy Landing* at the Maryland Science Center in Baltimore in 1977 (fig. 80). The effect is of joyous if visually precarious levitation, literally defying gravity. Snelson stresses that his structures are rooted in nature, but this is true more with respect to the principles of natural engineering than the end results. Although analogies to tensegrity structures can be found in nature, the forms of Snelson's sculptures are very much the artificial inventions of the human engineer. Leonardo would have been pleased to see natural principles brilliantly exploited to create works that "nature never invented." Tensegrity structures are still provoking innovative research among mathematical engineers such as Simon Guest at Cambridge, not least in terms of how they "find form" through a mode of self-organization.

The most spectacular realization of tensegrity engineering on a large scale is the Kurilpa Bridge, which arches over the Brisbane River in Australia (fig. 81). The architects Cox Rayner collaborated with an engineering team from Arup, led by Ian Ainsworth. Their bridge is over 1,500 feet long, with a main span of 420 feet and a clear deck width of 21 feet. Bridges are of necessity heavy things, and even Arup's relatively light structure uses some 550 tons of steel. Yet it exudes a jazzy sense of airborne flightiness. The main deck is suspended from a series of diagonal masts linked by a tensegrity structure that involves a series of independent horizontal spars. Within this network a second, smaller tensegrity array supports a protective canopy for those traversing the bridge. The result is both exhilarating and full of somatic tension. One could be forgiven for imagining that the severing of one of the steel cables would result in a chaotic collapse of the whole into a dislocated series of mighty rods, much like a catastrophic collapse of a pile in a child's game of pick-up sticks. The reality is that the multiplicity of cables ensures a greater degree of redundancy, or over-provision, than in more conventional designs, providing safety and robustness that belie the jaunty appearance.

FOLDS, FROM PAINTING TO BUILDING, AND BACK AGAIN

At the beginning of this chapter we noted that a piece of cloth dropped on a flat surface in a set of untidy folds constitutes a stable structure. However, a number of varied technologies, with respect to both materials and computer design, are needed before complex folds can be exploited on the large scale of architectural enclosures.

The earliest masters of the geometry of naturalistic folds in the postclassical era were the painters and sculptors of the Italian Renaissance, particularly in the late fifteenth century and most notably in Florence. We know that a number of artists developed a technique for stabilizing patterns of folds by saturating linen with liquid clay and allowing it to set over a model—presumably not a living model but a clay or wooden form that allowed the cloth to settle into the kinds of folds they wanted. The technique was particularly favored in the workshop of Andrea Verrocchio, in which Leonardo was trained. Given the high finish of the surviving examples—often sketched in ink using a fine brush on tinted linen, with white heightening—it is difficult to arrive at definite attributions. The illustrated exam-

Figure 81. Kurilpa Bridge, Brisbane River, Cox Rayner and Ove Arup, 2009

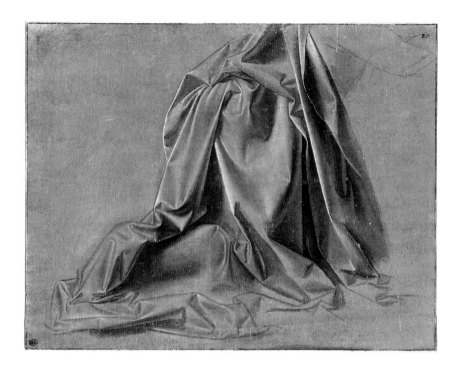

Figure 82. Study
for the drapery of
a kneeling figure,
Leonardo da Vinci

ple in the Louvre bids fair to be by Leonardo himself—and is in any event representative of the technique (fig. 82). There is a powerful sense of varied forces of compression, sometimes resolved into rounded curves and at other places creased into jagged angles. Light acts as a sculptural agent, but it also has a life of its own, rebounding in glimmers on shaded surfaces within the caves of the folds. We may imagine this study is for a kneeling angel in an Annunciation, such as Leonardo's early picture in the Uffizi, but it does not correspond exactly to any known painting. His later drapery studies, especially those associated with his projects for a Virgin, Child, and St. Anne, move away from the literally set shapes of the brush drawings on linen and convey a powerful sense of a process that is still unfolding—or rather folding (fig. 83). There is a strong feeling of something akin to a geological process in action—what Ruskin called the "leading lines." Leonardo was writing in the Codex Leicester about such processes on a massive scale in the body of the earth at the same time this drawing was made.

STRUCTURAL INTUITIONS

The effort put into such studies is understandable. Draperies, to which we tend not to pay enough attention, were conspicuous and significant elements in Renaissance compositions, whether altarpieces or narratives. The nature of the cloth, thick or thin, fine or rough, colorful or somber, patterned or plain, played an important role in the characterization of the participants. Modeled draperies testified to the physical presence of the posed figures and frequently conveyed their motion (and sometimes that of the air). They also testified to the status of their wearers. Leonardo typically formulated rules for their portrayal. He writes at one point, "Ensure that in your draperies the part that surrounds the figure reveals the way in which it

Figure 83. Study for the drapery of the Virgin, Leonardo da Vinci

is posed, and that part which remains behind it should be ornamented in a fluttering and outspread manner." Leonardo is describing what became known as the "wet-style" draperies characteristic of ancient Roman statuary, in which the cloth clings to frontal contours of the body as if dampened. Drapery is generally an under-studied subject in the history of art, potentially spanning the era from ancient Egypt to the present day—though there are signs that it is beginning to attract more attention.

The technique of folding migrated from painting and sculpture into architecture and engineering only comparatively recently. The move was facilitated by the advent of new engineering techniques, notably in the casting and reinforcing of relatively thin skins of concrete, in the advent of new materials that can adopt complex arrays of curves, and in advances in computer design that permit calculations for the stability of such elaborate shapes. Folding first came internationally

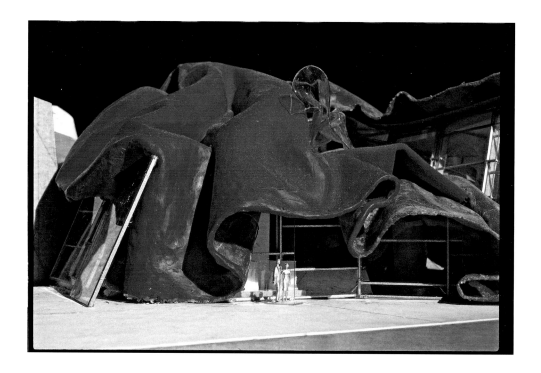

Figure 84. Detail of a
model for the Lewis
House, Frank Gehry,
1990

to more prominence in architectural practice in the work of Frank Gehry. The
test bed for his ideas over a decade of experimentation was the house he was plan-
ning for the insurance magnate Peter Lewis. A key problem of the design of what
was intended to be a linked series of units in a horizontal array was how to provide
a rhythmic unity such that the whole became more than the sum of the parts.
The solution is said to have arrived accidentally—in keeping with many stories of
key creative moments in art and science—when a piece of velvet was placed over
the troublesome model at the end of day. The result was a folded roof of rippling
curves over a series of rectilinear pavilions (fig. 84). The story is undoubtedly more
complicated than this, involving Gehry's long-standing fascination with shapes in
drapery and his desire to break away from the visual restrictions of the post-and-
lintel system of traditional buildings. And he was certainly not the first to seek a
new formal language for a kind of organic architecture with curves. However, the
story captures the essence of what became Gehry's signature style in which the

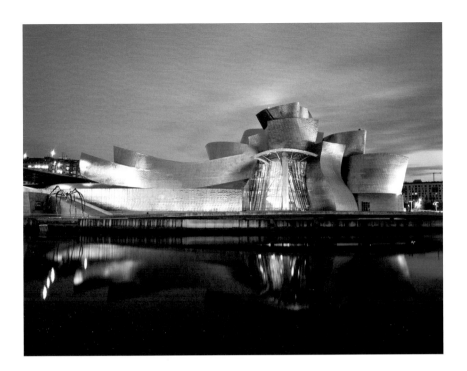

Figure 85.
Guggenheim
Museum, Bilbao,
Frank Gehry, 1997

outer integument of the building sweeps, soars, and plunges in space like something that has emerged unpredictably from the scrumpling of a sheet of cloth.

The Lewis house was never to be realized, but a kind of tacit agreement between the architect and a remarkable patron over the years allowed the project to serve as a subsidized laboratory for Gehry's evolving ideas. Two buildings did later result from their collaboration, the Peter B. Lewis Building for the Weatherhead School of Management at Case Western Reserve University, and the Lewis Science Library at Princeton. The former is characterized by turbulent waves of stainless steel plates, while the latter sets diagonal facets of structure in dynamic competition with each other.

The first major manifestation of Gehry's new vocabulary of folding was the Guggenheim Museum in Bilbao, completed in 1997 (fig. 85). The titanium-clad exterior, scintillating in the light, seems to invite us to see visual analogies— surges of water, the scaly sheen of sinuous fishes, billowing sails, the curves of a

ship's hull, the organza fantasies of an extravagant milliner—none of which are literal sources for the forms he has created but speak of how common shaping forces are evoked.

Under the surging skins of Gehry's buildings lies a huge quantity of steel girders, which help the interior spaces to assume functional rectilinearity when it is needed. Museums and art galleries need some vertical walls, and visitors benefit from interior contours that are less dizzying than those that dominate the external rhetoric—unlike the diagonal exterior and interior shards of Daniel Libeskind's unsettling Hamilton Building at the Denver Art Museum. When we ask about the Guggenheim in terms of its ostensible function to display items of artistic merit, it is apparent that the building is intended in an assertive way to be *the* work of art—to cite what Frank Lloyd Wright is reputed to have said about his famous museum in New York, also financed by the Guggenheim Foundation. Since the ritual of visiting museums and art galleries has become a modern performative act, much like earlier acts of devotion in great cathedrals, such an assertive exterior is integral to the psychological function of the museum for the aesthetic pilgrim. There remains, however, the question of whether the visual instabilities of such expressive buildings are positively exciting or negatively unsettling when they perform their roles as places where people do things that involve contemplation and amenable social interaction.

Younger designers have moved away from the massive concealed armatures required by Gehry and Libeskind and have begun to explore the structural integrity of folds in their own right. A series of innovators in other fields—artists, designers, mathematicians, and computer scientists—have been experimenting with incredibly complex variations on folding and crumpling as a kind of high-tech origami. The scientist Eric Demaine of MIT embraces many aspects of the art and science of folding across a wide variety of digital and material media. His inventions range from the incredibly ingenious making of cute bunny rabbits from a single folded sheet (the folding of which is determined by computer algorithms) to elaborate creations of luscious folds in colored glass. The conceptual and practical ingenuity does not quite overcome the sense (as with many computer-generated visuals) that the results constitute a kind of technological kitsch. By contrast, the French artist Vincent Floderer uses manual dexterity and unpredictability to crumple and crease dry and moist sheets of paper into delicate patterns

of closely packed pleats. The illustrated example generates one hundred points, folded by Anne Cécile Plancq from a square centered in the middle of a sheet. The result is suggestive organic shapes that evoke, converge upon, and sometimes overtly imitate the forms of exotic flowers, marine organisms, and fungi (fig. 86). The manual operations of squeezing and unfolding set the parameters for the shapes while the actual folds self-organize into configurations that are richly varied and unpredictable in the details of their form. The parallels with the generation of forms in nature are clear, with their genetic shaping imperatives in the context of physical law, iterations of process, and the detailed contingencies that come individually into play.

The potential of such folding systems for large-scale and load-bearing structures in architecture is being explored by a number of designer/theorists, most prominently the American architectural guru Greg Lynn. In this they have sometimes drawn support from the opaque theories of the French phi-

Figure 86. *White Coral*, created by Vincent Floderer, folded by Anne Cécile Plancq, made from 100 points folded out of a square centered in the middle of the sheet, Tengu-jo paper 6gr/m², paper 90 × 90 cm, model 15+ cm, extensible, 2001

losopher Gilles Deleuze, who developed an elusive metaphysics of physical
and mental space in which the notion of folding and the dissolving of inside
and inside have played a prominent role: Folding-unfolding no longer sim-
ply means tension-release, contraction-dilation, but enveloping-developing,
involution-evolution. . . . The simplest way of stating the point is by saying
that to unfold is to increase, to grow; whereas to fold is to diminish, to
reduce, to withdraw into the recesses of a world. Yet a simple metric change
would not account for the difference between the organic and the inorganic,
the machine and its motive force. It would fail to show that movement does
not simply go from one greater or smaller part to another, but from fold to
fold. When a part of a machine is still a machine, the smaller unit is not the
same as the whole.

Notwithstanding the difficulties in transferring Deleuze's elusive and metaphys-
ical poetics into the physics of real buildings, there is an obvious seduction in
coupling the innovative use of actual folded forms in architecture to a system of
thought that aspires to overthrow conventional notions of space—of openness/
enclosure, inside/outside, boundary/extension—avowedly in the light of the
modern science of space-time.

The architectural designs of Greg Lynn show how a kind of "deconstructive" architecture can be realized in which the concepts of exterior and exterior space are dissolved in a Deleuzian manner. His competition design for the European Central Bank in Frankfurt resembles a giant Henry Moore sculpture reshaped in the light of the kind of valiant diagrams that strive to depict multidimensional space in popular science books (fig. 87). Inventive and beautiful examples of such visualizations are those by Malcolm Godwin in Stephen Hawking's *The Universe in a Nutshell*. In the walnut shell motif used for the front cover (fig. 88), galactic formations swim in a cosmic soup inside a spherical bowl ringed by interpenetrating orbits. As a metaphorical evocation of the subject of Hawking's book, the image is not meant to be directly illustrative, but all visualizations of cosmic phenomena that exist dimensions beyond our sensory realm ultimately have to work in a nonliteral way, exploiting analogy, suggestion, and implication.

Figure 88. *Universal Nutshell*, Malcolm Godwin, for Stephen Hawking's *The Universe in a Nutshell*, 2001

As an elusively nonsolid building, Lynn's design is thrilling. As an environment for the conduct of banking, even in its most speculative modern guise, it seems to promise more spatial and conceptual instability than most of us would wish in a major European financial institution. A website devoted to the Gehry building for the Weatherhead School of Management bizarrely claims that "the waterfall of stainless steel plates that compose the roof, can be seen as representing the onslaught of new business needs in our rapidly changing global economy. The brick walls, symbolic of traditional ways of conducting business, do not collapse under the impact of these waves, but respond and adapt in graceful curves." In the event, the competition for the bank building was won by a moderately adventur-

ous design by the Vienna-based group Coop Himmelb(l)au which consists of a
diagonally sliced tower block. Convincing clients to build deconstructive archi-
tecture is harder than inspiring radical thinking in schools of architecture.

Lynn has inspired a chorus of younger designers, a number of whom teach in
universities and colleges around the world. One of the pioneers is the Canadian
Manuel Báez. The philosophical base of Báez's own thinking is the "crystal and
flame," inspired by Italo Calvino's posthumously published *Six Memos for the
New Millennium.* For Calvino, the crystal is the very symbol of order in nature,
not least the order we crave. At the opposite pole is the disorderly and dynamic
process of fire. Although the crystal and flame are sharply contrasting in their
essential natures, they exist for Báez in a symbiotic relationship through the
interaction of order and chaos as revealed by modern mathematics. He is, unsur-
prisingly, a fan of D'Arcy Thompson's expositions of growth and form. The inter-
action between structure and process is expressed in Báez's designs through elab-
orately folded sheets or membranes composed of regular sets of malleable cells
that reconfigure themselves as they generate unexpected curves. The origami-like
folds can bear remarkable loads far in excess of the unfolded membrane. The trick
on the larger scale is to realize the structures with thin, flexible, and strong mate-
rials that do not tend to tear under tension or fracture along the more compressed

ridges of the folds. Báez's project for the Ottawa Tulip Festival (fig. 89) envisages an envelope that can be reconfigured, infallibly adopting stable shapes that have organic and more specifically floral properties.

Another of the younger theorists in this experimental area of design is the Greek architect Sophia Vyzoviti, who was trained partly in Holland. She is less concerned with single folded sheets than with twisted and bent bands of cut material that resemble linked Möbius strips. In common with others involved in an architecture that would be impossible to realize without computers, her work paradoxically reinstates the role of physical modeling using manipulated sheets of real material in an abstract play of form. As she acknowledges,

> Physical modelling has been rendered relevant in the context of technology-driven architecture because of its emergence potential with respect to form—and structure generation—which not only complements but also challenges digital morphogenesis. This new genre of physical modelling is radically different from architectural models—whose function has been more or less substituted by renderings or 3d prints—it produces abstract yet full of potential, generative material diagrams.

A comparably intimate symbiosis of mathematical computer modeling, rapid sketching, and curvaceous handmade models in card and other familiar materials characterizes the exhilarating work of Cecil Balmond, long the leading figure at Arup, the engineers of the Kurilpa Bridge (fig. 81). The first design to emerge under his own name, rather than under the aegis of Arup, is the remarkable meandering bridge over the River Mondego at Coimbra in Portugal (fig. 90). Completed in 2007 in collaboration with the Portuguese engineer António Adão da Fonseca, it consists of two soaring walkways cantilevered from opposite lateral edges on inverted triangular supports. White arcs launch themselves across the water from either bank, looking as if they are destined not to meet in the middle. As they are about to overlap, the decks swerve lovingly toward each other and merge in a visual pause that functions as a natural viewing platform. The air of surprise is underlined by the jazzy balustrade formed from colored transparent panels in a fractal pattern. Such is the expressive potential of the eccentric meeting of the sensuous curves that the bridge has been named by locals in honor of the

Figure 90. The junction of the "Pedro e Inês Bridge," Coimbra, Portugal, Cecil Balmond and António Adão da Fonseca, 2007

legendary lovers Pedro and Inês. The reference is to the fourteenth-century prince who enjoyed an illicit relationship with Inês de Castro, who was the queen's lady in waiting. The prince's father had Inês killed, but when Pedro became king he declared his dead lover to be his true wife and, according to legend, commanded courtiers to pay homage to her disinterred body.

As an independent engineer-inventor-designer-artist, Balmond does more than use advanced mathematics, visionary drawing, and material modeling to design exhilarating structures. He uses nonlinear and multidimensional algorithms to create artistic forms that exist in their own right—as autonomous "sculptures"— at the tense edge between geometry and organism that has been a recurrent theme of this chapter (fig. 91). At this cutting edge in design, there are fascinating parallels with the kind of folded structures being investigated by Lakshinarayan Mahadevan and his team at the Wyss Institute at Harvard—across what

Figure 91. *Lattice,*
Cecil Balmond, 2009

seems to be an unlimited range of natural phenomena. One paper, for instance, "Growth, Geometry and Mechanics of a Blooming Lily," written by Haiya Liang and Mahadevan, brings powerful new analyses to bear on observations of natural form that would have delighted Leonardo and Thompson.

Yet alongside this cutting-edge high tech in art, engineering, and science, the traditional media still have something to say. The Scottish artist Alison Watt paints monumental folds of white and black drapery on very large canvases. Having begun her career as an award-winning portraitist, she abandoned the explicit individuality of faces in favor of the implicit individuality of creased drapery. In her set of four canvases, entitled *Still,* exhibited in the Memorial Chapel in Old St. Paul's Church during the Edinburgh Festival in 2004, she conjures up metaphors of peace and purity in a manner that evokes the traditional imagery of the Virgin without being illustrative in a traditional way (fig. 92). Such was the feeling

Figure 92. *Still*, Alison Watt, installed in the Memorial Chapel, Old St. Paul's Episcopal Church, Edinburgh, oil on canvas, 368 × 368 cm, 2003–4

of rightness of *Still* in the chapel that it has been retained in place. It exudes a consoling sense of calm eternity. Watt greatly admires old masters who used drapery with communicative intent, such as Zurbarán. The efficacy of her folds, raised to a new level of autonomous potency, depends not least on the spectator's intuition that they are real configurations that speak of the interaction of the material and the forces of the agencies that have shaped it. Again there is a sense of the *natura naturans* that lies behind *natura naturata*. We entered the topic of folding via a crumpled piece of cloth, an apparently mundane image of the kind to which we generally pay no real attention. Watt shows that in the right hands the mundane can become magical.

4

Waves, Ripples, Splashes

Fluids in Motion

Motions of fluids, most readily visible in nature in the flow of water, have fascinated and frustrated over the ages. They have fascinated with their beguiling patterns, their sinuous waves, spiraling turbulence, and pretty splashes. They have frustrated generations of investigators who have attempted to subject the complex patterns to analysis and to reduce them to set laws and predictability.

I recall as a child watching the leaping flames of the fire that was lit in the lounge of my parents' house on Sunday afternoons in the winter. Each dancing tongue of flame, apparently spouting from unseen apertures in the shiny coal, seemed to adopt its own flickering shape according to its special personality. During the flame's transitory life, it seemed to observe some kind of rule that gave it shape and endowed it with a special character but without prescribing a definite form.

Leaning over the stern of a boat on the River Thames, I recall staring at the spiraling wake as the displaced water tumbled into the space left by the departing hull, mingling with the aggressive turbulence of the churning propellers. As the resulting waves moved toward the bank, chasing those generated by the prow of

the boat, they did so in a succession of Vs, one after another, eventually slapping on the bank and somersaulting back into the incoming waves. The strange, non-repeating compound of shapely pattern and endless variation was deeply engaging—for reasons that did not then concern me.

I now know that the mathematics of the time was not coping adequately with such unpredictable orderliness. My childhood fascination certainly predated Edward Lorenz's classic 1972 paper "Predictability: Does the Flap of a Butterfly's Wings in Brazil Set Off a Tornado in Texas?," in which he posited that even a tiny change in initial conditions or a small perturbation in a system while it is running can exercise massive and unpredictable effects. Lorenz had arrived at what became the key tenets of chaos theory while grappling with the ever-challenging problem of weather prediction. He did not so much solve the problem as demonstrate why predictability has clear limits when dealing with such complex systems. Their behavior is not random but is determined by series of intersecting probabilities. If the actual behavior of the system is plotted on a graph, the various phases of the system are contained within a shape called an attractor. The attractor denotes the parameters of what is possible within a chaotic system and plots the probabilities built into the system's dynamics. However, even knowing the mathematics of the attractor, we find that precise forecasting of what the system will look like at any given moment of time is impossible. This is because the trajectory of the system is extremely sensitive to even minute changes in the starting conditions.

Relatively common examples may help. If we watch water emerging in an expanding cone of spray from a hose pipe, it is clear that the droplets vary erratically in their trajectory but that there is a limit on the outermost distance that a single drop can reach, and that very few drops approach that limit. The same basic stipulations apply when we drop a stone into a body of still water. We will see the beautiful pattern that characteristically results as the displaced water leaps upward, without our being able to predict either the absolute shape of the splash or how high and wide a particular droplet will travel. The same configuration will never precisely recur even if we repeatedly drop the same stone again from the same height. It seems as if we are watching a piece of visual music in which each successive form develops in some varied way from the tune with which it commenced. As with Bach's *Goldberg Variations,* an Indian raga, or a pibroch on Scottish bagpipes, such systems seem to strike a deep chord in our minds.

Other aspects of the motion of fluids manifest more regular geometries, such as the laws that govern their transmission through channels, as we saw in chapter 2. The most notable of the regularities is the propagation of waves with regular frequencies and amplitudes. Wave phenomena are complex and varied, but the classic mechanical wave with which we will be concerned consists of an oscillation or standing wave that travels across matter in space, transferring energy to successive points without displacement of the particles of the medium along the direction of the wave's travel. If the waves are regular, they will be punctuated by points or nodes of minimum or zero displacement.

This can be readily witnessed and understood when we grasp one end of a tethered rope and shake it repeatedly up and down (or from side to side). A succession of waves will appear to progress toward the tethered end although the actual substance of the rope does not flow in a longitudinal direction. Successive waves are reflected at the tethered end of the rope. Points on the rope between the stationary nodes will move transversely up and down (or from one side to the other). According to how far and fast we move our hand laterally, we can adjust the number and dimensions of the waves that form along the rope. I suspect that many of us as children conducted informal experiments of this kind with skipping ropes. Again we have an instinctive fascination with a phenomenon that exhibits slippery equilibrium, in this case with an emphasis upon periodic behavior coupled with the paradox of apparent motion without any longitudinal travel of actual matter. The centrality of wave theory in modern physics needs no emphasis from me.

I will approach both these topics of fluid motion through our now familiar entry point of Leonardo, beginning with waves and ripples, about which he developed characteristically innovative observations and ideas. But he provides more than our entry point. In a more sustained way, he stands as the supreme early investigator of the complex geometry of water in motion.

LEONARDO AND THE SHAPES OF LIQUIDS IN MOTION
The most developed of Leonardo's discussions of waveforms occurs in the Codex Leicester, that is to say, around 1506–10. Typically he delights in the geometrical poetry of the behavior of the elements. On folio 12v (fig. 66), where he also discusses the architecture of hemispherical bubbles, he notes "how the wave in the

percussed [round] vessel runs several times from the circumference to the middle of the pot, and from the middle it returns to its circumference." Leonardo, as a keen reader of Dante, would have been well aware that his Tuscan predecessor had used such wave patterns in Canto XIV of the *Paradiso* as an analogy for the way that the voices of St. Thomas Aquinas and Beatrice resonated in his mind: "The water in a rounded dish vibrates from the centre to the rim, or from the rim to the centre, depending on how it is struck, from inside or out. Just as the glorious spirit of Thomas fell silent, this thought suddenly came into my mind, because of the analogy that sprang from his discourse, and Beatrice's, whom it pleased to begin speaking, after him." It may have been Dante's analogy between ripples of water and the transmission of sound that inspired Leonardo's conviction that sound radiates concentrically from its point of origin.

Leonardo knew that the apparent lateral motion of a wave did not necessarily involve the flow of material: "The movement of the wave is faster than the movement of the water that generates it. This is seen by throwing a stone into dead water, which generates around the place of the percussion a circular motion that is fast, and the water that produces this circular surge does not move from its place, and nor do things that float on the water move" (14v; fig. 93). He also observed that sets of ripples seem to intersect each other without interfering with their basic shapes. He showed that if the ripples are in flowing water they will be distorted in an elliptical manner. He wondered why the waves did not interfere with each other's progress. He speculated that they did not actually pass through each other but were repeatedly reflected back and forth in the same configuration. Perhaps what we see as an unhindered continuation of the same ripple after its encounter with another is actually a product of a series of reflections that serve to duplicate the geometry of the original ripples. In the same set of diagrams on folio 23r he noted how waves reflected from the protrusion on a bank observed the same geometry as the incident waves. For good measure, he recorded on 14v that the ripples generated when triangular or rectangular objects are dropped into water rapidly adopt the standard form of concentric ripples. And finally he sketches the cross-section of a splash. The geometrical improvisations in Leonardo's marginal illustrations blend induction and deduction in a wonderful diagrammatic synthesis.

Figure 93. Studies of concentric ripples in water and a splash, Leonardo da Vinci, ca. 1508–10, Codex Leicester, 14v

The inductive component is overtly represented in the Codex Leicester in his scheme to have a craftsman make an experimental tank (fig. 94). In two marginal illustrations on folio 9v he sketches a rectangular tank with an upright board penetrated by an aperture above it at one end. It is worth quoting the whole of the note he has squeezed in:

Experiment

Make a test, in your tank, to state to which direction the thing *n,* at the bottom, is pushed, if the wind goes from *a* to *b.*

I judge that it will come back to *m;* that is it will have a motion contrary to the motion of the wind.

In order to see whether the small surface wave causes the water to move high on its base, mix in your tank water with millet seed, and through the panes of glass you will see what you need to see; but try to get a terracotta trough, with a large and flat bottom, four-and-a-half feet long and one foot wide; have it made here, by the ceramicist.

Figure 94. Studies of an experimental water tank, Leonardo da Vinci, ca. 1508–10, Codex Leicester, 9v

In the drawings this remarkably precocious piece of laboratory equipment is set up to study the effect of wind moving over the water surface, but Leonardo also envisaged it being devoted to seeing what happens when water pours through the raised mouth and falls turbulently into the still water below. The famous drawings at Windsor, of which this is the most complex (fig. 95), seem to have resulted from investigations made with his tank. He was able to anatomize the process by concentrating on its component parts, most notably the performance of the water vortices in the depths and on the surface and the behavior of submerged air, all of which he synthesized in this climactic demonstration.

It was his special understanding of water in spiraling motion that he brought to bear on the performance of blood in operating the three-cusp aortic valves in the human heart (fig. 96). He realized that the cusps were not muscular and did not work by indirect muscular action. He therefore reasoned that it must be the motion of the blood itself that effected closure in the constricted neck of the aorta.

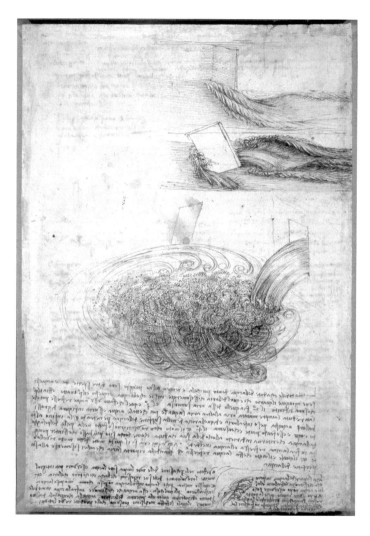

He drew various graphic models for the flow of the blood in the neck of the valves, demonstrating how the out-turning vortices filled the cusps, shutting the entrance until the next thrust of pumped blood.

His deductive modeling did not stop there. In the diagrammatic drawing in the top right corner he records his intention to "make this test in glass and have water and millet [seed] move in it." Mory Gharib, of Caltech, who has actually built Leonardo's proposed model, has utilized modern imaging techniques to demonstrate how close Leonardo's visualizations are to what actually happens inside the valve. Coming at the question from the point of view of a practicing heart surgeon, Francis Wells has recently demonstrated how extraordinary are the observational precision and functional insights in the suites of heart drawings

Figure 95. Study of a stream of water pouring from an outlet into a still body of water, Leonardo da Vinci, ca. 1510

(based largely on the heart of an ox) undertaken quite late in Leonardo's career.

Inevitably for Leonardo, such fundamentals of form and dynamics could not but be part of the wider manifestation of the action of forces in nature. He struck at these issues through visual analogy. Sensing that the skeins of spiraling water behind an obstacle look like very curly hair, he explained that the direction of flow of each water current was equivalent to the weight of each strand of hair, while

the propensity of water to move in circles within itself was paralleled by the desire of hair to curl. The result in both cases—one belonging to dynamics and the other to statics—is a helix. When he was designing a wig for Leda in his (lost) painting *Leda and the Swan* he took his cue as an engineer of hair from nature, working intricate variations on spirals and openly delighting in the interplay between his tight geometry and the more unruly spurts of Leda's own hair (fig. 97).

On the scales of his experimental tank, the heart, and Leda's wig, the vortices are decorative, benign, and functional. As he emphasizes, the turbulent motion of blood in the heart generates heat and provides essential motive power for the life of our bodies. On larger

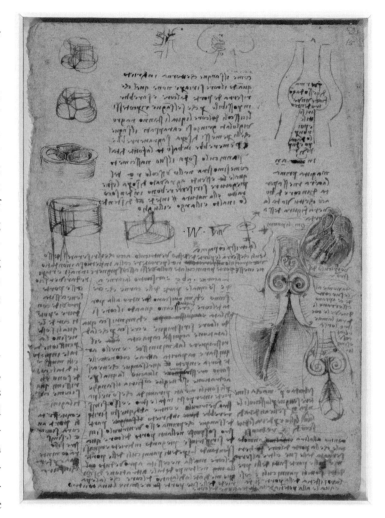

Figure 96. Studies of the form and action of the aortic valve, with a model of the neck of the aorta, Leonardo da Vinci, 1516

scales it is a different story. Much space in the Codex Leicester is devoted to the analysis of raging water currents in nature and what the engineer can do to contain them. We know that Leonardo was regarded by civic authorities as an expert in hydrodynamic engineering. At the largest earthly scales, the forces unleashed by the "Prime Mover" are such that human defenses are of "no avail." His set of late Deluge drawings, in which the surface of the body of the world is ravaged by

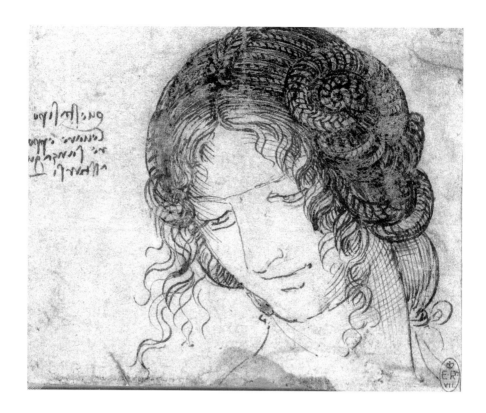

Figure 97. Study for
the head of Leda and
her wig, Leonardo da
Vinci, ca. 1506

spiraling cataclysms, express his sense of the irresistible force of fluids in violent
motion with great power.

At this level of operation, with respect to taming the visual chaos of water in
motion and its wider manifestation in art, Leonardo remained largely isolated
until the nineteenth century. If there are earlier parallels, they exist in the art of
China. Not the least of the problems before modern ways of imaging is that a
comprehensive unraveling of the complexity was impossible with the naked eye.
As we will see, "instantaneous" photography came to play a role.

D'ARCY THOMPSON AND THE GEOMETRY OF FLUIDS

It is with the other founding hero for my notion of structural intuitions, D'Arcy
Thompson, that the rules of flow that govern dynamic phenomena and the static

forms that result from them come back into play in the most intense way. The static forms were our focus in chapter 2. Thompson lamented the lack of hard mathematics in the understanding of form in the natural sciences. His criticism is expressed on the second page of *On Growth and Form*:

> The zoologist or morphologist has been slow, where the physiologist has long been eager, to invoke the aid of the physical or mathematical sciences; and the reasons for this difference lie deep, and in part are rooted in old traditions. The zoologist has scarce begun to dream of defining, in mathematical language, even the simplest organic forms. When he finds a simple geometrical construction, for instance in the honey-comb, he would fain refer it to psychical instinct or design rather than to the operation of physical forces; when he sees in snail, or nautilus, or tiny foraminiferal or radiolarian shell, a close approach to the perfect sphere or spiral, he is prone, of old habit, to believe that it is after all something more than a spiral or a sphere, and that in this "something more" there lies what neither physics nor mathematics can explain. In short he is deeply reluctant to compare the living with the dead, or to explain by geometry or by dynamics the things which have their part in the mystery of life.

Thompson's desire is not to replace poetic metaphysics with dry mathematics but to bring precision and pleasure into a new union. In one of my favorite quotations, quite Ruskinian in tone, he declares that

> the physicist proclaims aloud that the physical phenomena which meet us by the way have their manifestations of form, not less beautiful and scarce less varied than those which move us to admiration among living things. The waves of the sea, the little ripples on the shore, the sweeping curve of the sandy bay between its headlands, the outline of the hills, the shape of the clouds, all these are so many riddles of form, so many problems of morphology, and all of them the physicist can more or less easily read and adequately solve: solving them by reference to their antecedent phenomena, in the material system of mechanical forces to which they belong, and to which we interpret them as being due. They have also, doubtless, their immanent

teleological significance; but it is on another plane of thought from the physicist's that we contemplate their intrinsic harmony and perfection, and "see that they are good."

His citing of the "good"—a reference to Genesis in the Bible—reminds us that Thompson believed in a form of natural design which, though not in direct opposition to Darwinian evolution, did seek physical explanations for natural forms that were not adequately modeled by random variation and natural selection, as we will see later.

A visually appealing example of how he proceeded is provided by his study of splashes, an example of which we first saw at the foot of a page in the Codex Leicester (fig. 93). Thompson was inspired to look at the fluid morphology of splashing by "Mr Worthington's beautiful experiments on splashes." Arthur Worthington, professor of physics at the Royal Naval College in Devonport, used high-speed photography to capture the succession of beguiling shapes that resulted from the dropping of spheres into fluids. The most notable set of photographs, published in his *A Study of Splashes* in 1908, depicts the now iconic corona formation (fig. 98). Thompson narrates the process with the same complex precision to which Leonardo aspired.

> The phenomenon is two-fold. In the first place, the edge of our tubular or crater-like film forms a liquid ring or annulus, which is closely comparable with the liquid thread or cylinder . . . , if only we conceive the thread to be bent round into the ring. And accordingly, just as the thread spontaneously segments, first into an unduloid [a surface of revolution of constant curvature], and then into separate spherical drops, so likewise will the edge of our annulus tend to do. This phase of notching, or beading, of the edge of the film is beautifully seen in many of Worthington's experiments. In the second place, the very fact of the rising of the crater means that liquid is flowing up from below towards the rim; and the segmentation of the rim means that channels of easier flow are created, along which the liquid is led, or is driven, into the protuberances: and these are thus exaggerated into the jets or arms which are sometimes so conspicuous at the edge of the crater.

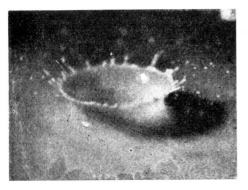

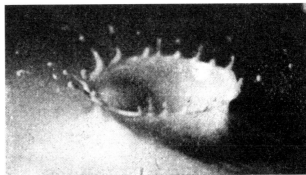

Thompson elegantly extends his obser-
vations of such formative physics into
the world of the handmade.

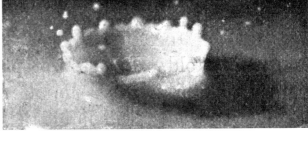

To one who has watched the potter
at his wheel, it is plain that the pot-
ter's thumb, like the glass-blower's
blast of air, depends for its efficacy
upon the physical properties of the
medium on which it operates, which for the time being is essentially a fluid.
The cup and the saucer, like the tube and the bulb, display (in their simple
and primitive forms) beautiful surfaces of equilibrium as manifested under
certain limiting conditions. They are neither more nor less than glorified
"splashes," formed slowly, under conditions of restraint which enhance or
reveal their mathematical symmetry. We have seen, and we shall see again
before we are done, that the art of the glass-blower is full of lessons for the
naturalist as also for the physicist: illustrating as it does the development of
a host of mathematical configurations and organic conformations which
depend essentially on the establishment of a constant and uniform pressure
within a closed elastic shell or fluid envelope. In like manner the potter's art
illustrates the somewhat obscurer and more complex problems (scarcely less
frequent in biology) of a figure of equilibrium which is an open surface, or
solid, of revolution.

Figure 98. Corona
formation and
collapse in a splash,
Arthur Worthing-
ton, from *A Study of
Splashes*, London,
1908, in D'Arcy
Wentworth Thomp-
son, *On Growth and
Form*

The visual fascination of the corona, above all as photographed in bright red by Harold Edgerton in his Strobe Alley at MIT, has resulted in it becoming perhaps the most popular example of instantaneous photography. As a poster it is familiar in student rooms, particularly of science students, who often seem happy to seize upon an artistic product of their chosen discipline.

As alert as Leonardo to analogous forms in the organic and inorganic worlds, Thompson recognized a splash formation in the shapes of simple tubular sea creatures with coronal fringes, and in later editions developed more elaborate parallels between the dendritic branching of drops of viscous fluid falling through water and the fronds dangling from the "umbrella" of various medusoids (jellyfish). They are characterized by Thompson as varieties of inverted splashes. Moreover, he is able to adduce analogies between the successive forms adopted by drops of gelatin and the stages of morphogenesis in jellyfish.

The problem that Thompson faced—admitting himself that his book is "all preface"—is that he could vividly demonstrate the shared characteristics of shapes across organic and inorganic phenomena, and produce cogent analyses of the geometries involved, but could rarely adduce a definite casual mechanism or a set of causes that directed biological forms to assume the shape they did. For Darwin the mechanism was natural selection; that is to say, all aspects of the form of the jellyfish had been selected on the basis of improved function. For the growing bands of geneticists after 1900, belatedly latching on to the theory of Gregor Mendel, the key drivers of form are the genes (and the proteins for which they "code"), which mutate and produce the variations on which natural selection then acts. As a developmental biologist said to me some twenty years ago, "There's genes and proteins; that's all!"

We now know that things are a good deal more complicated than this monolithic determinism, not least in relation to a series of factors within the cytoplasm of the cell and so-called junk DNA that perform roles in switching the genes on and off. The units of junk DNA in our chromosomes have recently been claimed to perform key roles in gene expression, courtesy of a massive collaborative project named Encode. Whether or not all the claims can be substantiated, there are certainly things going on in gene expression that are highly complex. We are also becoming alert to the role of self-organization by which physicochemical systems of some complexity spontaneously generate robust shapes in response to

Figure 99. "Liese-gang's Rings," D'Arcy Wentworth Thompson, after Leduc, from *On Growth and Form*, 1917

the inherent forces within the systems. In computers we have new tools that can model self-organization. We can now set up the parameters and starting conditions of a system and let the forms emerge on their own account without further intervention. Self-organization should not be viewed as anti-Darwinian. If natural selection works as well as it can, it is sensible to view it as ensuring that genes take advantage of every bit of formative help along the way.

Thompson himself was aware of some early demonstrations of what we now know as self-organization. The most notable instance was a phenomenon described by the German chemist Raphael Liesegang. Thompson notes how a series of rings are produced by chemical processes of diffusion and precipitation (fig. 99):

If we dissolve, for instance, a little bichromate of potash in gelatine, pour it on to a glass plate, and after it is set place upon it a drop of silver nitrate solution, there appears in the course of a few hours the phenomenon of Liesegang's rings. At first the silver forms a central patch of abundant reddish brown chromate precipitate; but around this, as the silver nitrate diffuses slowly through the gelatine, the precipitate no longer comes down in a continuous, uniform layer, but forms a series of zones, beautifully regular, which alternate with clear interspaces of jelly, and which stand farther and farther apart, in logarithmic ratio, as they recede from the centre.

Characteristically, Thompson notes a resemblance to the concentric patterns in the "ocelli" or eyes of the Emperor moth. He points unsympathetically "to Darwin's well-known disquisition on the ocellar pattern of the feathers of the Argus Pheasant, as a result of sexual selection . . . in striking contrast to this or to any other direct physical explanation!" He later records with evident disapproval that the ocelli in "the jewelled splendour of the peacock and the humming-bird, and the less effulgent glory of the lyre-bird and the Argus pheasant, are ascribed to the unquestioned prevalence of vanity in the one sex and wantonness in the other." It is with some relief that Thompson records in a footnote that William Bateson, the dedicated Darwinian and pioneer Mendelian who coined the term *genetics,* "appears inclined to suggest a purely physical explanation of an organic phenomenon: 'The suggestion is strong that the whole series of rings (in Morpho) may have been formed by some one central disturbance, somewhat as a series of concentric waves may be formed by the splash of a stone thrown into a pool, etc.'"

Thompson would have been much taken with the creation of novel eyespots and eccentric eyespot distributions in butterfly wings by the Portuguese artist Marta de Menezes (fig. 100). She has used precision tools, including microsurgical needles, red-hot cauterizing needles, and tools for micrografting, to intervene in a very minor way with the development of the patterns while the butterflies were still in their cocoons. The pre-wings disks do not possess nerves. Her tiny interventions disrupted the operation of the forces of tension and compression in the pattern formation without affecting the structural integrity of the wing itself. The eyespots then self-organized in new ways that were not due to genetic dictat and that were not heritable. The resulting butterflies appeared to enjoy entirely satisfactory lives.

Thompson's discussions of the eyespots triggered a notably rhapsodic footnote:

Delight in beauty is one of the pleasures of the imagination; there is no limit to its indulgence, and no end to the results which we may ascribe to its exercise. But as for the particular "standard of beauty" which the bird (for instance) admires and selects (as Darwin says in the Origin, p. 70, edit. 1884), we are very much in the dark, and we run the risk of arguing in a circle: for well nigh all we can safely say is what [Joseph] Addison says (in the

Figure 100. *"Nature?"*
Live *Bicyclus anynana*
butterfly with mod-
ified wing pattern,
Marta de Menezes,
2000

412th Spectator) later—that each different species "is most affected with the beauties of its own kind."

For Thompson the myriad splendors of decoration in nature go far beyond simple matters of sexual attraction.

MAKING CHEMICAL WAVES

The kind of rhythmical patterns produced by Liesegang remained largely curiosities until the 1970s, when the so-called BZ reaction became accepted as a significant phenomenon in chemistry. The reaction acquired its name from two Russian scientists. The first was Boris Belousov in the 1920s, who attempted to model the breakdown of glucose by enzymes. He observed that the resulting mixture did not settle progressively into a steady state but persisted in pulsing, manifesting repeated changes in color from clear to yellow and black, and back again. The second was Anatoly Zhabotinsky, who as a young scientist in the 1960s placed his predecessor's observations on a wider experimental basis. The illustrated reaction involves a mixture of sodium bromate, malonic acid, sulfuric acid, and ferroin.

Figure 101. *BZ*
Reaction, Antony Hall,
2007

The concentric rings arise from alternating periods of greater and lesser excitabil-
ity in the mixture, while the spirals are occasioned by perturbations that intro-
duce a kind of infectious variety into the system (fig. 101).

The patterns produced by BZ reactions in what are called "excitable medi-
ums" are now familiar enough in popular science, not least because they appear
to show chemistry acting as an art nouveau or art deco designer. I wonder if BZ
reactions were known to the contemporary human designer of the carpet of the
hotel in which I was staying in Charlottesville while delivering the Page-Barbour
lectures (fig. 102). It is probable that she or he was plugging more generally into
the wide category of natural formations (organic and inorganic) that adopt such
neatly compressed ripples and spirals. It is clear that certain images in science are
well placed to become popular when they carry such wide and visually appeal-
ing echoes. Nowadays the "natural magic" of such phenomena lends itself well
to videos on the Internet. The carpet has since been replaced in a campaign of
renovation.

That such chemically induced patterns have implications for morphology in the natural world was first seriously explored by Alan Turing, pioneer of artificial intelligence and brilliant wartime code breaker. In 1952 he published a paper called "The Chemical Basis of Morphogenesis," but it made few waves at the time. Turing argued that when reaction and diffusion were competing with each other in a fluid mixture there were certain conditions in which stationary and relatively stable patterns arose, caused by graded concentrations in the chemicals. Turing's paper is now much cited, not least as computer modeling techniques have become able to run his mathematical processes. I wonder, however, if it has been much read.

The first thing to say is that his paper is entirely concerned with mathematical models for the chemical processes that result in organized forms. The models are not tested in actual experiments, though later accounts of his ideas generally illustrate patterns arising from actual chemical processes. The mathematics may not be difficult for skilled mathematicians, but it is certainly taxing for most biologists. Turing consolingly says, "The relative degrees of difficulty of the various sections are believed to be as follows. Those who are unable to follow the points made in this section should only attempt §3, 4, 11, 12, 14 and part of §13. Those who can just understand this section should profit also from §7, 8, 9. The remainder, §5, 10, 13, will probably only be understood by those definitely trained as mathematicians." I read the whole paper but was relieved to reach the six sections he recommends for the mathematically challenged.

Figure 102. Carpet formerly in the hallway of the Marriott Courtyard Hotel, Charlottesville

Turing is modeling what he calls "morphogens," which are the active agents that directly produce forms: "The function of genes is presumed to be purely catalytic. They catalyze the production of other morphogens, which in turn may only

be catalysts. Eventually, presumably, the chain leads to some morphogens whose duties are not purely catalytic." For evidence of morphogens in biology, he looks to the developmental biologist Conrad Hal Waddington: "The evocators of Waddington provide a good example of morphogens. . . . These evocators diffusing into a tissue somehow persuade it to develop along different lines from those which would have been followed in its absence." Waddington was a professor at Edinburgh University and greatly respected Thompson. Waddington's *Organisers and Genes* (1940) and Thompson's *On Growth and Form* are conspicuous among the five references given by Turing at the end of his paper, though Turing's own prose never approaches the lucid elegance of his exemplars.

Among the dense formulas and equations, there is just one rather desultory illustration of what the resulting forms might look like—a series of irregular blobs forming a "dappled pattern." The biological examples are few, "because biological phenomena are usually very complicated." Turing is demonstrating the basic principles at work rather than trying to generate actual biological forms.

The biological example he cites most appositely is the hydra:

> Hydra is something like a sea-anemone but lives in fresh water and has from about five to ten tentacles. A part of a Hydra cut off from the rest will rearrange itself so as to form a complete new organism. At one stage of this proceeding the organism has reached the form of a tube open at the head end and closed at the other end. The external diameter is some-what greater at the head end than over the rest of the tube. The whole still has circular symmetry. . . .
>
> According to morphogen theory it is natural to suppose that reactions . . . take place in the widened head end, leading to a . . . breakdown of symmetry. . . . It is not unreasonable to suppose that this head region is the only one in which the chemical conditions are such as to give instability.

This instability around the unstable rim results in the protrusion of tentacles. The hydra, as a jelly cylinder with its ring of tentacles, was, unsurprisingly, one of the gelatinous marine organisms that Thompson had compared to a Worthington splash.

Figure 103. Whorl formation in *Acetabularia acetabulum*

stalk apex

cap

whorl of hairs

stalk

nucleus (2n)

whorl scar

1 cm

rhizoid

JUVENILE

ADULT

REPRODUCTIVE

Some of the potential that Turing envisaged for computer models of morphogenesis was realized by the late Brian Goodwin, who had studied with Waddington. Goodwin's classic piece of modeling involves the Mermaid's Cap (*Acetabularia*), which consists of a single cell but grows up to two inches long. Before it arrives at its mature form as an elegant parasol, it throws out a series of short-lived dendritic whorls (fig. 103).

Goodwin uses Turing's model of reaction diffusion to plot the way that raised concentrations of calcium act as a short-range activator for the cytoplasm, while the mechanical strain of the cell wall acts as an inhibitor. As the stem develops, its calcium gradient, peaking at the growing tip, becomes unstable, and the tip is transformed into an annulus. At points around the annulus further calcium peaks arise, and at the weakened spots in the cell wall a series of protrusions originate rather in the manner of the corona of a splash. The protrusions push outward, branching to create successive whorls.

Goodwin was increasingly positioned (by others and by himself) outside the

mainstream of developmental biology, in which theories of morphogenesis were dominated by genetics in alliance with hard Darwinism. From my stance outside professional biology, the opposition between the genetic and physicochemical explanations seems unnecessary. Processes determined by genes and proteins operate within the parameters of their own material natures and those in the immediate environment, while the self-organizing processes need the underlying template of the organic ensemble that is to be activated and the means to point it in a definite direction. We may recall Thompson's analogy of the potter. The directing agent (in this case the potter) has an idea of the shape for the pot that is to be thrown, while such physical parameters as the viscosity of the clay and the speed of the wheel are used by the potter to let the shape emerge in a sensuous process that may be described as "orchestrated self-organization."

DRIPPING AND SPLASHING INTO ART

When we turn to drips and splashes in art, it is obvious where to begin. Jackson Pollock stands supreme as the first artist who transformed the serendipitous behavior of liquid paint into the prime formative process in the making of a painting. Many earlier artists had exploited chance and the inherent behavior of paint to endow their works with painterly vitality, but not as their central technique. By 1946 Pollock was moving away from biomorphic forms—often dense and somewhat surreal in appearance—and was experimenting increasingly with overlaid tracks of paint dripped onto horizontal canvases from waving brushes and swinging cans (fig. 104).

It is interesting to discover that Pollock owned the 1945 edition of *On Growth and Form,* which contained an expanded section on "falling drops" and illustrated the corona splash in the later and overtly spectacular photograph by Edgerton. This final edition also included analysis of drops of fluid falling into other fluids of different viscosity. I am not suggesting that Thompson was responsible for Pollock starting to drip. Indeed he had exploited liquid paint before 1945. However I think it is evident that the biologist's discussion of the behavior of viscous fluids when falling fed into Pollock's new concept of how to make paintings that depended crucially on the properties of cohesion and flow in different kinds of paint. Accounts of Pollock in action speak of his trance-like state and dance-like motions as he became mentally and physically immersed in the nature of

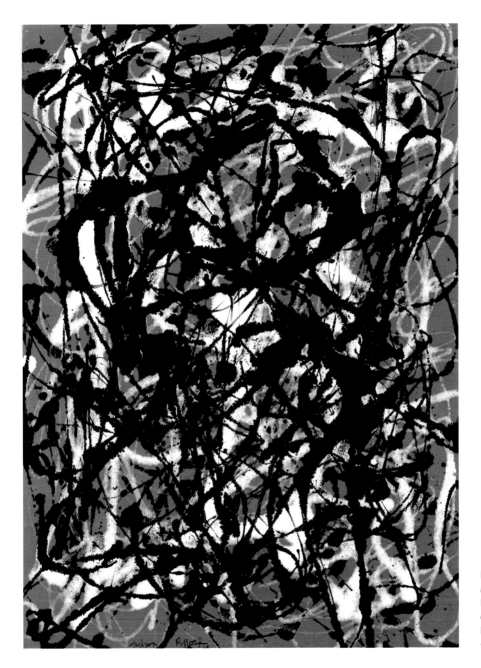

Figure 104. *Free Form*, Jackson Pollock, oil on canvas, 19¼ × 14 in/48.9 × 35.5 cm, 1946

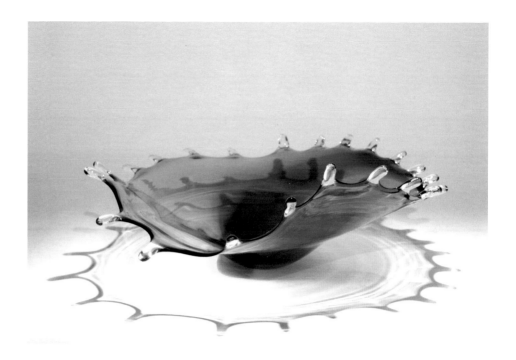

Figure 105.
"Kandinsky" spritz
bowl, Charlotte Sale,
2010

his materials and their behavior. They are intuitive exercises in creative viscosity. They also fall into the category of "orchestrated self-organization."

Thompson had suggested that blown glass and thrown pots are "neither more nor less than glorified splashes." Splashes and the material properties of glass come together beautifully in the clear splash bowls by Mark Bickers, and in the series of colored spritz bowls by Charlotte Sale (fig. 105). Bickers (whose work was facilitated by the National Endowment for Science, Technology and the Arts in Britain) and Sale have both seen how glass lends itself in transparency, sheen, and natural shapeliness to the classic form of the Worthington-Edgerton splash. The glass bowls are not literally formed by splashing, but they invite our recognition that they might well have been. While Bickers looks to industrial-scale fabrication, Sale's method is more craft based and exploits the inherent flow of heated glass. She begins by blowing a ball of colored glass, which is opened up to a cup shape. A trail of clear glass is drawn around the rim and then cut in such way as to leave protrusions. The bowl is then heated and spun, with the droplets forming

Figure 106. *Rainbow Splash*, Andy Goldsworthy, 1980

the shapes that they will. Each individual bowl bears witness to another process of "orchestrated self-organization."

The bowls by Bickers and Sale play to our intuitive sense of when material and form arrive at a harmonious union. They are consistent with the common trope that glass is a "super-cooled liquid"—though it is actually an amorphous solid that does not have a crystalline structure. When we look at their splashes, instinct and learning both come into play. The glass looks beguiling and appropriate in this shape, much as a jellyfish exhibits a kind of floral beauty in an aquarium, but our knowledge of the splash corona as revealed by high-speed photography is necessary for us to appreciate the source of the artists' inspiration and the reference they are making.

Perhaps the most literal exploitation of actual splashes by an artist occurs with some of the "Throws" by Andy Goldsworthy. As we have seen, his making of art

from natural materials relies on a varied interplay between structural order and unpredictable contingencies. Some works stand closer to one pole; some stand closer to the other. Close to the chaotic pole are photographed events in natural settings where Goldsworthy throws loose aggregates of material into the air or into water. The results are highly unpredictable but, like many chaotic phenomena, manifest a certain shapeliness. The clusters of stone and soil that he throws into rivers are very untidy versions of Worthington's laboratory splashes, scattered, fragmentary, and rhythmically jagged. Like Worthington's, their nature becomes fully apparent only through photography. While experimenting with cause and effect Goldsworthy observed that the finer of briefly suspended droplets acted in the sun to form an elusive rainbow. What is apparently one of the artist's slighter and most ephemeral works actually carries an important message: much like a scientist whose attention is productively captured by something that he or she was not originally looking at, the rainbow was glimpsed outside the immediate focus of Goldsworthy's attention. The rainbow then became the specific focus of a series of splashes. Regular beating of the skin of the water with a stick gave the best results (fig. 106).

Goldsworthy exploits high-quality still photography to "freeze" an unseen moment in the phenomenon in the Worthington manner. Other artists are turning to the relatively new medium of video to build the motion of water into their works. A particularly effective example is *Water Falls Down* by Matthew Dalziel and Louise Scullion. The video, running at a little under ten minutes, and with sound by Geir Jenssen, is constructed in three parts: the first shows a delicate sapling of isolated birch trembling during an insistent snowfall; the middle section shows a resistant upright boulder over and around which a torrent of water cascades in a Leonardesque manner (fig. 107); the final section concludes with a strange scene of people being baptized by immersion in the unwelcoming North Sea near the village of St. Combs in the northeast of Scotland. The whiteness of the snow, of the turbulence, and of the surging marine foam serves as a leitmotif. The formal fascination of the cascades, currents, turbulence, and waves is integral to the flow of emotions summoned up by each of the three "movements," much as in a string quartet that evokes the varied moods and rhythms of nature.

THE MUSIC OF WAVES

Musical analogies have been suggested in passing at various points in our meandering journey. When we look in more detail at waveforms in various media the analogies become more than attractive analogies; they positively signal shared behaviors between phenomena that are characterized by wave motion. In 1680 Robert Hooke observed the geometrical patterns that a layer of flour assumed on a glass plate when it was vibrated by drawing a violin bow across the edge of the glass. He had in effect made sound waves visible. His insight was developed systematically by the German physicist and musician Ernst Chladni in his *Discoveries in the Theory of Sound* in 1787. Chladni used a metal plate on which sand was sprinkled, agitating it like Hooke with a drawn bow. The sand aggregates on the

Figure 107. Still from the second section of the video *Water Falls Down*, Dalziel + Scullion, 2001

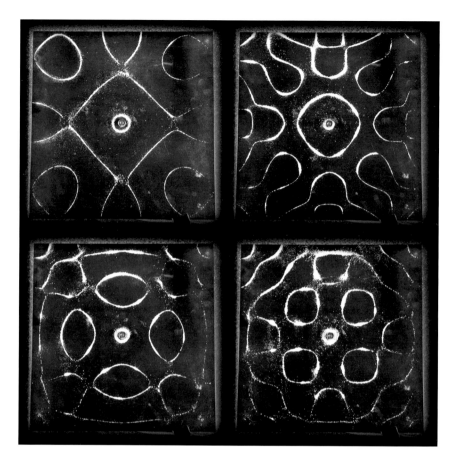

Figure 108. Chladni figures in a metal plate, fixed at the center and vibrated by a loudspeaker

stationary nodes between zones of the plate that are vibrating in opposite directions (fig. 108). The patterns vary captivatingly as the frequencies and amplitudes of the vibrations are changed.

Susan Derges, whom we previously encountered peering into an arching array of water droplets in chapter 3, worked her own variations on this theme in her video *Hermetica* in 1989, having produced her own Chladni figures. She has subsequently produced a series of beguiling photograms of intricate wave patterns in flowing and surging water. The title of the video refers to the Greek god Hermes (Mercury), given that mercury is the substance involved in her artistic experiment, and also to ancient Hermetic wisdom, including the magic of alchemy, to

STRUCTURAL INTUITIONS

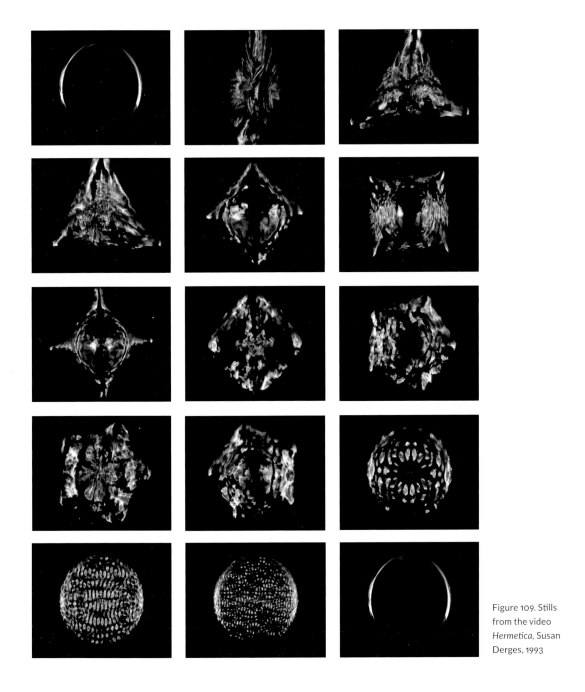

Figure 109. Stills
from the video
Hermetica, Susan
Derges, 1993

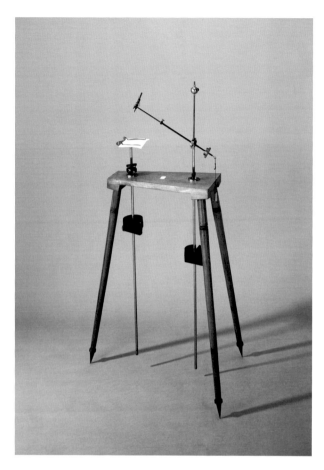

Figure 110.
Harmonograph

which she is much drawn. A still droplet of mercury begins by reflecting a video camera on its surface. It is then agitated by vibrations of rising frequency from a speaker, breaking into intricate dance patterns that move through alternating phases characterized by no obvious order and ones that tremble with symmetrical figures. Sound shapes the inorganic droplet into strangely organic geometries (fig. 109).

Perhaps the most notable and theoretically sophisticated of the nineteenth-century devices that arose in the wake of Chladni's manifestation of visible sound waves was the harmonograph, perfected by the Scottish mathematician Hugh Blackburn (fig. 110). It consists of two adjustable pendulums swinging at right angles to one another, one holding a pen, the other supporting a drawing surface. By varying the relative frequency and phases of the pendulums—which may be adjusted to musical intervals—a remarkable range of interwoven ellipses, spirals, and complex geometrical loops are automatically drawn by the mechanical draftsman as a form of visual music.

The harmonograph has provided a source of inspiration for Conrad Shawcross in a sculpture commissioned for the foyer of the Sadler Building in Oxford Science Park. Shawcross devised his own harmonograph machine and set the pendulums to achieve a ratio of 9 : 8—the frequency of the musical interval of a major second and corresponding to the note D in the Pythagorean scale (fig. 111). Whereas the paper in a normal harmonograph is fixed to the plate over which the pen moves, Shawcross pulled a roll of paper across the swinging plate to create the figure of

STRUCTURAL INTUITIONS

a long oscillation that tapers away, as if into silence. The resulting figure was translated by computer into a three-dimensional form, and fabricated as a massive aluminum vortex, which hangs from wires attached at critical balance points. While it originates with a single, archetypal note, the sculpture has a continually changing "visual sound." As the spectator moves within the foyer, successive degrees of order and disorder appear and disappear. Only from the bridge crossing at first-floor level do its main symmetries become fully evident.

TWO PUBLIC SPIRALS

Spirals featured prominently in chapter 2 and again with Leonardo at the beginning of this chapter. Spiral waveforms have otherwise made less of an impression during the course of this chapter than many readers might have expected. I decided here to concentrate on less familiar aspects of waves, ripples, and splashes. However, I would like to finish with two spirals, one from art and the

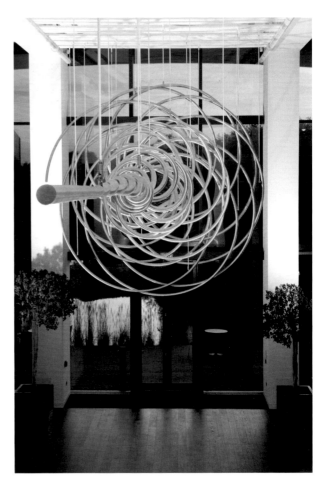

Figure 111. *Fraction (9:8)*, Conrad Shawcross, Oxford Science Park, Sadler Building

other from astronomy, which will suffice to stand for the many that have arisen in artistically flavored science and scientifically inclined art.

The work of art is by the land artist Chris Drury, *Carbon Sink: What Goes Around Comes Around*. I have chosen this not least because it shows that an engaging work of visual art can have a potency (in part unexpected) even in a world weary of art shocks. The shock in this case is not the kind of shallow art world sensation with which we are familiar, but erupted within a vicious political-cum-financial arena of censorship.

Figure 112. *Carbon Sink*, Chris Drury, University of Wyoming, 2012 (destroyed)

Drury has consistently explored the presence of the spiral in nature's dynamic and static processes in diverse geographic locations, ranging from whirling winds in the snowfields in the Antarctic to reed beds in Sussex, and across a wide range of micro–macrocosmic scales, from the patterns of blood flow in the heart to ridged formations of earth that snake across a Yorkshire valley. He has also been consistently alert to environmental issues. *Carbon Sink*—the name refers to a reservoir that can absorb and retain carbon for an indefinite time—takes its form from the gurgling helix that forms in a body of water when it revolves around a hole in the bottom of its container, as we all recognize in our baths and showers (fig. 112). The work was commissioned by the University of Wyoming and financed by a private donation as part of the sculpture program of the university's art museum in 2012. The incurving ridges of the vortex are pine logs obtained from trees killed by the pine beetle. The logs closer to the center are charred by fire. Between the cylin-

STRUCTURAL INTUITIONS

drical limbs of the wooden whirlpool are shiny rows of black coal, dipping into a dark void at the center. Drury explains,

> Both these materials were once living trees and died during times of climate warming. At this time the burning of fossils fuels is giving rise to warmer winters in the Rockies, as a result the pine beetles survive the winters, and the forests in the Rockies are dying from New Mexico to British Columbia—a catastrophic event. Wyoming is rich in both coal and oil. . . . Everyone in the State benefits from the taxes levied on the coal and oil companies, including the University of Wyoming. At the same time Children born now will never know what a wild Mountain Forest looks like, and there will be fires and erosion in the mountains which will [a]ffect all living things.

Given controversies about climate change and fossil fuels, Drury was of course well aware that his work was entering a political territory. He claimed that he was inviting people to think. This is fair, inasmuch as a work of art of this kind cannot make a statement. It serves, as we emphasized in chapter 2, as a field for interpretation. It is only a work of art, however thoughtful, not a declaration of public policy on behalf of the university. It would, for instance, be possible to argue that it optimistically implies that carbon sinks will solve the problem of atmospheric pollution caused by burning fossil fuels.

In the event, *Carbon Sink* became the center of the kind of opportunistic storm in which politicians exercise self-righteous bluster for their own ends. The first hostile blow was struck by the Republican majority leader in the state legislature, Tom Lubnau. He seized the opportunity presented by the sculpture to "educate some of the folks at the University of Wyoming about where their paychecks come from." He then threatened to introduce legislation "to avoid any hypocrisy at UW by insuring that no fossil fuel derived tax dollars find their way into the University of Wyoming funding stream." The executive director of the Wyoming Mining Association, Martin Loomis, singing from same "Big Coal" hymn sheet, reminded the university that it receives "millions of dollars in royalties from oil, gas, and coal to run the university, and then they put up a monument *attacking me* and demonizing the industry" (my italics). His e-mails to the university were blunt. "What kind of crap is this?" Loomis asked the university's director for gov-

ernmental and community affairs. During the controversy, a journalist provoca-tively accorded a subtitle to the sculpture, "What Comes Around Goes Around." Within a year, the university had succumbed to the strident threats, destroying *Carbon Sink,* claiming that it had suffered water damage.

What the story of Drury's sculpture serves to remind us—in a book that it is not primarily concerned with the social and political contexts in which art and science occur—is that human creations are not just obedient products of the social factors behind their making but active players in the shaping of those con-texts. In some cases that active role becomes overt in a way that the artist could not have expected.

The scientific spiral I have chosen comes from "Big Science," which necessar-ily operates in large political and financial contexts. Major astronomy has always been expensive. In the era of Tycho Brahe and Johannes Kepler, around 1600, substantial aristocratic or state patronage was needed to support extensive pro-grams of observation with large and precise instruments. Kepler's great polyhe-dral model of the universe, which we encountered in chapter 1 (fig. 12), was to be realized as a magnificent piece of courtly clockwork, and the folding plate on which it was depicted is conspicuously dedicated to the Duke of Württemberg. In our era, the largest-scale programs are run by state or international agencies and would on the face of it seem to be insulated from the need to ingratiate them-selves with patrons using seductive visual means. In reality, the major agencies like NASA go to considerable trouble to translate scientific data into compelling public images (fig. 113). They employ specialists in computer graphics to create a form of space art that can best be described as "the cosmic sublime." The Hubble Space Telescope prominently brandishes its "gallery" on its home page, and fea-tures "an ever-changing slide show of Hubble's finest and most popular images." These images play an important public role in helping to justify the astronomical expense of the programs.

Among the most spectacular of the Hubble artifacts are the dazzling images of spiral and ring galaxies, a number of which feature in the "Hubble Heritage Proj-ect." A recent, particularly spectacular example, christened the "Rose," has been released to the public at a timely moment. The account begins,

In celebration of the 21st anniversary of the Hubble Space Telescope's deployment into space, astronomers at the Space Telescope Science Institute in Baltimore, Md., pointed Hubble's eye to an especially photogenic group of interacting galaxies called Arp 273. The larger of the spiral galaxies, known as UGC 1810, has a disk that is tidally distorted into a rose-like shape by the gravitational tidal pull of the companion galaxy below it, known as UGC 1813. A swath of blue jewels across the top is the combined light from clusters of intensely bright and hot young blue stars. These massive stars glow fiercely in ultraviolet light.

Figure 113. The Arp 273 galaxies as "seen" by the Hubble Space Telescope, 2013

The idea that Hubble's eye can be turned to "see" such cosmic visions is appealing, but its mode of obtaining data or "sense impressions" (some from outside the visual spectrum) and realizing it in visual form involves complicated technological recording and digital processes that are fundamentally different from the optically based procedures involved in human visual perception and representation. The resulting images of Hubble's observations encode data as color, a process that involves complex compounds of convention and our perception of color on flat planes.

All aspects of the scintillating spiral of Arp 273 as assembled by its graphic maker—its color, texture, implied depth, its definition against the background, and the starburst highlights—have been creatively enhanced for their descriptive potency and also for the way they evoke our awe. It comes as something of a disappointment (to me at least) to find that Arp 273 has been named after the astronomer, Halton, not the sculptor, Hans, whose works are characterized by a wonderfully sinuous geometry.

The scales of time and dimension are beyond enormous. In the imaginative hands of John Dubinski, the Canadian astronomer and visualizer, these scales are compressed within a series of wonderfully seductive and suggestive animations (fig. 114). He uses "supercomputer simulations of realistic model galaxies to illustrate these slow and majestic dynamical processes on an accessible timescale and so breathe life into the iconic images of galaxies created by the world's great telescopes." He is creating a new kind of music of the spheres, not only from past and current events but also from predicted events some billions of years into the future.

In the case of the illustrated example, he explains the huge complexity of the technical processes and visual choices in creating the simulation:

> Our home galaxy, the Milky Way, is predicted to collide with the nearby Andromeda galaxy in 3 billion years. The two galaxies were bound to each other at birth but after receding from one another in the expanding universe, gravity took hold and so they are now falling towards each other on a collision course as confirmed by recent observations. The image depicts the two galaxies at a time shortly after the point of closest approach some 3 billion years from now. The Milky Way is the smaller system containing about

half as many stars as Andromeda. Gravitational tidal forces distort the two galaxies as they pass one another, exciting spiral forms and flinging out long tails of stars. Within a few billion years after this passage, the two galaxies will fall back together and coalesce, transforming into a single elliptical galaxy.

This event was simulated using more than 300 million particles to represent the stars and dark matter making up the two galaxies. The particles are initially arranged in spinning disks and bulges to represent the stars and spheroids to represent the dark matter, following configurations constrained by the observed properties of the Milky Way and Andromeda. A supercomputer is used to compute the Newtonian gravitational force on each particle from the evolving system, and the resulting orbital trajectories are found by solving Newton's equations of motion. The beautiful spiral forms are the result of the collective behaviour of gravity acting on the large systems of stars distributed within two differentially rotating disks. The image only

Figure 114. The Milky Way collides with the Andromeda galaxy, John Dubinski

shows the stars of the two systems with the older inner disk and bulge stars coloured red as they are in nature and the younger outer disk stars coloured blue.

The reason why some galaxies manifest such brilliant spiral arms is a matter of active debate in astronomy, and different types of galaxies are shaped by varied factors, including massive collisions of the kind we see in Dubinski's projection. A possible explanation for one of the types of spiral arm is given by "spiral density wave theory" as proposed by Chia Chiao Lin and Frank Shu in 1964. This envisages that the spiral element in a galaxy is revolving at a different speed from the disk in which it is embedded. The spiral arms correspond to regions of the disk that are denser, progressing around the galaxy more slowly than the individual stars and the interstellar gas and dust.

What may be happening is explained via an analogy that has achieved classic status. We are asked to consider what happens when a lorry is lumbering slowly down a dual carriageway. As cars moving at various higher speeds pull out to pass the lorry, a slow jam of cars accumulates beside and behind it. Once they have passed the lorry, the faster vehicles spread out again and resume their higher speeds. Although a succession of different cars are involved, the position and nature of the jam remain stable in relation to the lorry. The density wave in a spiral galaxy may be regarded as a jam of this kind, formed as the stars and interstellar material work their way in to and out of the slower and denser regions in the spiral arm. The compression at the point of the "traffic jam" in the arms results in the formation of stars, the brightest of which have a short lifetime but serve from our point of view to define the course of the arms. A nice analogy.

It is not my intention here to endorse the spiral density wave theory, and certainly not to give anything like an adequate account of the complex and controversial physics of the diverse galaxies—which I am certainly not competent to do—but, as a historian, to draw out continuities in the modes of intuitive visualization that recur in art and science across the whole range of scales and across the whole period in which art and science have engaged with natural processes. It is telling with respect to these recurrent modes of modeling that the visionary physicist and cosmologist Lee Smolin has turned to Turing's reaction-diffusion systems to account for spiral galaxies.

As always, the newly seen or unseeable is subject to modeling in terms of things that fall within our visual compass and which we think we understand. We respond to underlying patterns similar to those with which we are already familiar. Analogies, metaphors, and models are used to render the unknown in imagery that we are able to grasp. These processes of visualization abound at every stage in our visual and mental processes, from the very first intuitions that articulate what we can see to the final acts of communication through which professional artists and expert scientists translate their work into the public domain. Creative artists and scientists are in effect great virtuosos of faculties that we all possess by evolutionary necessity and tend to take for granted.

5

Rhetorics of the Real
Taking It on Trust

I should say at the outset that I am not using the term *rhetoric* negatively to imply that an account, visual or verbal, is false or inflated, but to indicate that it deploys particular strategies of persuasion in making its point or points. We now tend to talk about "empty rhetoric" to dismiss an argument. But for Aristotle, as for the later Roman authors on oratory, Cicero and Quintilian, rhetoric as the *ars bene dicendi* (the art of expounding well) was "the faculty of discovering in any particular case all of the available means of persuasion." For Cicero it dealt with the true and the plausible. I am here using it to refer to techniques of persuasion, not to validity of content.

It is also worth saying how the issues of visual rhetorics and trust relate to the concept of structural intuitions, inasmuch as they might seem to belong to rather different cognitive fields. To be fully effective, rhetorical devices rely heavily on particular types of structural intuition, serving to direct our attention to features in an image that we have a propensity to understand and trust in terms of visual conviction and consistency within a given context. At the end of the preceding

chapter I stressed that the unknown is mastered via the familiar. Effective visual rhetoric feeds the perceptual and representational basics that artists and scientists have perfected over the years to trigger our recognition of key elements in a representation that convince us of their reality and structural coherence.

STRANGE BUT REAL

The duck-billed platypus (*Ornithorhynchus anatinus*) is a strange animal, specific to Australia and unknown to naturalists before the late eighteenth century. It is a bit like a beaver but has a snout that appears to belong to a duck. How many of us have seen one? I do not recall having seen a living example, although I have been to Australia. I am reasonably sure that it exists. In lectures I have asked whether anyone has seen a duck-billed platypus. The great majority have not, but only one person has been prepared to doubt its existence—and that person was just being smart.

Does our belief in the creature's existence place us in a superior position to someone in the sixteenth century who was convinced that unicorns could be found roaming some remote portion of the habitable earth (generally said to be India)? For the platypus we may cite "reliable" books and journals with photographs and various moving images of the living animal. Our biology teacher, who has certified expertise, has told us about it. We may have seen a stuffed specimen in a museum, perhaps displayed with its family in a naturalistic diorama. Perhaps we know someone who has seen one. We certainly have a massive aggregation of what we take to be trustworthy testimony about the platypus, but the *principle* of believing what we have *not* seen is essentially the same as the trust that a sixteenth-century reader placed in Conrad Gesner's great volumes of animals, which illustrate a sprightly and handsome unicorn (fig. 115).

The great majority of our knowledge, whether we are a research scientist, a bricklayer, or a politician, comes to us via sources we trust. We simply cannot check the original source of every item of knowledge that is transmitted to us— for obvious practical reasons. We trust some received knowledge more confidently than others, on the basis of various criteria. The foremost of these is our judgment about the authority of the source. This criterion has always provided the ground base for all branches of knowledge, including history and the sciences. Gesner placed particular emphasis on the quality of his sources, informing the reader accordingly. Today, evaluating a source's authority is as urgently relevant as it has ever been, given the proliferation of visually convincing rubbish on the Internet, but there is little enough education in how to evaluate critically websites that present material with apparent authority and conviction. This is a topic to which we will return at the end of this chapter.

Perhaps the next most important criterion is the consistency of the knowledge with a belief system in which large amounts of wisdom all lock together to reinforce each other. We will see this at work when we look at the unicorn. There are also more personal factors, like knowing someone who testifies with unshakable conviction about the truth of something they have witnessed. Convincing representations play a major role. If an illustration breathes an air of apparent naturalism, especially in more recent times when it looks as if it is the product of photography, we are predisposed to suspend any disbelief that we might have harbored. The collective visual qualities that serve to inculcate trust make up the rhetoric of

reality. Voluminous arrays of authoritative charts, graphs, and tables of data serve to create a matching "rhetoric of irrefutable precision." This second kind of rhetoric lies outside our present scope.

Ideally of course we should strive to be our own eyewitness and check all data on those occasions where it is both possible and of high priority. This is the aspiration of the scientist who sets up an experiment, either to confirm a hypothesis or to verify someone else's results, or the historian who undertakes a direct scrutiny of an original document, unpublished or published by another. We expect that the nature of the resulting account will verbally and visually deploy communicative means that convey the eyewitness quality and precision of the expert's experience. These rhetorics have evolved over time. In the past someone recording nature might have said, "I have seen this many times." Or less directly, "I have been told this by a trustworthy witness." Now we are informed more drily that "it has been observed that . . ." This is not to say, however, that we can trust either what a highly responsible witness tells us or what we see on our own account.

This lesson was taught to me by an outstanding biology teacher, Dennis Clarke, at Windsor Grammar School. We had dissected various animals. Next came rats, a much-favored animal for experiments. During the course of our cutting and probing as tyros of dissection, he asked us to find the rat's gallbladder. After a decent interval he inquired about our success. A small cluster of hands were raised, mine included. "That's a strange thing," he said. "Rats don't have a gallbladder." The moral is that we strive (and often succeed) to see what we are looking for even when it is not there. We could see the form of a gallbladder where none existed.

All these various factors behind witnessing and trust come into vivid play in the first published account of that most improbable Australian mammal with a beak. Its first authoritative describer, George Shaw, bears witness not just to the platypus but to every aspect of the actual process of witnessing that experts conduct on our behalf. Shaw, educated in medicine at Oxford, was assistant keeper at the Natural History Museum in London when he published his account of the platypus in volume 10 of his journal, the *Naturalist's Miscellany,* in 1799, and subsequently in the first volume of his *General Zoology: Or, Systematic Natural History* in 1800. Shaw's account provides a splendidly transparent demonstration of the strategies that a judicious eyewitness account increasingly needed to deploy to

be taken seriously in Britain and in the international community of empirically minded scientists around 1800.

What Shaw knew was the complete skin of a platypus. It has often been assumed that his specimen was that sent to Britain by the keen naturalist Captain John Hunter, governor of New South Wales and an associate of Joseph Banks. Whatever Hunter's rather unhappy travails as governor of what was still in part a penal colony, he was in the eyes of naturalists well established as a serious witness of Australia's strange fauna. Hunter made his own rather disproportioned drawing of a platypus, published in 1802 in the second edition of David Collins's *An Account of the English Colony in New South Wales,* as "an amphibious animal of the mole kind." Hunter had sent his first specimen to the Newcastle Literary and Philosophical Society, one of the substantial regional organizations devoted to the frontiers of science, technology, and humane learning. He was an honorary member of the Newcastle Lit & Phil. He also sent them a pickled wombat. The wombat has survived in the Hancock Museum in Newcastle, but the platypus has disappeared. It is best known in a woodcut by Thomas Bewick in 1805, who provides a lively lay description.

> The platypus is about the size of a small Cat, it chiefly frequents the banks of the lakes; its bill is very similar to that of a Duck, and it probably feeds in muddy places in the same way; its eyes are very small; it has four short legs; the fore legs are shorter than those of the hind, and their webs spread considerably beyond the claws, which enables it to swim with great ease; the hind legs are also webbed, and the claws are long and sharp. They are frequently seen on the surface of the water, where they blow like a turtle: their tail is thick, short and very fat.

The example known to Shaw was not that sent to the Lit & Phil but came from a less reliable source. It was brought to England in October 1798 by an unnamed naval officer who had acquired it along with some other specimens from another officer, who in turn had obtained it from a "serjeant." Shaw himself did not outline this shaky provenance. It was no doubt with some relief that he was able to record in the amplified account he produced for his *General Zoology* that two further specimens had been "very lately sent over from New Holland [Australia] by

Governor Hunter, to Sir Joseph Banks." The pedigree of specimens was important. Other platypuses had seemingly arrived in Britain before the one described by Shaw, but they did not have better pedigrees than the many confected monsters that arrived from exotic places. The examples with dubious provenances tended not to warrant serious attention. Although Shaw does not inform us of the uncertain origins of his first specimen, he goes on to tell us reassuringly that the skin he inspected is in the safe hands of "Mr. Dobson, so much distinguished by his exquisite manner of preparing specimens of vegetable anatomy."

Shaw prudently "entertained suspicions" when confronted with the first specimen. He was well aware that there had been a centuries-old trade in skillfully assembled prodigies of nature, including a lively market for dead mermaids that supplemented the income of enterprising Chinese fishermen. To be duped by a faker would seriously undermine the reputation he had carefully constructed for himself. His first account conveys his tempered excitement at the new discovery:

> Of all the Mammalia yet known it seems the most extraordinary in its confirmation; exhibiting the perfect resemblance of the beak of a Duck engrafted on the head of a quadruped. So accurate in the similitude that, at first view, it naturally exhibits the idea of some deceptive preparation by artificial means: the very epidermis, proportion, serratures, manner of opening, and other particulars of the beak of a shoveler, or other broad-billed species of duck, presenting themselves to the view: nor is it without the most minute and rigid examination that we can persuade ourselves of its being the real beak or snout of a quadruped. . . . A degree of skepticism is not only pardonable, but laudable; and I ought perhaps to acknowledge that I almost doubt the testimony of my own eyes with respect to the structure of this animal's beak; yet must confess that I can perceive no appearance of any deceptive preparation; . . . nor can the most accurate examination of expert anatomists discover any deception in this particular.

The detailed account that follows is a masterly piece of sober and measured description. It is laced with technical terms that serve to underline his status as an expert. I am giving excerpts here:

The body is depressed, and has some resemblance to that of an Otter in miniature: it is covered with a very thick, soft, and beaver-like fur, and is of a moderately dark brown above, and of a subferuginous white beneath. . . . The mouth or snout, as before observed, so exactly resembles that of some broad-billed species of duck that it might be mistaken for such: round the base is a flat, circular membrane, somewhat deeper or wider below than above; viz. below near the fifth of an inch, and above about an eighth. The tail . . . is about three inches in length: its color is similar to that of the body. The length of the whole animal from the tip of the beak to that of the tail is thirteen inches: of the beak an inch and half. The legs are very short, terminating in a broad web, which on the fore-feet extends to a considerable distance beyond the claws; but on the hind-feet reaches no farther than the roots of the claws. . . . The internal edges of the under mandible, (which is narrower than the upper) are serrated or channelled with numerous striae, as in a duck's bill. The nostrils are small and round, and are situated about a quarter of an inch from the tip of the bill, and are about the eighth of an inch distant from each other. . . . The ears or auditory foramina are placed about half an inch beyond the eyes. . . . the eyes, or at least the parts allotted to the animal for some kind of vision . . . are probably like those of Moles, and some other animals of that tribe; or perhaps even more subcutaneous; the whole apparent diameter of the cavity in which they were placed not exceeding the tenth of an inch.

This description provides the foundation for a nice piece of analysis that intuits the habits of the animal: "When we consider the general form of this animal, and particularly its bill and webbed feet, we shall readily perceive that it must be a resident in watery situations; that it has the habits of digging or burrowing in the banks of rivers, or under ground; and that its food consists of aquatic plants and animals."

The descriptive language used, most notably the biological terminology that would be recognized by his professional colleagues or professionally minded "amateurs," coupled with the evidence of very careful measurements, is crucial to the rhetoric of reality deployed by Shaw.

Illustrations lay at the very center of this strategy. He included a good recon-

struction of the appearance of the complete animal (fig. 116), together with plates
of the feet and snout of the platypus as separate specimens "of their Natural size"
to enhance our ability to undertake a detailed and objective scrutiny of the strange
creature (fig. 117). Indeed, the full title of the periodical (which he had himself
initiated) was the *Naturalist's Miscellany; Or, Coloured figures of Natural Objects
Drawn and Described Immediately from Nature*. The plates were produced for
the *Miscellany* by his close collaborator Frederick Nodder, who was one of those
entrusted with the illustrations in Banks's great botanical project the *Florilegium*.
Illustrations lay at the heart of the enterprise, since a good picture encourages us
to become surrogate eyewitnesses. The veridical naturalism to which the growing
band of British professional illustrators aspired had earlier been expressed in its
most doctrinaire form by the anatomical illustrations commissioned by William
and John Hunter, as we will see.

The other major string in Shaw's set of strategic bows was the Linnaean system
of classification, which was by then more or less de rigueur for a serious zoolo-
gist or botanist. Assigning a new organism a binomial handle and a place in the
great scientific system of nature was crucial. Shaw named it the *Platypus anatinus,*
"Flat-foot, bird-snouted," and assigned it to its due place: "The animal exhibited
on the present plate constitutes a new and singular genus, which, in the Linnaean

arrangement of Quadrupeds, should be placed in the order *Bruta,* and should stand next to the genus Myrmecophaga [the Anteaters]." Its modern Latin name is *Ornithorhynchus anatinus,* that is, belonging to the genus "bird snout" and the species "duck-like." Other members of the genus are known only in the fossil record. Classification is an ancient structural art, reliant upon our propensity to group "things of a kind" in tabular arrays.

It is in the nature of such unexpected discoveries that unanimous acceptance is never forthcoming, not least in the rival worlds of other authorities on animals. Forgery is suspected. Something similar happens with the attribution of newly discovered works to major artists. However, in the case of the duck-billed creature, further specimens, dissections, and illustrations quite rapidly transferred the platypus from the realm of unicorns and mermaids into the territories of trust upon which naturalistic representation and description depend. Nevertheless, it remains a wondrous and improbable beast. For Shaw it verified "in a most striking manner the observation of Buffon; vizs. that whatever was possible for Nature to produce has actually been produced." And in the bizarre world of Internet fringe science it has served the purposes of those who argue that life on earth is a manifestation of alien interventions. Although to most of us the central findings of modern biology are as plain as the nose on one's face, there is no saying to what ends visual knowledge produced by sober witnesses might be devoted by those who do not consent to our normative bodies of shared assumptions.

Figure 117. Beak and feet of the duck-billed platypus, illustrated by Frederick Nodder, in George Shaw, *The Naturalist's Miscellany,* vol. 10 (1799)

[The unicorn's] eye happened to fall upon Alice: he turned round instantly, and stood for some time looking at her with an air of the deepest disgust.

"What—is—this?" he said at last.

"This is a child!" Haigha replied eagerly, coming in front of Alice to introduce her, and spreading both his hands towards her in an Anglo-Saxon attitude. "We only found it to-day. It's large as life, and twice as natural!"

"I always thought they were fabulous monsters!" said the Unicorn. "Is it alive?"

—LEWIS CARROLL, *Through the Looking-Glass*

Historically, we have little more than two centuries of witnesses to certify the existence of the platypus. For the unicorn we have almost two millennia of elaborate descriptions. There was a long textual tradition, beginning with those ancient books that paraded the wonders of the natural world. Numerous accounts bore witness to the existence of a one-horned quadruped that resembled in bodily form a horse or goat. In Pliny's highly influential *Natural History* we read in book 8 of "a very fierce animal called the monoceros which has the head of the stag, the feet of the elephant, and the tail of the boar, while the rest of the body is like that of the horse; it makes a deep lowing noise, and has a single black horn, which projects from the middle of its forehead, two cubits [about three feet] in length." There may be elements here derived from accounts of the Indian rhinoceros. The detailed and vivid description of Pliny's unicorn, compounded from parts of animals known to us, clearly exploits the rhetoric of reality—that is to say, a series of reinforcing verbal and visual signs that convey the impression of something having been witnessed firsthand. Pliny's account of the creature's voice and the color of its horn offers two such signs. Its existence was potently underlined by at least eight appearances in the Old Testament of the Bible, as a *unicornis* in the Latin Vulgate or "unicorn" in the King James edition.

The unicorn became progressively locked into an elaborate and self-reinforcing belief system that ran across theology, literature, heraldry, medicine, and natural science. The legends of the unicorn as developed in antiquity and the Middle Ages, above all in the collection of natural history tales in the *Physiologus* (Bestiary), the earliest version of which was written in Greek, characterize the elegant *monoceros* as indomitable in combat and wholly elusive when hunted. Only a virgin can captivate and then capture a unicorn on behalf of the frustrated hunters.

The stories in the Bestiary were specifically cast as moral tales, and the associations of the virgin with Mary and the unicorn with Christ were unsurprisingly taken up by those who promoted readings of the book of nature in Christian terms. More widely, in the context of courtly symbolism the hunt of the unicorn served as a picturesque tale in which the unicorn came to stand for a chaste beloved. Two great and incredibly luxuriant sets of late fifteenth-century tapestries survive in the Musée de Cluny and the Metropolitan Museum in New York, the former a set of six telling the story of the unicorn and lady via the five senses, and the latter comprising seven narratives that depict the hunt, eventual capture, and captivity of the virtuous animal. The perceived character of the unicorn explains its regular use as a heraldic beast, most notably as paired with the regal lion as a supporter of the coats of arms of successive monarchs of England and Scotland after the uniting of the crowns.

We should not forget that literally tangible evidence of the unicorn's existence was available in the form of its twisted and tapering horn (actually the tusk of the narwhal), which became a prized exhibit in collections of curiosities. In the inventory of the Medici Palace in Florence in 1492, a horn is massively valued at 6,000 florins. The most expensive painting, by Fra Angelico, is estimated at only 100.

In the Renaissance and in the era of the printed book, the textual accounts and symbolic renderings of the unicorn were reinforced by increasing numbers of convincingly naturalistic and detailed depictions. We find pretty exemplars among the varied animals in Bosch's *Garden of Earthly Delights* and in Cranach's *Paradise*. Its name, like those of the other animals, was assigned by Adam. A pair of unicorns is regularly seen boarding Noah's Ark in sixteenth- and seventeenth-century pictures of the story of the biblical Flood. Not being able to see a living specimen did not hinder a skilled artist from parading his skills in naturalistic depiction. The visual tricks at the command of a skilled Renaissance artist served as a double-edged sword, as well adapted to giving visual conviction to images of the false as the true. Leonardo's rapid sketch of a prim virgin pointing to the unicorn whom she has tethered with a collar and leash portrays an animal that is easier to accept as real than a contemporary representation of a giraffe (fig. 118). His drawing dates from the later 1470s, during his earliest period in Florence, and he is likely to have known the prized horn in the Medicean inventory. Leonardo's

composition was probably devised for a decorative object produced in honor of one of the young ladies in the Medicean circle.

Not only was the horn an exotic rarity, but it was also highly valued for its medicinal virtues, particularly in its powdered form as an antidote to poisons. It was said that the unicorn in the wild would dip its horn into fetid and undrinkable water to render it pure. It is shown performing this charitable role in Bosch's *Garden,* and Leonardo again provides a succinct sketch of the legend (fig. 119). His

supple unicorn, conjured up in a few deft strokes of the pen, is no less convincing than his beautifully observed studies of cats interacting with children.

In his great compilation of the universal knowledge of animals the Swiss naturalist Conrad Gesner deals at considerable length with the often inconsistent accounts of the unicorn over the ages and with apparent regional variations, but his single synoptic illustration of the monoceros in 1551 serves to endow it with a clear pictorial reality that was imitated in many later volumes (fig. 115). Always keen to seek verifying evidence, Gesner tells us that he could not confirm the medicinal or magical properties of the horn, since even the powdered version was far too expensive for his budget.

Figure 119. A unicorn purifying a pool of water, Leonardo da Vinci, ca. 1481

In other of the great printed books that illustrate wonders of the animal kingdom in the sixteenth and seventeenth centuries we often find more than a single type of unicorn. This is at least in part because of the diverse accounts of its appearance and habits in the earlier sources, including Pliny. In his *Discours de la licorne* in 1582 the French royal surgeon Ambroise Paré expressed concerns similar to those of Gesner about the reliability of the available information, but was not prepared to conclude that the beast was chimerical. In the first edition of Bernhard von Breydenbach's popular *Peregrinatio in Terram Sanctam* (Journeys to the Holy Land), Erhard Reuwich provided an illustration of a single unicorn in company with other exotic beasts, but in later editions we are presented with three types of single-horned, horsey creatures. By the time of Pierre Pomet's *Histoire générale des drogues* (General History of Drugs) in 1694, no less than five types of unicorn are paraded for our inspection, including the aquatic camphur with

Figure 120. Five unicorns, from Pierre Pomet, *Histoire générale des drogues*, 1694

its webbed rear feet (like the platypus) and the twin-horned pirassoipi (fig. 120). Such subtle if imaginary taxonomies of unicorns in books by reputable authorities served nicely to certify each authority's extensive knowledge.

It is unsurprising to find a "unicorn horn" in the assemblage of wondrous things in Ole Worm's compendious Danish Museum, occupying much of the width of the third shelf from the bottom on the end wall, above boxes of shells and accompanied by metal and mineral specimens (fig. 121). More surprisingly, in the printed account of his *Museum Wormianum* published in 1655 (after his death), the antiquarian and philosopher decisively identified his horn as the tusk of a narwhal. This sobering note did little, however, to diminish belief in the existence of the animal as a whole.

Careful observers were not ready to write off the unicorn definitely, even as late as the mid-nineteenth century. Francis Galton, Charles Darwin's cousin, wrote to his mother from Walfish Bay (in current Namibia) on 8 December 1851 that "all the Bushmen assure me that the unicorn is found here. I really begin to believe in the existence of the beast, as reports of the animal have been received in many parts of Africa, frequently in the North." He had reported earlier in the same letter on the hunting of rhinos, which provided massive bodies of visual evidence about at least one exotic beast with a single horn.

We may think our age knows better. But what are we to make of an advertisement for the circus of Ringling Bros. and Barnum & Bailey that invites us to "see

for yourself the living unicorn!" (fig. 122). Since P. T. Barnum had risen to fame through his American Museum in New York, a huge metropolitan version of a *Wunderkammer* that exhibited such wonders as a mermaid, we may suspect fakery. When we see an apparently trustworthy photograph of a goat-like unicorn with a kid sharing the front page of the *New York Post* on 17 April 1985 with a "framed" rapist, we may begin to harbor doubts on our own account (fig. 123). An inside page explains that two poseurs with the "stage" names of Otter G'Zelle and Morning Glory were creating unicorns by transferring horn buds of young goats onto the center of their forehead. Timothy Zell (aka "Otter G'") later founded the Church of All Worlds and the Grey School of Wizardry. The successful grafts are

Figure 121. Ole Worm's Museum, frontispiece from *Musei Wormiani Historia*, Leiden, 1655

in defiance of Baron Cuvier's assertion that a central horn was impossible because it would have to grow from the junction between the frontal bones of the skull. In fact horns do not sprout from bones but arise within the flesh, fusing with the underlying bones in due course. However, horns do not arise naturally in such a way that they attach themselves to the edge of bones. Cuvier was both wrong and right. The horns of rhinos are compounded from the keratin that is found in hair, while the tusk of a narwhal (*Monodon monoceros*) is a radically redirected tooth.

However, in the final analysis, no one can assert with *absolute* certainty that the unicorn does not exist. As they say, absence of evidence is not evidence of absence. Hope springs eternal, as it does with the Abominable Snowman and the Loch Ness Monster. Needless to say, the Internet is not lacking sites set up by enthusiasts who are more than happy to fill the vacuum. It is not hard to find notably convincing "photographs" of elegant unicorns in romantic landscapes and of corpses in decorative wooden boxes. At the time of writing the available video evidence is less than compelling.

1515
RHINOCERVS

THE REAL MONOCEROS

In the inscription above the compelling woodcut of a rhinoceros by Albrecht
Dürer, the artist tells us that he is showing us its "gestalt" (shape) (fig. 124).

> After Christ's birth, the year of 1513 [actually 1515] on the day of 1 May, there
> was brought from India to the great and powerful king Emanuel of Portugal
> at Lisbon a live animal with the name rhinoceros. His shape is here repre-
> sented. It has the colour of a speckled tortoise and it is covered with thick
> scales. It is like an elephant in size, but lower on its legs and almost invulner-
> able. It has a strong sharp horn on its nose which it sharpens on stones. The
> stupid animal is the elephant's deadly enemy. The elephant is very frightened
> of it as, when they meet, it runs with its head down between its front legs and
> gores the stomach of the elephant and throttles it, and the elephant cannot
> fend it off. Because the animal is so well armed, there is nothing that the ele-
> phant can do to it. It is also said that the rhinoceros is fast, lively and cunning.

Figure 124.
Rhinoceros, Albrecht
Dürer, woodcut, 1515

Figure 125. *Rhinoceros*, Hans Burgkmair, woodcut, 1515

The unfortunate beast, drowned in a shipwreck when it was being sent on to Rome, had originally been presented to Afonso de Albuquerque, the governor of Portuguese India, by the ruler of Gujarat, Sultan Muzafar II. The governor then transported the rhino in a spice ship on the arduous journey to Lisbon, where it was given to Dom Manuel I, the king of Portugal. The king in turn saw it as the ultimate diplomatic gift for Pope Leo X. Before its fatal dispatch, Dom Manuel tested the account of the enmity of the rhino and elephant as recounted in Pliny's *Natural History* and faithfully recorded in Dürer's inscription. In the event, the elephant fled and no combat ensued.

It is clear that Dürer, who was in Nuremberg, never saw the creature alive or dead. He had access to a letter describing the rhino and a sketch of some kind. His German contemporary Hans Burgkmair, in Augsburg, also made a woodcut in the same year, producing a more sober likeness, and indicating that the rhino's front feet were tethered (fig. 125). Burgkmair must have gained access to similar sources as those available to Dürer. Burgkmair's rhino, for all its estimable qualities, was eclipsed.

In any event, Dürer portrays the rhinoceros as the ultimate quadruped fighting vehicle, equipped with mighty armor and fearsome weapons. Its pointed and scaly horn is augmented by a smaller spiral spike on the shield at the top of its shoulders. The leathery folds of the Indian rhino's skin, often very pronounced

STRUCTURAL INTUITIONS

in life, have been further exaggerated
to assume the character of late medi-
eval plate armor, as depicted by Dürer
in his famous engraving *Knight, Death
and the Devil* a year earlier. In Germany
the Indian rhino is still called a *Pan-
zernashorn,* from the word *panzer* for
armor. To complement its frightening
character, the rhino's small eye has the
air of malign sadness that marks the
melancholic temperament in which
Dürer was so interested. Well might the
elephant be afraid.

The conviction of Dürer's draftsman-
ship in depicting the rhino's mighty
carapace is fully supported by the
brilliant graphic detail with which he
describes its surface marking and inter-
nal textures. The eyelet patterns on its
ribbed side and armored shoulders are
conjured up using dots, dashes, and
denser hatching of a kind that speak of
something really seen by the eyes of the
artist. They are comparable to the light

Figure 126.
St. Jerome, detail,
Albrecht Dürer,
engraving, 1514

effects on the wall in his 1514 engraving of St. Jerome as the sun passes through
the bull's-eye windows (fig. 126). The clever details in the *Rhinoceros* provide a
vivid demonstration that representational techniques developed to serve observed
effects can readily be deployed independently of direct observation. They become
rhetorical devices.

Dürer's visual persuasiveness was such that his image served as the rhinoceros's
true likeness even when further animals became available in Europe. It seemed
to embody the very nature of rhinocericity. It became more real than the real
thing. Its persistence can be traced in successive books of animals, not least via

The Figure of the Chameleon.

627

Afrca produceth the *Chameleon*, yet is it more frequent in *India*: he is in shape and greatnesse like a Lizard, but that his legs are strait and higher, his soles are joined to the belly as in Fish, and his back standeth up after the same manner, his nose stands out not much unlike a Swines, his tail is long, and endeth sharp, and he foldeth it up in a round, like a Serpent, his nails are crooked, his pace slow, like as the Tortois, his body rough, he never shuts his eyes, neither doth he look about by the moving of the apple, but by the turning of the whole eye. The nature of the colour is very wonderfull, for he changeth it now and then in his eyes and tail, and whole body beside, and he always assimilates that which is neerest to, unlesse it be red or white. His skin is very thin, and his body clear, therefore the one of these two, either the colour of the neighbouring things in so great subtilty of his clear skin, easily shines as in a glass, or else various humours diversly stirred up in him, according to the variety of his affections, represent divers colours in his skin, as a Turky-cock doth in those fleshy excrescences under his throat, and under his head; he is pale when he is dead. *Matthiolus* writes that the right eye taken from a living Chameleon takes away the white spots which are about the thorny coat of the eye; his body being beaten, and mixed with Goats milk, and rubbed upon any part, fetcheth off hairs; his gall discusseth the Cataracts of the eye.

The strange nature of the Chameleon

CHAP. XIII.
Of Celestial Monsters.

its appearance as a full-page image in the highly authoritative encyclopedia by Gesner. It was natural that when Ambroise Paré wanted a vivid depiction for his book *Des Monstres et prodiges* (On Monsters and Marvels) in 1573 he should annex Dürer's image, via Gesner—here illustrated in an English edition of Paré's collected works (fig. 127). His text is based on the account by Pliny that Dürer quoted in his text. Paré shared the widespread belief that the advent of a natural prodigy was intended by God to signify a moral message or exceptional event. Others were the product of malignant forces in nature and arose as the result of some kind of devilish action. The book of nature always contains messages for the alert student of its myriad creatures.

Looking at Paré's rhino on the same double-page spread as a woodcut of a chameleon, it is likely that the lizard-like creature would have seemed somewhat more plausible to Paré's English readers. However, the reader might well think

Figure 127. Rhinoceros and chameleon, Ambroise Paré, from *The Works of That Famous Chirurgeon Ambose Parey*, translated by Thomas Johnson, London, 1678

STRUCTURAL INTUITIONS

Il gran Rinoceronte qui si vede,
 Dall' Africa condotto in sto contorno,
Petrus Longhi cive et pinze. quadra Filo in.

C della Bolsa Smisurata in sede,
 Del suo naso cornuto eccovi il corno.
 Aipi Wiene Vol.EEEE.

that the artist has made a mistake with the chameleon's feet, but the detail of its fused "fingers" in opposing sets of three and two is actually well characterized. On the other hand the chameleon's dome-like eyes, which can orbit independently as Paré notes, are depicted as standard eye shapes that are more believable than the actual domed eyes would have been.

The extent to which Dürer's rhino worked better than the animal itself to convey the essence of its perceived character from a human standpoint can be effectively demonstrated by its regular use in the posters to advertise the Europe-wide tours of Clara, the female Indian rhinoceros, between 1741 and her death in London in 1758. Clara had been adopted as an orphan by the director of the East India Company and passed into the hands of Douwe Mout van der Meer, who sailed with her to Rotterdam in the ship he captained. Her exhibition to the Dutch public caused a sensation—and provided sufficient income for the sea cap-

Figure 128. Clara the Rhinoceros and spectators in Venice, Pietro Longhi, etching, 1751

tain to change profession into a showman. Clara became more widely traveled than any European diplomat, visiting Germany, Austria, Switzerland, Poland, France, Italy, Bohemia, Denmark, and England after her initial exposure in the Netherlands. She visited a number of the countries more than once. Douwe Mout was not shy of using printed images based directly on Dürer to advertise his charge and to provide souvenirs, even though there were measurable discrepancies between printed expectation and Clara's flesh-and-blood reality, particularly after she lost her horn—a condition recorded in a painting and print by Pietro Longhi in Venice in 1751 (fig. 128). Looking at Longhi's Venetians in carnival garb, we might well echo Lewis Carroll's implied question of who looks strange in whose eyes. A "ringmaster" with a goad stick or whip brandishes Clara's detached horn as a necessary part of the rhetoric of show, declaring, "From its horned nose, here is the horn"—as the inscription records.

At the same time that Dürer's characterization continued to exercise its spell, Jean-Baptiste Oudry in Paris in 1749 achieved a different kind of rhetoric of reality by portraying Clara in her horned glory and at full life-size (fig. 129). This is one of a series of magnificent animal paintings produced by this greatest of all animal painters for Duke Christian Ludwig II of Mecklenburg-Schwerin, mainly based on specimens in the Royal Menagerie in the French capital. Now restored to something like its original magnificence, after being damaged and rolled up, Oudry's huge painting somehow manages to resist the gravitational pull of Dürer—although we may wonder whether Clara's horn was ever as elegantly curved and burnished as it looks here. It certainly looks more modest in Oudry's drawing. To portray something life-size, as William Hunter did with the spectacularly pictorial engravings in his *Gravid Uterus* in 1774, particularly when it is not the most practical thing to do, is to go to one particular extreme in the rhetoric of reality. John James Audubon was to do this in the 1820s with his monumental colored prints of American birds. There are very definite limits of practicability. We may recall the *amplificatio ab absurdam* in Lewis Carroll's *Silvie and Bruno Concluded* in 1893. The unnamed narrator is informed by the enigmatic "Mein Herr," a mysterious alien visitor, that his "Nation"

"actually made a map of the country, on the scale of a mile to the mile!"
 "Have you used it much?" I enquired.

"It has never been spread out, yet," said Mein Herr: "the farmers objected: they said it would cover the whole country, and shut out the sunlight! So we now use the country itself, as its own map, and I assure you it does nearly as well."

The quest for "objectivity" has been characterized as a predominantly nineteenth-century endeavor, fueled by new technologies such as photography, but the aspiration itself was clearly apparent in the Renaissance, as we have seen, and flourished with particular vigor within the current of empiricism in eighteenth-century science.

Oudry was just one of many artists, including George Stubbs in England, who succeeded in asserting Enlightenment empiricism over the tradition of serial borrowing, and Dürer's image progressively lost its grip in natural history. But it has not lost its aura. Like Leonardo's *Last Supper* it remains iconic and sits firmly in our memory bank of visual images. It is very much *the* rhino. Visiting a wildlife park with my grandchildren, I still feel a tinge of disappointment with the real thing—which is I suppose wondrous enough but still does not quite shape up to my acquired imagination.

Alongside the great succession of printed books of familiar and exotic fauna from the sixteenth century onward, there ran a comparable and impressive series of florilegia. The particular driver behind the plant books was the tradition of herbals in which the medicinal uses of plants endowed them with a human significance beyond that possessed by most animals. The tone had been set by the *De materia medica* by Dioscorides in the first century AD, which became the standard text for centuries and was widely provided with illustrations of diverse types and quality.

The Renaissance story of the plates in the printed volumes looks straightforward enough, and has been told many times. The schematic woodcut illustrations in the earliest herbals were succeeded by increasingly lifelike "portraits" of the plants in a way that conveyed far more information about their appearance, and therefore better served the purposes of identification. Thus it seems obvious if we look at the vivid illustration of one of the varieties of bugloss or borage by Hans Weiditz in Otto Brunfels's *Herbarum Vivae Eicones* in 1530 (fig. 130) that it is far more lifelike and informative than the schematic image in the early *Garten der Gesuntheit* (Garden of Health) in 1485, shown here in an image from a half-size reprint (fig. 131), only five months after its first publication. Weiditz, a pupil of Dürer's, used his artistic accomplishments to provide a picturesque sense of the appearance of the real-life plant with its creased leaves and wrinkled flowers.

When we then turn to one of the borages in what became the great classic herbal, Leonhart Fuchs's *De Historia Stirpium* in 1542 (fig. 132), we are presented with a rather different kind of conviction. The naturalistic touches are there, to be sure, such as the folding of some of the leaves, but the main features of the bugloss are presented with a linear clarity that makes such key features as the configuration of the flower head readily apparent. It is clear that this is less of a pictorial portrait of how the plant looks to the artist and more of a demonstration of the whole and parts of the plant within a naturalistic framework. In fact if we look back to the illustration in Brunfels's book we have to work hard to extract those general characteristics that would allow us to identify it in the field. There is, as we will see, a case for arguing that the kind of schematization in the early herbals served the purpose of identification better than the more complex naturalistic images. Since borage was renowned as an antidote to melancholy, it was good to know that the herbalist possessed criteria through which it could be reliably recognized.

Notwithstanding what must have been careful control of the demonstration by the botanist himself, Fuchs certifies the *direct* transposition of nature in his plates by the inclusion at the end of the book of portraits of those responsible—the "picturers of the work" (fig. 133). We see Albrecht Meyer on the right drawing a cut flower from life, while Heinrich Füllmaurer transposes the image onto the wood block that is to be "carved" by Veit Rudolf Speckle, whom Fuchs stresses is "by far the best engraver in Strasbourg." It is interesting that the "artist" (as we would now characterize Meyer) is not given priority over the "craftsmen." There is, however, no doubting who is the great master of the enterprise. Fuchs himself is portrayed in sumptuous full length—"at the age of 41"—immediately after the title page (fig. 134). Like Vesalius, he was well aware of his status as the hero of his own enterprise. Unrelenting observation by a professional observer was becoming a heroic activity. The notably individualized portraits of the four men responsible for the magnificent book underscore the fact that we are presented with true portraits of the plants. Brunfels had similarly claimed in his title that his "images" were taken "from life"—*vivae eicones*. Both Brunfels and Fuchs could fairly mount the same claim. What the divergences in their illustrations show is that it depends on what aspect of "life" is to be prioritized in the necessarily selective business of depiction.

Figure 130. Bugloss, by Hans Weiditz, from Otto Brunfels, *Herbarum Vivae Eicones*, Strasburg, 1530

Figure 131. Bugloss, from Johannes von Cuba, *Garten der Gesundheit*, Augsburg, 1485

Figure 132. Bugloss, from Leonhart Fuchs, *De Historia Stirpium Commentarii Insignes*, Basel, 1542

Figure 133. "Picturers of the work," from *De Historia Stirpium*

Figure 134. Portrait of Leonhart Fuchs, from *De Historia Stirpium*

The issue of how naturalism is pitched in relation to the conveying of detailed information is generally more pressing in the depiction of plants than in the representation of animals. There are many types of plants that look quite similar, whereas animals for the most part fall into relatively demarcated categories. Moreover, the use of plants for medicinal purposes meant that correct identification of the appropriate specimen might be a matter of life or death.

The portrayal of chimerical plants is of less moment in botanical illustration than in the pantheon of monstrous animals. There was a limited tradition of fantastical plants, not least because plants lent themselves less readily to picturesque tales of their behaviors. A rooted plant was of necessity less elusive than the swift

unicorn. Also, specimens from overseas were more readily obtained and transported than exotic beasts. There were however some notable plant legends, not least in the case of the mandrake (*Mandragora*), a plant of renowned potency as a drug and the roots of which were supposed to manifest a humanoid form. The magical plant gave its name to a play, *La Mandragola,* by Niccolò Machiavelli, which was first performed in 1518. During the course of a notably tangled plot, the reputed properties of the plant were exploited to persuade a virtuous wife to sleep with an eager young man, since her husband had not managed to impregnate her with the desired heir.

Such were the mandrake's human characteristics that it was supposed to scream when its roots were dragged from the soil. The great French engraver Abraham Bosse, who taught the geometrical art of perspective at the Académie des Beaux-Arts, provided a convincingly naturalistic etching of the plant's root in the form of a woman's abdomen, pudenda, and thighs for the French Royal Academy of Science's grand encyclopedia of plants (fig. 135). Given Bosse's skill, we may be inclined to believe our eyes, even though earlier illustrations had already shown the plant with thick but normal roots, often with two main branches. If we look at his illustration in one of the best of the expensive, hand-colored copies, the sense of the real thing is even more vivid.

Was Bosse simply lying? He made the by now standard claim that his depiction was *au naturel*. I suspect that he had obtained a plant whose roots had adopted something of this formation, much as potatoes and parsnips can sometimes assume bizarre shapes suggestive of an animal or human form. The Science

Figure 135. Mandrake with humanoid root, Abraham Bosse, from *Histoire des Plantes*, or *Les Plantes du Roi*, 1668–99, Paris

Museum in London possesses a mandrake root that does just this (fig. 136). It may well be that Bosse has given his specimen a certain degree of graphic help in making it conform to a female homunculus. In any event, the possible resemblance of the roots of the plant to the human form can hardly serve as a reliable way of identifying this or any other plant.

It may indeed not be the profusion of convincing visual detail, such as the surface textures and hairiness of the roots, that serves best to identify the plant in question. Identity is a matter of matching the specimen to hand with the set of key taxonomic characteristics that signify whether it is this or that plant. When I was studying botany at school, I was given *A Handbook of British Flowering Plants* by Melderis and Bangerter, published in 1955. As it happens, the viper's bugloss is one of the flowers featured in the frontispiece. The text and illustrations that follow distinguish more reliably than the early printed herbals between the types of bugloss (*Lycopsis* and *Echium*) and members of the large borage family (including *Borago*). The temptation when trying to identify a new plant was to leaf rapidly through the pictorial illustrations hoping to chance across a matching picture.

Figure 136. Humanoid mandrake root

After a number of hit-and-miss searches, I learned from experience that it was far better to use the "recognition key" at the start of the handbook. This took the reader systematically through various characteristics such as "basic leaf forms" (fig. 137) accompanied by schematic illustrations that were deliberately free of pictorial grace notes. The text explains that "although the groups are artificial [i.e., not corresponding to Linnaean taxonomy] they form an easy guide by which the plants may first be classified according to some striking characters so that the search for the family name is made considerably easier." Having narrowed down the field of potential identifications, the user then had to enter the more

finely grained distinctions in the texts devoted to species within each of the families. The drawings of the leaf types graphically share more in common with the schemata in the early printed herbals than with the naturalistic depictions of Weiditz.

Which type of illustration might we consider to be more real? The answer involves defining "real" in relation to the criteria we are deploying. If our functional criterion of matching the illustration to reality is the leaf form and other morphological features, the schematic outlines do the job well. If we want a plant that looks "real" in the naturalistic sense, as a portrait of a whole specimen, we obviously need to look at the elaborate renderings in one of the botanical picture books. Such was the main market for botanical books during the sixteenth, seventeenth, and eighteenth centuries that the illustrations needed to be pictorially engaging and beautiful. A book with many illustrations was expensive to produce and stood at the luxury end of the printed book trade, particularly in the case of the very costly hand-colored copies.

Figure 137. Basic leaf forms, from Alexander Melderis and Edward Bangerter, *A Handbook of British Flowering Plants*, London, 1955

The move away from the picture book began in the eighteenth century with Linnaeus, who preferred to see the illustrations to his text look like the actual specimens in the field or in a botanical garden—mirroring an argument that was sometimes made in anatomical science, namely that the thing itself was the only reliable and workable illustration, as "Mein Herr's" mapmakers discovered. In the nineteenth century, as we will see with anatomy, the professionalizing of the sciences through the founding of dedicated official bodies responsible for systematic instruction led to a need for less expensive books that conveyed knowledge in a manner that was more concerned with efficacy than style. Books began to be aimed at students rather than aristocrats. The era of the official textbook was arriving.

The other great territory of naturalistic illustration from the Renaissance onward was anatomy. The tradition of great picture books reflects a comparable transition from highly elaborated naturalism—with many pictorial cues to tell us that we are looking at a surrogate for the real thing—to a more functional representation of what is essential for the prime purpose of the illustration in a given communicative context. However, the schematic never came to play a primary role in the representations of bodies and organs, even though diagrammatic illustration was certainly present as an undercurrent in various ways.

The first and in many ways definitive anatomical picture book, Andreas Vesalius's *De Humani Corporis Fabrica* in 1543, combines a Roman-style heroism with a naturalistic rhetoric of reality drawn directly from the northern European tradition, of which Dürer is a supreme representative. This dual heritage corresponds to his origins in Brussels and his role as professor in Padua at the famous university. The characterization of the man's physique in Vesalius's remarkable series of "muscle men" recalls the heroic bodies of ancient sculpture that were emulated in the major centers of innovation in Italian Renaissance art, of which Padua was one. In the most dramatic of the muscle men (fig. 138), with the dissected man's diaphragm pinned on the wall to his left, Vesalius's stark anatomical striptease in a stony landscape declares his heroic engagement with self-revelation. This is in keeping with the ancient sibylline tag *Nosce te ipsum*—"know thyself"—which was used as a recurrent justification for human dissection. It is also consistent with the tone of the illustration of a mourning skeleton, which is accompanied by the ancient tag *Vivitur ingenio, caetera mortis erunt*—"genius lives on, all the rest will perish"—which asserts the immodest tone of the anatomist's great enterprise. Vesalius the "genius" even outdoes Fuchs in including two portraits of himself at the start of the book, one of which shows him in action in the anatomy theater.

The draftsman employed by Vesalius, Jan Stefan van Kalkar (or Calcar), had worked in the Venetian *bottega* (workshop) of Titian, who was fully alert to the grandeur of ancient Rome. As his name suggests, Jan Stefan (or Stephan or Steven) came from the northern town of Kalkar, near the Germany-Holland border, and he was brought up in an environment in which leading Netherlandish artists were already adopting key aspects of the Italian style. On the other hand, the gruesome meatiness of the muscle men is fully in keeping with earlier anatom-

Figure 138. "Seventh muscle man," Jan Stefan van Kalkar, from Andreas Vesalius's *De Humani Corporis Fabrica*, Basel, 1543

Figure 139. Tools
for dissection and
a vivisection board,
Jan Stefan van
Kalkar, from Andreas
Vesalius's *De Humani
Corporis Fabrica*,
Basel, 1543

ical illustration in Germany. Vesalius himself is keen to underline the reality of his presentation of the butchered corpse when he explains directly to us in his text that the dissected man has been suspended by a rope under the back of his skull that passes through his eye sockets in order to show features of deeper structures in the neck.

As a great dissector, Vesalius is shown on the title page of the *Fabrica* with a knife in his hand rather than sitting in the professorial high chair in a supervisory role. He further underscores the hands-on reality of what he is presenting by an unsettling display of his tools (fig. 139). These make up an assemblage of instruments far from the specialized and often elegant equipment we associate with later surgeons. They are laid out on and in some cases stabbed into a stout board equipped with rings around its edges. Another illustration tells us that this a vivisection board to which pigs would be tethered, in emulation of Galen, the great Roman anatomist of the first century AD. Again, the rhetorics of realism and the ancient ideal are acting in concert.

The rhetorical mode of representation that overtly declaims its reality runs as a continuous thread through anatomical illustration over four centuries, sometimes erupting in extreme forms. The most conspicuous representatives in the seventeenth century are the magnificent pictures provided by Gherard (or Gérard) de Lairesse for Govert (or Gottfried) Bidloo's *Anatomia Humani Corporis* in 1685. The large copper plates of dissected organs openly display the wooden blocks that

204

STRUCTURAL INTUITIONS

are used to support dissected organs, the tools of dissection, pins that stretch out the specimens for our scrutiny, and even in one instance the intrusion of the hand of a demonstrator holding back the brain to show the forms beneath. The refined graphic technique conveys an overt sense of the actual and fresh substance of the flesh and fat (fig. 140).

Bidloo came from a prominent family of Mennonites, and there are aspects of his faith that are consistent with the visual character of his treatise. Mennonites, particularly the Anabaptists, emphasized the bodily suffering of the great succession of martyrs, as recounted in the *Martyr's Mirror*. The account of the death of St. Mark is typically vivid: "In the eighth year of Nero . . . the heathen priests and the whole populace seized him, and with hooks and ropes which they fastened around his body, dragged him out of the congregation, through the streets and out of the city; so that his flesh everywhere adhered to the stones, and his blood was poured out upon the earth, until he, with the last words of our Saviour, committed his spirit into the hands of the Lord, and expired."

Figure 140. Dissection of the abdomen, Gherard de Lairesse, from Govert Bidloo's *Anatomia Humani Corporis*, 1685

The Mennonites were deeply suspicious of sensuous and diverting decoration. A corresponding emphasis on ungilded reality suffuses Bidloo's plates. He declared that he was after the perfect truth of something taken "from life." There is a special feeling for the actuality of dismembered bodies. In the illustrated dissection of the abdomen, the meaty reality of the dissecting room is stressed by the

presence of a pestiferous fly crawling across the edge of the cloth over the corpse's left thigh. This touch of trompe l'oeil realism was sanctioned by antique precedents as precisely the kind of trick that Pliny records in ancient art. It is worth remembering that Gherard de Lairesse was known as the "Dutch Poussin" for his mastery of the classicizing, academic style rather than painting the genre scenes more usually associated with Dutch art. The union of naturalism and the antique is again sustained.

The supreme example in the eighteenth century is William Hunter's magisterial *Anatomia Uteri Humani Gravidi* (*The Anatomy of the Human Gravid Uterus*) in 1774. As a keen collector of art and the foundation professor of anatomy at the Royal Academy of Arts in London, Hunter was well positioned to recruit high-level artists to participate in his lavish enterprise to depict the pregnant uterus in life-size plates (fig. 141). He was also well equipped to articulate the role of naturalistic representation. He was alert to the two poles in anatomical illustration, asking in his preface whether we should strive to produce "a simple portrait in which the object is represented exactly as it is seen," or should we favor "the representation of the object under such circumstances as were not actually seen, but conceived in the imagination." In the latter case, the illustrator can "exhibit in one view, what could only be seen in several objects." As a committed empiricist, Hunter was convinced that the only nonarbitrary way to proceed was to show what was actually visible in the actual specimen before the eye of the illustrator, rather than artificially synthesizing. Shiny and matte surfaces are carefully differentiated in the virtuoso prints. Hunter's dedication to the seen thing went so far that in one plate he showed a damp membrane reflecting the glass panes in one of the windows of his Windmill Street dissection room. The presentation of his great plates, in their whole demeanor and in their detailed parts, is designed to assert the reliable presence of the woman's abdomen for our scrutiny—although a good deal of visual tidying up has been accomplished to lend a certain elegance to a book that was designed to be sold on subscription to rich patrons.

A nice indication of Hunter's unshakable faith in naturalistic representation lies in his employment of George Stubbs, who also produced a compelling painting of a rhinoceros for William's brother John Hunter, which is among the items from John's collection that survive in the Royal College of Surgeons. William was much interested in contemporary controversies about extinction, not least in

TAB II *Conspectus viscerum abdominalium a latere dextro, partibus continentibus Thoracis, et Hypochondria ac maxima omento parte sublatis.*

relation to the large fossil bones of what was known as the "Irish Elk," a massive prehistoric deer (*Megaloceros giganteus*) whose remains were being discovered in Irish peat bogs. Its antlers were of astonishing size. When the Duke of Richmond imported a young bull moose from Canada in 1770, Hunter dispatched Stubbs to capture its likeness, which helped confirm that the Irish remains were not those of the kind of moose that still existed (fig. 142). Three years later, when the Duke imported another living specimen, Hunter took Stubbs's painting with him to compare the two examples, one in a "portrait" and the other in the flesh. As Hunter said, "Good paintings give much clearer ideas than descriptions."

Even with such declaredly naturalistic images that flaunted their visual empiricism, a series of pictorial devices are deployed to disarm our skepticism, to enhance the informational content of the image, and to establish an appropriate psychological framework. The viewer's connivance is not only solicited but utterly necessary if the painting is to do its job. In the case of the moose, the infor-

Figure 141. Superficial view of the uterus of a pregnant woman, Jan van Rymsdyk, for William Hunter's *Anatomia Uteri Humani Gravidi* (*The Anatomy of the Human Gravid Uterus*), 1774

Figure 142. *Young Bull Moose*, George Stubbs, 1770

mational content is enhanced by the display of an adult moose's antlers on the ground, and unless we realize that this is the case we will, like one art historian, be inclined to think that the animal is gloomily contemplating its own fallen antlers. The background of a precipitous hill and moody sky is in one sense irrelevant, but it is important in setting up our relationship to the prime subject. Stubbs supplies a grand and stirring environment that evokes the inherent drama of wild nature. The context for that drama was shifting as scientists like Hunter were beginning to contemplate the possibility of serial extinctions of mighty creatures from the prehistoric past. Rhetorics of reality tend to be complex and multilayered if they are to be fully effective in their past and present contexts.

The detailed naturalism exploited by Hunter did not fade away in the nineteenth century, and its descriptive role was eventually taken over by photography, but the era of the functional textbook for medical students in the mid-nineteenth century brought with it a distinctively different visual vocabulary. The new style is what I have called the "non-style"—that is to say, one that is consciously plain and eschews the elaborately seductive pictorialism of the great picture books. The book that decisively declared the new mode of illustration, as decisively as Vesalius had established the pictorial mode in the Renaissance, was Henry Gray's *Anatomy: Descriptive and Surgical,* with its 363 "drawings by H. V. [Vandyke] Carter, late Demonstrator of Anatomy at St. George's Hos-

Figure 143. Anatomy of the neck with the external carotoid artery, Henry Gray's *Anatomy: Descriptive and Surgical*, ed. T. Pickering Pick, 1887

pital." It first appeared in a fat but unpretentious quarto volume in 1858, bound in matter-of-fact brown cloth. Not least, it was relatively affordable. The extreme sobriety of Gray's text is matched by the unadorned directness of Carter's woodcuts. There is no elegant picture of a complete body, only sober delineations of the parts in woodcut lines that vary little in their descriptive role. In the edition by T. Pickering Pick in 1887, a limited amount of functional color was allowed to temper the visual restraint (fig. 143). The labeling of the components directly on the illustration knowingly adds to its functionality while offending traditional elegance. The air of Gray's *Anatomy* is functional, professional, institutional, and educational, much like my later botanical textbook. The mode is still naturalistic in the broad sense, but most of the stylish rhetorics of the earlier books have been cast off.

As we come to the end of the formal chapters, a vivid way of summing up how the structures of images function in particular contexts of communication is to look at the schematic signs that are used to designate men's and women's toilets around the world. They demonstrate that conveying the "real" by some kind of process of matching is not as simple as the use of some general kind of "photographic" likeness. The range of resemblance in portraying the human figure in different contexts extends from a functional schema—like the merest indications of head, body, arm, and legs in the manner of a child's rudimentary drawing—to the high elaborations of face, body, and costume in an eighteenth-century portrait. In this I draw continued inspiration from Ernst Gombrich's *Art and Illusion,* first published in 1960. His presence stalks a number of themes in this book and is particularly evident in this chapter.

In the Mori Tower in Tokyo (housing the Mori Art Museum on its lofty fifty-second and fifty-third floors), men and women are guided to their designated toilets by representations that are about as stripped down as they could be (fig. 144). The man consists of a dot for a head with two vertical bars for both his body and legs, and a crossbar for his shoulders. The bar that signifies his shoulders is moved down to denote the woman's hemline. There are obvious stereotypes at work here—men with wide shoulders and women wearing skirts or dresses (what about Scottish men who wear kilts?)—but as with all effective stereotypes or topoi they rely upon a certain general consent as to what is typical.

In a restaurant in London, the Vietnamese Bahn Mi Bay, the schemas are even more extraordinary and center upon posture, not on morphology and costume (fig. 145). The basic figures consist of the round dot and single bar, which do not serve to differentiate one from the other. Rather, the woman is shown sitting or squatting in a compressed S-bend, obviously from the side, while the man thrusts the middle of his body forward. We know that the thrust is forward, since his dot-head is off center and is by implication looking downward. The differentiation is here accomplished through the different poses associated with men and woman urinating, though the schemas beg the question of what men do when they defecate.

It is possible to imagine that the Mori signs could function individually as legible representations. They exhibit minimal resemblance and may retain some mea-

Figure 144. Women's and men's signs, toilets at the Mori Art Museum, Tokyo

sure of legibility outside their functional context—our binary choice of the right type of toilet. However, it is more difficult to see how the restaurant logos could, given their recourse to highly site-specific action, convey a coherent impression of the human figure outside their setting and the viewers' search for cues that direct them through one door rather than the other.

The physical and perceptual structures involved in the toilet signs are far simpler than most we have encountered during the course of the book, with the prime exception of the geometrical bodies with which we began. However, they rely upon the kind of structural intuitions we have been tracking throughout. In this case the key and shared structure is that the human head is a round kind of thing set on top of an upright kind of thing. It is clear that we are particularly adept at seeing simple schemas as bodies or facial features, as is the case with the "smiley" image and the "emoticons" that are popular signals of feelings in text messaging. The matching is nonarbitrary if extremely constrained.

Such schematic figures have quite extensive uses, beyond being exploited for toilet signs. When I was in the Army Cadet Corps at school we were instructed how to judge the range of a target by the relative legibility of standing human figures at progressively greater distances (particularly when concealed ground eliminated most other clues). I recall the existence of a calibrated scale based on decreasing levels of detail, in which peripheral features such as hands, feet, legs, and arms progressively disappear, until all that is discernible is a thin wedge shape. This corresponds to what Leonardo called "the perspective of disappearance." That we can still recognize this wedge shape as a distant human figure in a landscape, on a road, or at the top of hill is a notably complex task, relying upon an interacting set of perceptual cues and memory.

What we are equipped to do, to an awesome degree, is to extract those structures in what we see that make best sense in their contexts and in the context of our immediate interests. The gravitational pull is toward the simplest patterns that do the job that is needed. The operative contexts are those of the thing seen and the demands we make on what we see—whether that thing is made by nature or made by art.

Figure 145. Women's and men's signs, toilets at the Bahn Mi Bay restaurant, London

Afterword

The obvious question to raise after exploring the various interrelated themes in the five chapters via a series of wide-ranging samples is, what does all this tell us about the relationship between science and art?

My answer, which might be infuriatingly academic, is, it depends what you mean by science and art. This is a question that has a series of historical answers but does not to my mind lend itself to a definitive overall answer. Modern science is not a unitary endeavor. The complex gathering and analysis of data in environmental science is very different in its basis from knot theory in mathematical topology. The difficult behavioral analysis of chimpanzees in the wild shares little or nothing in common with the demanding complexities of quantum mechanics. When we extend our purview to the history of science from Greece to the twenty-first century, we see that what was known as science was different not just in its parts but also in its whole and in its attitude. Science in its early guises can be defined as systematic knowledge based on observation and reasoning, and pre-

sented in logical propositions. It was not a pursuit with a set of agreed protocols operated by professional scientists. Indeed the term *scientist* was not in use before the nineteenth century.

The foundations were qualitative rather than predominantly quantitative. The form and behavior of things in nature were based on the four elements of fire, air, earth, and water, and the four related properties, hot, dry, cold, and wet. These were expressed in various ratios by the four humors: cholic, melancholic, phlegmatic, and sanguine. It was only in the late seventeenth and early eighteenth century that these foundations were progressively replaced. In retrospect, we tend to pick out those episodes, like William Harvey's demonstration of the circulation of the blood, that look "scientific" in our eyes. Often the context for the admired episodes is very different from modern science, intellectually and socially. Harvey's short but seminal book is suffused with microcosmic theories. Those pursuits that we no longer see as scientifically worthwhile, such as alchemy, astrology, and physiognomy, we tend to write off as "pseudosciences" at best. Some of these activities were highly valued in their eras and enjoyed fruitful relationships with the visual arts, including physiognomics. The obsolete doctrine of the four humors was compellingly expressed in what remains one of the greatest of all paintings, Dürer's *Four Apostles* in Munich.

The same point about the nonunitary nature of science can be made with equal force with respect to art. Is the painter of a conventional portrait of the head of an Oxford College in the same business as Jonathan Callan when he sieves his cement plaster through holes? It does not seem to me that we have to think that they have anything significant in common. Let us look at this in terms of *causes*—as defined in the classical way. Aristotle's four causes were (1) the material cause, as the properties of the substance from which something is made; (2) the formal cause, by which something determines the shape or performance of something; (3) the efficient cause, as the active agency that applies formal cause to the material cause; (4) the final cause, which defines the aim or purpose of the thing that is being made. In the cases of the portrait painter and Callan, the only common element is that the efficient cause is embodied in a person undertaking intentional action, but the intentions are quite different. If we extend this into the historical realm, the carver of a tympanum of the Last Judgment on a medieval cathedral is really not in the same business as Callan in terms of the four causes. The fourth of

the Aristotelian causes is occupied in both science and art by advertent and inadvertent aims and purposes of extraordinary diversity.

Is the unity actually provided by the notion of "Art," defined as an activity designed to attract our aesthetic appreciation? I see no reason to assume that we can define "aesthetic" or "aesthetic excellence" in a precise way that embraces the portrait and a dust landscape. At best, "Art" and the "aesthetic" have come to signal an amenable kind of social and cerebral activity, with strong expectations of the kind of location in which it is defined as happening or being present, and of the kinds of state and private support that bring it into being.

In a previous book, *Christ to Coke: How Image Becomes Icon,* I asked if the eleven images I had chosen to examine necessarily shared anything in common. I used something I called "fuzzy category theory" to say that the question as asked did not have a definitive answer. Here I would like to suggest that the strategy might be applied more broadly to the definition of "science" and "art." What follows is adapted from the last chapter of that book. Even though what I am doing is at considerable remove from the proper mathematics of set and group theory, it is not particularly easy reading—but the issues by their nature are complex.

I should like to propose that we use an odd variant of fuzzy group theory in mathematics to handle the big categories of "science" and "art." It is probably best called fuzzy category theory. The notion of fuzziness in set and group theory has been developed to cope with situations in which absolute definitions, inclusions, and exclusions cannot be made. Fuzziness can handle categories that are identifiable and have broadly recognized characteristics, but at the same time the boundaries and membership of the categories are open to unresolvable disputes. The theory can also embrace both strong ties and those looser associations that lie outside the more obvious membership conditions.

Let us take a simple example of fuzzy categories. One of my grandsons used to reject food as "too hot" if it was above room temperature to a discernible degree. He was told that was not too hot—to no avail. I like my food much hotter than that, but not as hot as some people like it. Their food is "too hot" for me. Thus, if we have a category of "too hot," the definition of what belongs in that category is untidy, even though we know what it means. If we apply the category "too hot" to how hot the plate is to touch, the untidiness is even more pronounced. Even more so with "the weather is too hot." This is to say nothing of the category of "hotness"

applied to spicy foods. We have no difficulty in practice navigating through all the kinds and degrees and types of "too hot," and it is a useful category, but it is difficult to deal with it in a clear-cut and systematic manner. There is no general thermometer with the reading "too hot" on it, though there may be a specific one for babies' baths. It seems to me that the definitions of science and art are essentially like this across a wide disciplinary and historical span. What is and what is not science and what is and what is not art are neither tidily agreed on nor subject to any neatly definable rules, but we have a general sense of what kind of thing we and other people in our culture are talking about. Part of the historian's job is to define what earlier cultures were talking about when they mentioned art and science.

To demonstrate how fuzzy categories operate, let us imagine a two-dimensional field in which we distribute all those characteristics or factors (intellectual and social) that we deem to be active components in science or in art (fig. 146). In my diagrammatic field, the spatial or other separation between the various characteristics is not of definitive significance, since factors that we might initially categorize as widely separated might sometimes come to interact in complex and dynamic ways. Often the interactions will be most powerful with adjacent characteristics, but on other occasions the linked factors will be situated in seemingly

Figure 146. Fuzzy category field, with green, blue, and red groups

remote parts of the field. Nor is there any strict ranking, though we may imagine that characteristics we feel to be more significant are clustered toward the center.

I am not attempting here to identify the actual characteristics denoted by each of the twenty letters distributed erratically across the field. Rather I am demonstrating a mode of thinking about the overarching categories with which we are concerned. The proposal I am making is that it is possible for works of science or

art, each with a different set of characteristics, to belong by tacit assent within the overall field while not necessarily sharing any set of characteristics or even (surprisingly) any one characteristic in common.

Looking at our diagrammatic field, we see three groups of letters (representing characteristics or factors), eleven enclosed by the green border, ten by the blue, and nine by the red. There is no letter that appears in all three, which means that no factor can be deemed to be absolutely necessary. Lonely *P,* in the bottom right corner, is not in any group, but it is in the field because it has been generally identified as a common if not universal factor in the given category. *K* features in only the green, while *J* is shared with red. *E* and *H* look a bit marginal, included only once and located at the edge of the field, but they could potentially figure powerfully with other marginal factors in conjunction with a very few of the more central factors in another set. The red group includes less than half of the letters, but is strongly represented by the central factors. It would be possible to undertake a precise analysis of the various combinations of nine, ten, and eleven letters, but I want to retain a central element of subjective perception rather than resorting too dogmatically to mathematical theory.

I am envisaging a situation in which we instinctively recognize that the green, blue, and red groups are all readily identifiable as being members of the category of science or art, without having any *necessarily* shared factors or needing a critical number of factors. I also envisage that each group itself, with its defined characteristics, might well be associated more loosely with other factors outside the boundaries of the square, but without these other factors being drawn decisively within the boundaries of the group. What looks like a relatively weak set might be given a great boost from powerful associated factors outside the square. If this is anything like correct, it means that we can talk of science and art in a coherent way without assuming that the terms serve more than practical utility as fuzzy categories. In historical terms, fuzziness does mean the categories are weak. How art and science—or the arts and sciences—are defined at a given time provides a powerful framework within which participants define themselves and their activities.

This leaves the question of where "structural intuitions" reside in these categories. In a broad sense the structures reside in the "material," "efficient," and "formal" causes with respect to nature, while the intuitions reside in the "formal" and

"final" causes of our active and selective direction of perception, comprehension, and demonstration of the structures. This causal analysis is independent of our definitions of science and art. When the causes come to be deployed in relation to specific characteristics in the fields of either science or art, they diverge widely in both contemporary and historical terms. Since we have declined to define science and art as unitary activities, the actual operation of causes in any given instance will not exhibit unity or even an essential consistency.

The operations of the final causes are extraordinarily varied in function and form in their own right. If we return to our examples of Jonathan Callan and a portrait painter (in this instance thinking about Raphael as the painter of *Pope Julius II*), the political, institutional, social, and artistic contexts are notably divergent. Callan makes "Art" in the contemporary art world. Which is its own kind of social context. Raphael is using his skills in naturalistic portrayal to make a definitive image of the forceful but aged pontiff to serve a propagandistic function. Callan exhibits more affinity with the science of self-organized criticality than with the requirements of papal prestige. We can proliferate similarly contrasting examples across many types of art. We could easily also do the same for science, taking, for example, Gesner's *Unicorn* and Luminet's polyhedral cosmos.

The fuzzy category field and the nexuses occupied by historically diverse types of cause are not in reality two-dimensional, as in the diagram, but three-dimensional at least. To the factors, characteristics, or types, we need to add the dimensions of geography and time. Once the category field and causal nexuses are combined, we are entering a multidimensional zone of considerable complexity. I am not wishing to suggest that such diagrammatic conceptions, whatever their dimensions, have some kind of superior reality. They are simply ways of suggesting and representing something of the conceptual, historical, and geographical complexities that the historian is involved in charting.

As a final way of underlining the complexities, I should like to look at one more work of art. It is an installation in 1992 by the Scottish artist Glen Onwin (fig. 147). It was located in the handsome and partly derelict Square Chapel in Halifax, West Yorkshire (now restored for use as a vibrant arts center). The pavement inside the chapel was dominated by a square vat of black brine, within which clusters of crystals congealed around barren lands of floating wax. The aggregated morphology of each island was individual, yet the crystallized formations exhib-

Figure 147.
*Nigredo—Laid
to Waste*, Glen
Onwin, Halifax,
Square Chapel,
1992

ited clear similarities as a consequence of the underlying mechanisms of crystallization and aggregation. The islands did not assume fixed dimensions but varied according to climatic conditions.

The processes behind such formations stand within the province of the science of chemistry. And there is much in Onwin's response to the phenomena that is consistent with modern science. We may think of the search for the constants that decree that salt ideally seeks to crystallize in cubes, or those that determine common morphologies from the cosmic to the microscopic. We could also look to such contemporary concerns as fractal systems and diffusion-limited aggregation. We can also intuit the kind of environmental concerns that Onwin has expressed in his studies of an important salt marsh near Dunbar in Scotland.

However, Onwin was also delving into realms of meaning that share more with alchemy than with the prevailing tenor of modern science. His fascination with the emergence of self-organized shapes from fluid chaos suggestively conflates the dark *massa confusa* of alchemy with the origins of matter as conceived in modern science. If this association of alchemy and "proper" science seems like a strange marriage, it is appropriate to recall that Newton was an alchemist. The title of the Halifax installation, *Nigredo,* is openly alchemical in its reference to the primitive and sometimes recurrent stage of black putrefaction before purification in the transmutation of substances. The work's subtitle, *Laid to Waste,* alludes to Onwin's long-standing and modern concern for the fragile ecology of our planet.

Using our present criteria, we may strive to categorize Onwin's *Nigredo* as a work of art, as by a contemporary artist, as an installation, as Scottish, as ecological, as sci-art, and so on. However, its historical, geographical, visual, and intellectual affinities do not submit comfortably to restrictive taxonomies. We may recall that Susan Derges has comparably looked toward alchemy for inspiration. One of the attractions of alchemy for contemporary artists is a feeling that modern chemistry has become too detached from a holistic view of nature.

The end products of modern science seek to restrict the kind of fuzzy associations that allow artists to see alchemy as both an art and a science—indeed as it was viewed historically. A paper published in *Nature* needs to locate itself in a defined place in the spectrum of science; it needs to demonstrate its transparent operation of recognized protocols in method and exposition; it needs to use terms and illustrations that promise accepted precision; it needs to shut down

ambiguities as to how it can be read. The reader is expected to exercise analytical understanding, not unbridled imagination. This is, however, to speak only of the intended function of the end product. In all the preceding phases more creative fluidity comes into play, including what I am calling structural intuitions. The intuitions can obviously play a key role in the definition of the initial questions and hypotheses, but they can also potentially intervene at any subsequent stage, much as an engineer-designer like Balmond recurrently returns to handmade improvisations as his computer algorithms generate complex structures. And, in reality, the act of reading of the end product in *Nature* might well stimulate unintended acts of imagination, not least when the ideas behind the exposition are mapped onto another field.

The process of structural intuition is something we all do all the time. It is basic to the way that we make sense of the world, both with respect to how it is but also to how it will behave. If my grandson tosses his football on the roof of my garden shed, I know I cannot reach it, even with a ladder. However, reaching out with a hoe that I have taken from the shed, I can knock it off into his awaiting arms. This seems simple and obvious. But it actually relies upon an amazing compound of experience, knowledge, and expectation about such things as balls, poles, gravity, and the use of things to perform tasks for which they were not designed. What scientists and artists do is to elevate one or more facets of such cognitive and visualizing processes to obsessive levels. In doing so, they can make us look and understand in different ways.

As the last word, I should emphasize that structural intuition is not a thing. It is a collective term that is intended to point helpfully toward a complex compound of gravitational forces in our perception, cognition, and invention. It is one of my jobs as a historian to show that it defies our ability to set definable limits on its operation.

Sources and
Further Reading

A full-scale scholarly bibliography for the range of topics which I have touched upon would be larger than the book itself. Just as the book "samples" what I hope are telling episodes, so the list of reading by chapter is very selective, and is limited to important direct sources for the text and some readings that will carry the reader further into some of the key incidents and issues (including a wider range of bibliographical references). A number will allow the reader to do more justice to topics and individuals than I have been able to do. Some of the examples have been drawn from my two earlier attempts to gather and synthesize the regular essays I published in *Nature,* namely *Visualizations* and *Seen/Unseen.*

For the most-cited artist/scientist in the book, Leonardo da Vinci, I have used the standard nomenclature of the manuscripts (e.g., MS G, which is in the Institut de France). Keys to this system of reference can be found in many standard Leonardo books, including my monographs that appear below. A good range of Leonardo manuscripts are now available at http://www.leonardodigitale.com.

I am conscious that the selection leaves out writings by authors I admire, and there must be many others I ought to have read but have not.

INTRODUCTION

Bak, Per. *How Nature Works: The Science of Self-Organized Criticality.* New York, 1996.

Ball, Philip. *Flow, Shapes, Branches.* Oxford, 2011.

———. *The Self-Made Tapestry: Pattern Formation in Nature.* Oxford, 2001.

Ben-Jacob, Eshel, and Herbert Levine. "The Artistry of Nature." *Nature,* February 22, 2001, 985–86.

Cohen, Jack, and Ian Stewart. *The Collapse of Chaos.* London, 1994.

Darwin, Charles. *The Origin of Species.* London, 1859.

Descartes, René. *Regulae ad Directionem Ingenii* (Rules for the Guidance of Our Innate Powers of Mind), in *Descartes' Philosophical Writings,* selected and translated by Norman Kemp Smith, 10. New York, 1958.

Ede, Siân. *Art and Science.* London, 2005.

———. *Strange and Charmed: Science and the Contemporary Visual Arts.* London, 2000.

Hadamard, Jacques. *The Psychology of Invention in the Mathematical Field.* Princeton, 1945.

Haeckel, Ernst. *Anthropogenie oder Entwickelungsgeschichte des Menschen.* Leipzig, 1874.

———. *The History of Creation.* Trans. E. R. Lankester. London, 1868.

———. *Kunstformen der Natur.* Leipzig and Vienna, 1899–1904.

Huang, Menfei, Holly Bridge, Martin Kemp, and Andrew Parker. "Human Cortical Activity Evoked by the Assignment of Authenticity When Viewing Works of Art." *Frontiers in Human Neuroscience* 5, no. 134 (2011): 1–8.

Janoos, Firdaus, et al. "Spatio-Temporal Models of Mental Processes from fMRI." *NeuroImage* 57, no. 2 (2011): 362–77.

Kemp, Martin. *Leonardo da Vinci: The Marvellous Works of Nature and Man.* Rev. ed. Oxford, 2000.

———. *Seen/Unseen: Art, Science, and Intuition from Leonardo to the Hubble Telescope.* Oxford, 2006.

———. *Visualizations: The Nature Book of Art and Science.* Oxford, 2000.

Menon, Ravi, and Seong-Gi Kim. "Spatial and Temporal Limits in Cognitive Neuroimaging with fMRI." *Trends in Cognitive Neuroscience* 3 (1999): 207–16.

Myers, William. *Bio Design.* New York, 2012.

Randall-Page, Peter. http://www.peterrandall-page.com/about/intro.html.

Stafford, Barbara. *Echo Objects: The Cognitive Work of Images.* Chicago, 2007.

———. *Visual Analogy: Consciousness as the Art of Connecting.* Cambridge, Mass., 2001.

Strogatz, Steven. *SYNC: The Emerging Science of Spontaneous Order.* London, 2003.

Thaliath, Babu. *Natur und Struktur der Kräfte.* Würzburg, 2010. See http://babu-thaliath.com for a range of publications on structural intuitions.

Thompson, D'Arcy Wentworth. *On Growth and Form.* Cambridge, 1917.

Toll, Ian. *Pacific Crucible: War at Sea in the Pacific, 1941–1942.* New York and London, 2012.

Wallace, Marina, and Assimina Kaniari, eds. *Acts of Seeing: Artists, Scientists and the History of the Visual.* London, 2009.

Wilson, Stephen. *Art + Science Now.* New York, 2010.

1. PLATONIC PERCEPTIONS

Ball, Philip. On the British tombs with polyhedrons: www.rsc.org/chemistryworld/ Issues/2009/July/ColumnThecrucible.asp.

Bentley, Wilson. *Snow Crystals.* Ed. William Humphreys. New York, 1962.

Breidbach, Olaf. *Visions of Nature: The Art and Science of Ernst Haeckel.* Munich, 2006.

Donovan, Molly, and Tina Fiske, eds. *The Andy Goldsworthy Project.* Washington, DC, 2010.

Euclid. *Elements of Geometry.* Trans. Thomas Heath. Santa Fe, 2007.

Field, J. V. *Kepler's Geometrical Cosmology.* Chicago, 1988.

Fuller, Buckminster. See website maintained by Trevor Blake, http://synchronofile.com.

Gorman, Michael-John. *Buckminster Fuller: Designing for Mobility.* Geneva, 2005.

Haeckel, Ernst. *Kunstformen der Natur.* 2 vols. Leipzig and Vienna, 1904.

Kepler, Johannes. *Mysterium Cosmographicum.* Tübingen, 1596–97. Trans. by A. M. Duncan as *Mysterium Cosmographicum: The Secret of the Universe,* with intro. and commentary by E. J. Aiton. New York, 1981.

———. *The Six-Cornered Snowflake.* Philadelphia, 2010.

Klibansky, Raymond, Erwin Panofsky, and Fritz Saxl. *Saturn and Melancholy: Studies in the History of Natural Philosophy, Religion, and Art.* Ann Arbor, 2005.

Kroto, Harry. "Art & Science: Geodesy in Materials Science." In *Acts of Seeing,* ed. M. Wallace and A. Kaniari, 78–85. London, 2009.

Lachièze-Rey, Marc, and Jean-Pierre Luminet. *Celestial Treasury: From the Music of the Spheres to the Conquest of Space.* Cambridge, 2001.

Laurenza, Domenico. "The *Vitruvian Man* by Leonardo: Image and Text." *Quaderni d'Italianistica* 27 (2006): 37–56.

Leonardo da Vinci. On Vitruvian Man: http://leonardodavinci.stanford.edu/submissions/ clabaugh/history/leonardo.html.

Librecht, Kenneth. http://www.its.caltech.edu/~atomic/snowcrystals.

Luminet, Jean-Pierre. "Science, Art and Geometrical Imagination," http://fr.arxiv.org/ftp/ arxiv/papers/0911/0911.0267.pdf.

———. *The Wraparound Universe.* Wellesley, Mass., 2008.

Marshall, Dorothy. "Carved Stone Balls." *Proceedings of the Society of Antiquaries of Scotland* 107 (1976/77): 40–72.

Pacioli, Luca. *De Divina Proportione.* Venice, 1509.

Plato. *The Republic.* Trans. Benjamin Jowett. New York, 1991.

———. *Timaeus.* Trans. Benjamin Jowett. London, 2006.

Tucker, David. *A Dream and Its Legacies: The Samuel Beckett Lecture Theatre Project, Oxford c. 1967–76.* Gerrards Cross, UK, 2013.

Vitruvius Pollio. *Vitruvius: Ten Books on Architecture.* Trans. Ingrid Rowland. Cambridge, 1999.

Voss-Andreae, Julian. http://julianvossandreae.com.

Yong, Ee Hou, David R. Nelson, and L. Mahadevan. "Elastic Platonic Shells." *Physical Review Letters* 111 (2013): 1–5, http://www.seas.harvard.edu/softmat/downloads/2013–14.pdf. Zöllner, Frank. *Vitruvs Proportionsfigur: Quellenkritische Studien zur Kunstliteratur des 15. und 16. Jahrhunderts.* Worms, 1987.

2. SHAPED BY GROWTH

Ball, Philip. On Briony Marshall: http://www.rsc.org/chemistryworld/2013/05/life-forming-art-science-exhibition-briony-marshall.

Church, Arthur. *On the Relation of Phyllotaxis to Mechanical Laws.* London, 1904.

———. *Types of Floral Mechanism.* Part 1. Oxford, 1908.

Cook, Theodore Andrea. *Curves of Life.* London, 1914.

———. *Spirals in Nature and Art.* London, 1903.

Coomaraswamy, Ananda. *The Transformation of Nature in Art.* Cambridge, Mass., 1935.

Costa, Patrizia. "The Sala delle Asse in the Sforza Castle in Milan." PhD thesis, University of Pittsburgh, 2006.

Emboden, William. *Leonardo da Vinci on Plants and Gardens.* Portland, Ore., 1987.

Goodwin, Brian. *How the Leopard Changed Its Spots.* London, 1994.

Kaniari, Assimina. "D'Arcy Thompson's *On Growth and Form* and the Concept of Dynamic Form in Postwar Avant-Garde Art." *Interdisciplinary Science Reviews* 37 (2013): 63–73.

Kemp, Martin. "Doing What Comes Naturally: Morphogenesis and the Limits of the Genetic Code." In "Contemporary Art and the Genetic Code," ed. B. Sichel and E. Levy, special issue, *Art Journal* 55 (Spring 1996): 27–32.

———. "Natura Naturans: Peter Randall-Page and Nature's Pattern Book." In *Rock Music Rock Art: Peter Randall-Page New Work,* 7–18. Pangolin Gallery, London, 2008.

———. "Science in Culture: Trees of Knowledge." *Nature,* June 16, 2005, 888.

———. "Spirals of Life: D'Arcy Thompson and Theodore Cook, with Leonardo and Dürer in Retrospect." *Physis* 32 (1995): 37–54.

Marani, Pietro. "Leonardo e le colonne ad tronchonos: Tracce di un programma iconologico per Ludovico il Moro." *Raccolta vinciana* 22 (1982): 103–20.

Marshall, Briony. www.briony.com.

Moseley, Henry. *On the Geometrical Form of Turbinated and Discoid Shells.* London, 1838.

Palubicki, Wojciech, et al. "Self-Organising Tree Models for Image Synthesis," http://algorithmicbotany.org/papers/selforg.sig2009.pdf.

Randall-Page, Peter. http://www.peterrandall-page.com/about/intro.html.

Ruskin, John. *Elements of Drawing in Three Lectures to Beginners.* London, 1857. See also
 http://ruskin.ashmolean.org.

Thompson, D'Arcy Wentworth. *On Growth and Form.* Cambridge, 1917.

3. FOLDING, STRETCHING, COMPRESSING

Báez, Manuel. http://wewanttolearn.wordpress.com/2011/11/01/manuel-a-baez-crystal-flame-
 form-and-process.

Balmond, Cecil. *Crossover.* Munich, 2013.

———. http://balmondstudio.com.

Billington, David. *The Tower and the Bridge.* Princeton, 1985.

Bonet i Armengol, Jordo. *The Essential Gaudí: The Geometric Modulation of the Church of the
 Sagrada Família.* Trans. Mark Burry. Barcelona, 2001.

Boys, Charles Vernon. *Soap Bubbles and the Forces Which Mould Them.* London, 1902.

Cohen, Jean Louis, et al. *Frank O. Gehry: The Art of Architecture.* Guggenheim Museum Publi-
 cations. New York, 2003.

Conisbee, Philip. Essay in *Masterpiece in Focus: Soap Bubbles by Jean-Siméon Chardin,* 5–22.
 Exhibition catalogue. Los Angeles County Museum of Art, 1990.

Conversano, Elisa, et al. "Persistence of Form in Art and Architecture: Catenaries, Helicoids
 and Sinusoids." *Journal of Applied Mathematics* 4 (2011): 102–12.

Cornell, Joseph. *Joseph Cornell's Theater of the Mind: Selected Diaries, Letters, and Files.* Ed.
 Mary Ann Caws. New York, 2000.

Derges, Susan. *Liquid Form 1985–99.* Michael Hue-Williams Fine Art, London, 1999.

Doy, Gen. *Drapery: Classicism and Barbarism in Visual Culture.* London, 2002.

Floderer, Vincent. http://www.le-crimp.org/spip.php?page=presentation.

Hawking, Stephen. *The Universe in a Nutshell.* London, 2001.

Holm, Michael, and Kjeld Kjeldsen, eds. *Cecil Balmond: Frontiers of Architecture I.* Exhibition
 catalogue. Louisiana Museum of Modern Art, 2007.

Huerta, Santiago. "Structural Design in the Work of Gaudi." *Architectural Science Review* 39
 (2006): 324–39.

Kemp, Martin. "The Natural Philosopher as Builder." In *Cecil Balmond: Frontiers of Architec-
 ture I,* ed. M. Holm and K. Kjeldsen, 90–98. Exhibition catalogue. Louisiana Museum of
 Modern Art, 2007.

Koohestani, K., and S. Guest. "A New Approach to the Analytical and Numerical Form-Find-
 ing of Tensegrity Structures," http://www2.eng.cam.ac.uk/~sdg/preprint/formfind.pdf.

Liang, Haiya, and L. Mahadevan. "Growth, Geometry and Mechanics of a Blooming Lily,"
 http://www.seas.harvard.edu/softmat/downloads/2011-03.pdf.

Lynn, Greg. http://glform.com.

Mark, Robert. *Experiments in Gothic Structure*. Cambridge, Mass., 1982.

Neurohr, Theresa, and Damiano Passini. "Principles of Lightweight Structures in the Sculptural Conceptions of Naum Gabo." *Interdisciplinary Research Reviews* 34 (2009): 366–80.

Nikolinakou, M. A., A. J. Tallon, and J. A. Ochsendorf. "Structure and Form of Early Gothic Flying Buttresses." *Revue européenne de génie civil* 9 (2005): 1191–217.

Perkowitz, Sidney. *Universal Foam*. New York, 2000.

Plateau, Joseph. *Statique expérimentale et théorique des liquides soumis aux seules forces moléculaires* (Experimental and Theoretical Statics of Liquids Subject Only to Molecular Forces), 1873, http://www.susqu.edu/brakke/aux/downloads/plateau-eng.pdf.

Robbin, Tony. *Engineering a New Architecture*. New Haven, 1996.

Vitzoviti, Sophia. http://issuu.com/bis_publishers/docs/folding_architecture.

———. http://issuu.com/bis_publishers/docs/supersurfaces.

Watt, Alison. http://www.edinburghartfestival.com/commissions/alison_watt_2013/.

Wise, Chris. "Build with an Eye on Nature." *Nature,* February 14, 2013, 172–73.

4. WAVES, RIPPLES, SPLASHES

Ball, Philip. *Flow*. Oxford, 2009.

Bickers, Mark. http://markbickers.designerdesign.com.

Dalziel + Scullion. http://www.dalzielscullion.com/works_page/film/waterfalls.html.

Derges, Susan. *Elemental*. Ed. M. Barnes. Göttingen, 2010.

Drury, Chris. http://chrisdrury.co.uk/carbon-sink.

Dubinski, John. http://www.cita.utoronto.ca/~dubinski/nbody.

Goldsworthy, Andy. http://www.goldsworthy.cc.gla.ac.uk.

Goodwin, Brian. *How the Leopard Changed Its Spots*. London, 1994.

Encode Project. http://genome.ucsc.edu/ENCODE, and http://www.nature.com/news/encode-the-human-encyclopaedia-1.11312.

Jarron, Matthew, and Philip Ball, eds. "D'Arcy Thompson and His Legacy." Special issue, *Interdisciplinary Science Reviews* 38 (March 2013).

Jenny, Hans. *Cymatics*. Newmarket, NH, 2001.

Lin, Chia Chiao, and Frank Shu. "On the Spiral Structure of Disk Galaxies." *Astrophysical Journal* 140 (1964): 646–55.

Lorenz, Edward. http://eaps4.mit.edu/research/Lorenz/Butterfly_1972.pdf.

Kemp, Martin. "'Loving Insight': D'Arcy Thompson's Aristotle and the Soul in Nature." In *Turning Images in Philosophy, Science, and Religion: A New Book of Nature,* ed. C. Taliaferro and J. Evans, 5–24. Oxford, 2011.

———. "Metallic Music." *Nature,* October 14, 2010, 787.

Menezes, Marta de. http://martademenezes.com.

Morange, Michel. "Conrad Waddington and *The Nature of Life*." *Journal of Bioscience* 34 (2009): 195–98.

Sale, Charlotte. http://www.charlottesaleglass.com.

Smolin, Lee. "Galactic Disks as Reaction-Diffusion Systems," http://arxiv.org/pdf/astro-ph/9612033.pdf.

Thompson, D'Arcy Wentworth. *On Growth and Form*. Cambridge, 1917, 1945.

Turing, Alan. "The Chemical Basis of Morphogenesis." *Philosophical Transactions of the Royal Society of London, series B, Biological Sciences* 237 (1952): 37–72, http://www.dna.caltech.edu/courses/cs191/paperscs191/turing.pdf.

Waddington, Conrad Hal. *Beyond Appearance: A Study of the Relations between Painting and the Natural Sciences in This Century*. Edinburgh, 1969.

———. *Organisers and Genes*. Cambridge, 1940.

Wells, Francis. *The Heart of Leonardo*. London, 2013.

Worthington, Arthur. *A Study of Splashes*. London, 1908.

5. RHETORICS OF THE REAL

Bidloo, Govert. *Anatomia Humani Corporis*. Amsterdam, 1685.

Brunfels, Otto. *Herbarum Vivae Eicones*. Strasburg, 1530.

Daston, Lorraine, and Peter Galison. *Objectivity*. New York, 2007.

Clarke, T. H. *The Rhinoceros from Dürer to Stubbs, 1515–1799*. London, 1986.

Cuba, Johannvon. *Gartender Gesuntheit*. Augsburg, 1485.

Edgerton, Judy. *George Stubbs, Painter*. London, 2007.

Fuchs, Leonhart. *De Historia Stirpium Commentarii Insignes*. Basel, 1542.

Gesner, Conrad. *Historiae animalium*. 5 vols. Zurich, 1551–87.

Gombrich, E. H. *Art and Illusion: A Study in the Psychology of Pictorial Representation*. New York, 1960.

Gray, Henry. *Anatomy: Descriptive and Surgical*. London, 1858.

Hall, Brian. "The Paradoxical Platypus." *BioScience* 49 (1999): 211–18.

Hunter, William. *Anatomia Uteri Humani Gravidi* [The Anatomy of the Human Gravid Uterus]. Birmingham, 1774.

Kemp, Martin. "'The Mark of Truth': Looking and Learning in Some Anatomical Illustrations from the Renaissance and the Eighteenth Century." In *Medicine and the Five Senses,* ed. W. F. Bynum and Roy Porter, 85–121. Cambridge, 1995.

———. "Style and Non-Style in Anatomical Illustration: From Renaissance Humanism to Henry Gray." *Journal of Anatomy* 216 (2010): 192–208.

———. "Taking It on Trust: Form and Meaning in Naturalistic Representation." *Archives of Natural History* 17 (1990): 127–88.

———. "'The Testimony of My Own Eyes': The Strange Case of a Mammal with a Beak." *Spontaneous Generations* 6 (2012): 1–7; jps.library.utoronto.ca/index.php/SpontaneousGenerations.

Knoeff, Rina. "Moral Lessons of Perfection: A Comparison of Mennonite and Calvinist Motives in the Anatomical Atlases of Bidloo and Albinus." In *Medicine and Religion in Enlightenment Europe,* ed. O. P. Grell and A. Cunningham, 121–43. Aldershot, 2007.

Lavers, Chris. *The Natural History of Unicorns.* Cambridge, 2009.

Olsen, Penny. *Upside Down World: Early European Impressions of Australia's Curious Animals.* Canberra, 2010.

Paré, Ambroise. *The Works of that Famous Chirurgeon Ambose Parey.* Trans. Thomas Johnson. London, 1678.

Shaw, George. *General Zoology: Or, Systematic Natural History*, 1:228–32. London, 1800.

———. "Platypus anatinus." *Naturalist's Miscellany,* vol. 10. London, 1799.

van der Lande, Virginia M. "A Note on Richard Latham, FLS: Donor of the Holotype of *Ornithorhynchus anatinus* (Shaw, 1799) to the British Museum." *The Linnaean* 23:37–43.

Vesalius, Andreas. *De Humani Corporis Fabrica.* Basel, 1543.

Zell, Timothy. http://www.has.vcu.edu/wrs/profiles/ChurchOfAllWorlds.htm.

AFTERWORD

Kemp, Martin. *From Christ to Coke: How Image Becomes Icon.* Oxford, 2012.

———. "Onwin's Holistics." *Nature,* February 5, 1998, 391.

Mordeson, John, Kiran Bhutani, and Azriel Rosenfeld. *Fuzzy Group Theory.* Berlin, 2005.

Onwin, Glen. http://www.onwin.co.uk/site/Home.html.

Principe, Lawrence. *The Secrets of Alchemy.* Chicago, 2013.

Illustration Credits

Figs. 1–2: Wellcome Library, London. **Fig. 3:** Jonathan Callan. **Fig. 4:** Martin Kemp. **Fig. 5:** Julian Voss-Andreae; photo by Dan Kvitka. **Fig. 6:** © Ashmolean Museum, University of Oxford/Mary Evans, AN1927.2727-2731. **Fig. 7:** Biblioteca Ambrosiana, Milan, Italy/De Agostini Picture Library/© Veneranda Biblioteca Ambrosiana-Milano/Bridgeman Images. **Fig. 8:** Biblioteque Nationale, Paris, France/Giraudon/Bridgeman Images. **Fig. 9:** Venice, Accademia, © 2014; photo Scala, Florence; courtesy of the Ministero Beni e Att. Culturali. **Fig. 10:** Rosenwald Collection 1943.3.3522, National Gallery of Art, Washington, DC. **Fig. 11:** Martin Kemp and Matt Landrus. **Fig. 12:** Universal History Archive/UIG/The Bridgeman Art Library. **Figs. 13–14:** Jean-Pierre Luminet and Jeff Weeks. **Fig. 15:** Jean-Pierre Luminet. **Fig. 16:** Smithsonian Institution Archives, image no. SIA2014-06936. **Fig. 17:** © Kenneth G. Libbrecht. **Fig. 18:** © Tibor Bognar/Alamy. **Fig. 19:** J. Bernholc et al., North Carolina State University/Science Photo Library. **Fig. 20:** Collection of Norman D. Kalbfleisch and Neil A. Matteucci (Portland, Oregon). **Fig. 21:** Harry Kroto and Ken McCay. **Fig. 22:** Photo by Roger Stoller/photovalet.com. **Fig. 23:** United States Patent and Trademark Office. **Fig. 25:** Photo Nigel Young/Foster + Partners. **Fig. 26:** Carl Zeiss archives. **Fig. 27:** © Foster + Partners. **Figs. 28–29:** Albert and Shirley Small Special Collections Library, University of Virginia. **Fig. 30:** Andy Goldsworthy. **Fig. 31:** Andy Goldsworthy/National Gallery of Art, Washington, DC,

Gallery Archives. **Fig. 32:** Andy Goldsworthy. **Fig. 33:** Jan Wassenaar/www.2dcurves
.com. **Fig. 34:** Andy Goldsworthy. **Fig. 35:** © Ashmolean Museum, University of Oxford. **Figs.
36–37:** Photo by Martin Kemp. **Fig. 38:** The Royal Collection © 2014 Her Majesty Queen
Elizabeth II/Bridgeman Images; Windsor, Royal Library, 12592r. **Fig. 39:** The Royal Collec-
tion © 2014 Her Majesty Queen Elizabeth II/Bridgeman Images; Windsor, Royal Library,
12592r. **Fig. 40:** © RMN-Grand Palais (Institut de France)/René-Gabriel Ojéa; MS G 33r.
Fig. 41: © RMN-Grand Palais (Institut de France)/Thierry Le Mage; MS M 78v. **Fig. 42:** ©
2014 DeAgostini Picture Library/Scala, Florence. **Figs. 43–44:** Annie Cattrell. **Figs. 45–46:**
Jan Wassenaar/www.2dcurves.com. **Fig. 47:** © Natural History Museum, London. **Fig. 48:**
Creative Commons/http://commons.wikimedia.org/wiki/File:Duerer_Underweysung_der_
Messung_016.jpg. **Fig. 49:** © Hemis/Alamy. **Fig. 50:** © The estate of Nigel Henderson/
© Tate, London, 2014. **Fig. 52:** Peter Randall-Page; photo by Marc Hill. **Fig. 53:** Peter Cook/
View. **Fig. 54–57:** Peter Randall-Page. **Fig. 58:** Photo by Martin Kemp. **Fig. 59:** Photo www.
flickr.com/photos/noggin_nogged/863169535/. **Fig. 60:** Photo http://commons.wikimedia.
org/wiki/File:LaPedreraParabola.jpg. **Fig. 61:** © Expiatory Temple of the Sagrada Família.
Fig. 62: Photo © Michelle Enfield/Alamy. **Fig. 63:** Photo © John Kellerman/Alamy. **Fig. 64:**
Private collection/Prismatic Pictures/The Bridgeman Art Library. **Figs. 65–67:** Courtesy Bill
Gates/© bgC3. **Figs. 68–69:** Image © 2014 The Metropolitan Museum of Art/Art Resource/
Scala, Florence. **Fig. 70:** Wellcome Library, London. **Fig. 71:** © 2015 The Joseph and Robert
Cornell Memorial Foundation/VAGA, NY/DACS, London; photo © 2013 Smithsonian
American Art Museum/Art Resource/Scala, Florence. **Fig. 73:** Susan Derges. **Figs. 74, 77:**
Jan Wassenaar/www.2dcurves.com. **Fig. 78:** Eugene Freyssinet/Giraudon/The Bridgeman
Art Library. **Fig. 79:** © Tate, London, 2014; the work of Naum Gabo © Nina and Graham
Williams; image courtesy of Annely Juda Fine Art, London 16/10/2014. **Fig. 80:** Collection
of the City of Baltimore, MD. **Fig. 81:** © Arup. **Fig. 82:** © RMN-Grand Palais (Musée du
louvre)/Jean-Gilles Berizzi. **Fig. 83:** The Royal Collection Trust © 2014 Her Majesty Queen
Elizabeth II/Bridgeman Images; Windsor, Royal Library 12530. **Fig. 84:** Gehry Partners.
Fig. 85: © Guggenheim Museum, Bilbao; photo by Erika Ede. **Fig. 86:** Vincent Floderer;
folded by Anne Cécile Plancq; photo by Suzann Dugan. **Fig. 87:** United Architects. **Fig.
88:** Malcolm Godwin, Moonraker Designs; © Rosedale Publishing LLC, Pleasant Valley,
NY. **Fig. 89:** Manuel Báez. **Fig. 90:** © Cecil Balmond. **Fig. 91:** © Balmond Studio. **Fig. 92:**
Alison Watt/Ingleby Gallery; photo by Hyjdla Kosaniuk Innes. **Fig. 93–94:** Courtesy Bill
Gates/© bgC3. **Fig. 95:** The Royal Collection Trust © 2014 Her Majesty Queen Elizabeth II/
Bridgeman Images; Windsor, Royal Library, 12260. **Fig. 96:** The Royal Collection Trust ©
2014 Her Majesty Queen Elizabeth II/Bridgeman Images; Windsor, Royal Library, 19082r.
Fig. 97: The Royal Collection Trust © 2014 Her Majesty Queen Elizabeth II/Bridgeman
Images; Windsor, Royal Library, 12515. **Fig. 100:** Marta de Menezes. **Fig. 101:** Antony Hall,
www.antonyhall.net. **Fig. 102:** Photo by the author. **Fig. 103:** © 2004 Henry et al.; licensee
BioMed Central Ltd., http://www.biomedcentral.com/1471-2229/4/3/figure/F1. This is an

Fig. 104: © 2014 digital image, The Museum of Modern Art, New York/Scala, Florence; © The Pollock-Krasner Foundation ARS, NY and DACS, London 2015. The Museum of Modern Art (MoMA), the Sidney and Harriet Janis Collection, acc. no. 645.1967. **Fig. 105:** Charlotte Sale; photo by Murray Ballard. **Fig. 106:** Andy Goldsworthy. **Fig. 107:** Louise Scullion and Matthew Dalziel. **Fig. 108:** Department of Physics, Massachusetts Institute of Technology; photo by Eli Sidman. **Fig. 109:** Susan Derges. **Fig. 110:** Science Museum, London/Science & Society Picture Library. **Fig. 111:** Conrad Shawcross. **Fig. 112:** Chris Drury. **Fig. 113:** NASA, ESA, and the Hubble Heritage Team (STScI AURA). **Fig. 114:** John Dubinski. **Figs. 115–17:** Wellcome Library, London. **Figs. 118–19:** © Ashmolean Museum, University of Oxford/Mary Evans. **Figs. 120–21:** Wellcome Library, London. **Figure 122.** Poster for the circus with "living unicorn," Ringling Bros. and Barnum & Bailey, 1985. **Figure 123.** Unicorn on the front page of the *New York Post,* 17 April 1985. **Fig. 124:** National Gallery of Art, Washington, DC, Rosenwald Collection, 1964.8.697. **Fig. 125:** Albertina, Vienna. **Fig. 126:** National Gallery of Art, Washington, DC, Rosenwald Collection, 1943.3.3524. **Fig. 128:** Image © 2014 The Metropolitan Museum of Art/Art Resource/Scala, Florence. **Fig. 129:** Schwerin, Staatliches Museum Schwerin, Fotograf unbekannt; photo © 2014 Scala, Florence/BPK, Bildagentur für Kunst, Kulture, und Geschichte, Berlin. **Fig. 130:** University of Washington Libraries, Special Collections, negative UW36338. **Figs. 131–35:** Wellcome Library, London. **Fig. 136:** Science Museum, London/Science & Society Picture Library. **Figs. 138–41:** Wellcome Library, London. **Fig. 142:** Hunterian Art Gallery, University of Glasgow, Scotland/The Bridgeman Art Library. **Fig. 143:** Wellcome Library, London. **Fig. 146:** Martin Kemp. **Fig. 147:** Glen Onwin; photograph by Jerry Hardman-Jones, lent with kind permission by the Henry Moore Institute. **Figures on pages 65, 67, and 68:** From *The Elements of Drawing, in Three Letters to Beginners,* John Ruskin, New York, 1886.

Index

octahedrons, 19, *22,* 25, 38, 118

On Growth and Form. See Thompson, D'Arcy Wentworth

Onwin, Glen, 218–20; *Nigredo-Laid to Waste, 219*

Orly, hangars at, 115, *115*

Ottawa Tulip Festival, proposed pavilion at, *128,* 129

Oudry, Jean-Baptiste, 194–95, *195*

Pacioli, Luca, 27–31, 34, 37, 40; *De Divina Proportione,* 28, *29, 30*

parabolas, 11, 59, *61,* 116

Paré, Ambroise, 185, 192, 192–93, *192; Des Monstres et prodiges* (On Monsters and Marvels), *186, 186,* 192

Paris, 115, 194

Pearl Harbor, 15

Pedro I (king of Portugal), 130

phenakitiscopes, 112

phi (φ), 82–83, 86–87

photography, 1, 18, 142, 144, 146, 157, 158, 175, 195, 209

phyllotaxis, 19, 81, 87, 91

physiognomics, 77, 78, 214

Physiologus (the Bestiary), 182

pibroch, 136

Piero della Francesca, 28

pine beetle, 164–65

Plancq, Anne Cécile, 125, *125*

Plateau, Joseph, 112–14, 116

Plato, 16, 30, 34; *Timaeus,* 24–25, 31. *See also* Platonic solids

Platonic solids, 1, 16, 19, *22,* 23–26, 27, 28, 30, 34, 37–38, *37,* 39–40, 47, 52, 61

platypus, duck-billed (*Ornithorhynchus anatinus*), 174–75, 176–78, *180–81,* 182, 186

Pliny, 206; *Discourse de la Licorne,* 185; *Natural History,* 182, 190, 192

Poincaré, Henri, 39

Pollock, Jackson, 154, *155*

polygons, 13, 24, 38, 45, 46, 50, 52–53, 92

Pomet, Pierre, *Histoire générale des drogues* (General History of Drugs), 185, *186*

potter, Thompson's analogy of the, 145, 154

Prague, Charles Bridge, 43

psychology, 6, 38

Quintilian, 173

radiolaria, 45, 52, 54, 92, 103, 116, 143

Randall-Page, Peter, 92, *96,* 97, *97; Seed,* 93, *94,* 95

raga, Indian, 136

Raphael, *Pope Julius II,* 218

Rapine, Maximilien, 108, *109*

Reims, cathedral at, 68

Rembrandt, 8, 18, 83

Republic (Plato), 30. *See also* Plato; Platonic solids

Reuwich, Erhard, 185

Richmond, Duke of, 207

rope, 74, *75,* 137, 204, 205

Royal Academy of Arts, London, 206

Royal Academy of Science, France, 199

Royal College of Surgeons, London, 206

Royal Institution, London, 77, 111

Ruskin, John, 64–68, *69,* 120; *Elements of Drawing, 65, 67,* 68

Sagrada Família, 102–4, *103, 104, 105. See also* Gaudí, Antoni

Sale, Charlotte, 156, *156*

Salisbury, England, 31

sand, 11–12, *12,* 14, 102

sand dollars, 109, 159

Sanseverino, Galeazzo, 28

Santucci, Antonio, 39

Scotland, 26, *26,* 83, 158, 183, 220

Sforza, Bianca, 28

Sforza, Duke Ludovico, 27–28, 69